MILES DAVIS

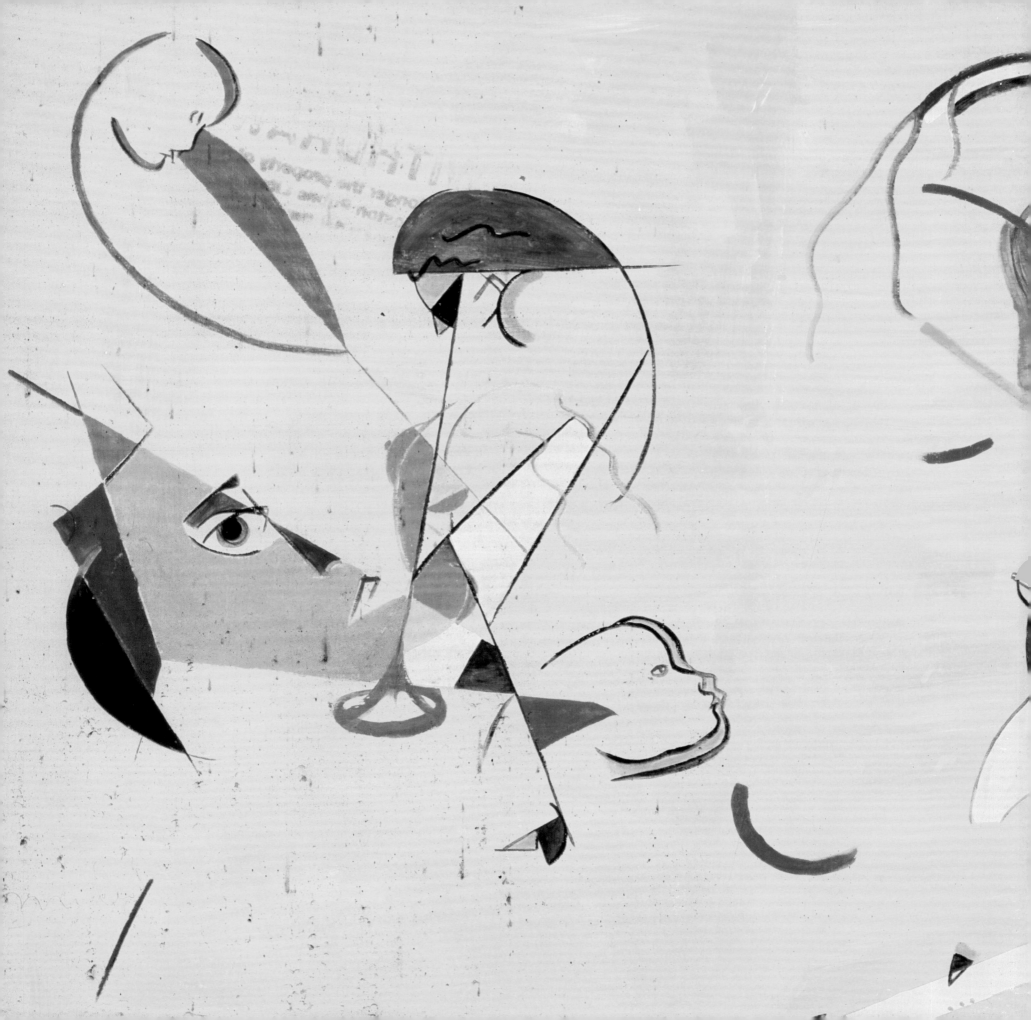

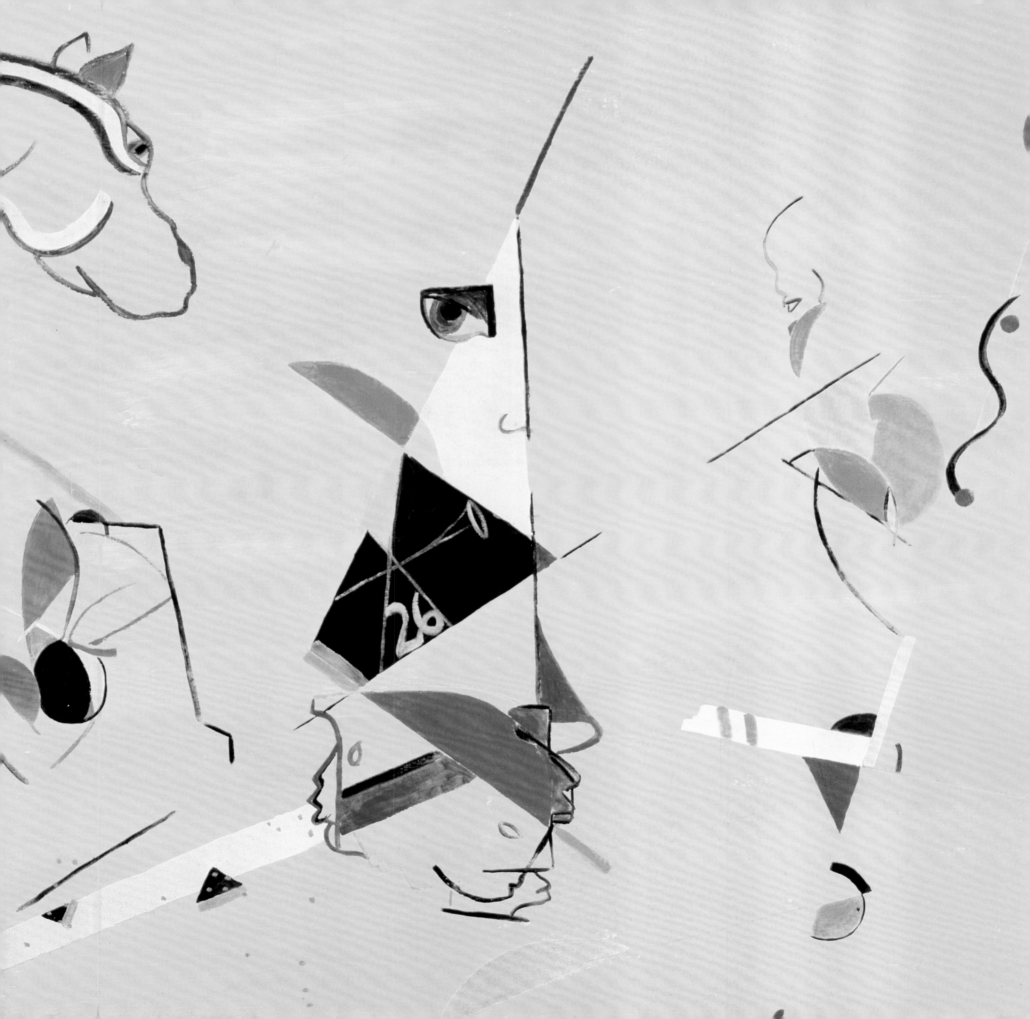

MILES

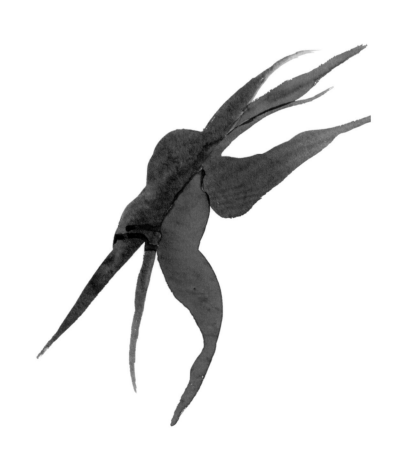

DAVIS

THE COLLECTED ARTWORK

TEXT BY SCOTT GUTTERMAN | FOREWORD BY QUINCY JONES

REFLECTIONS BY ERIN DAVIS AND VINCE WILBURN JR.

AFTERWORD BY CHERYL DAVIS

INSIGHT EDITIONS

San Rafael, California

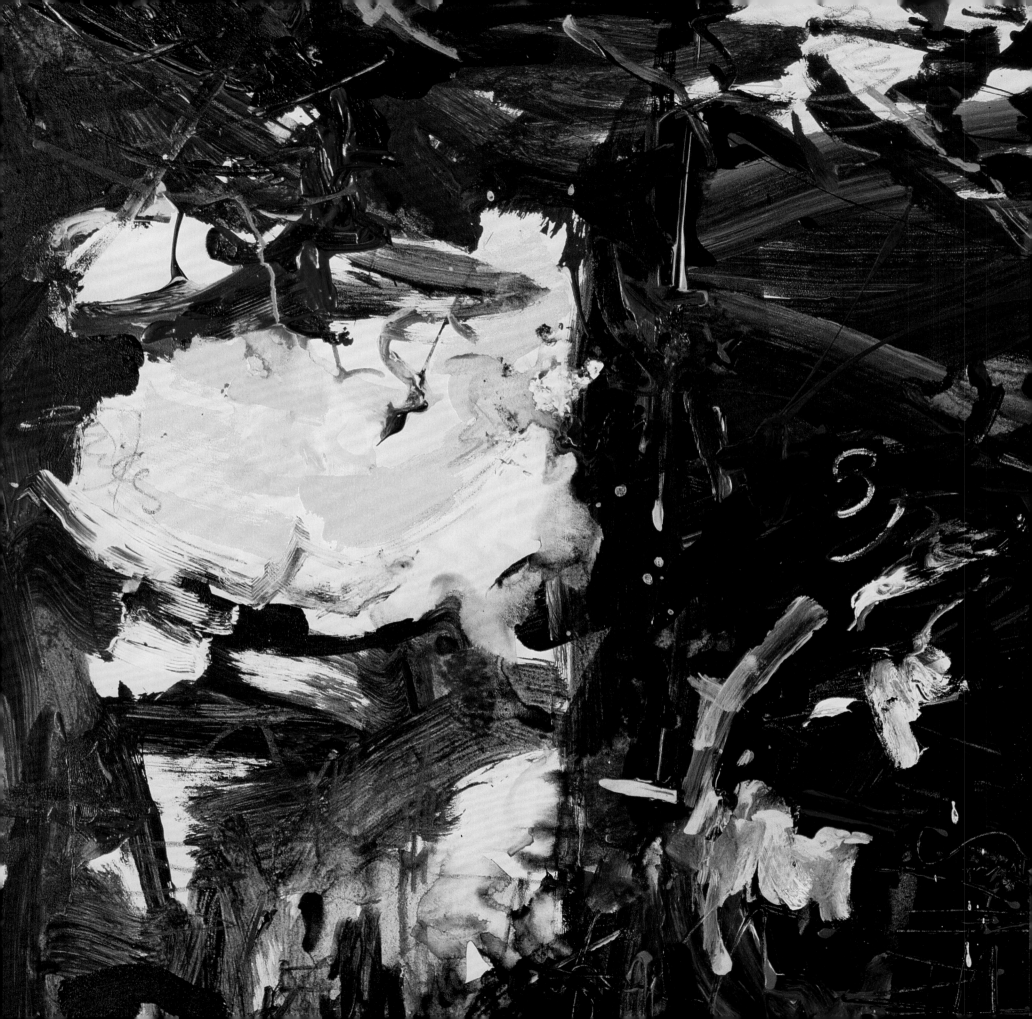

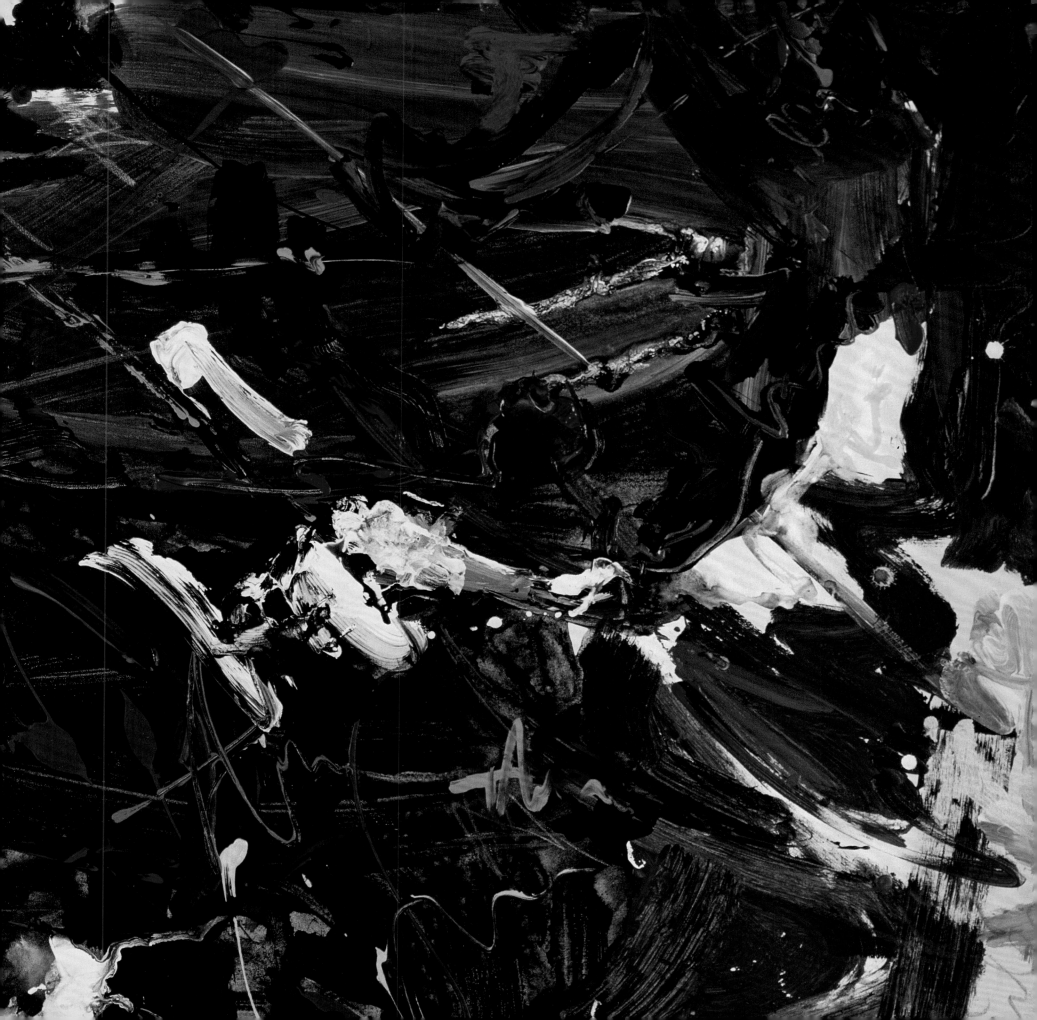

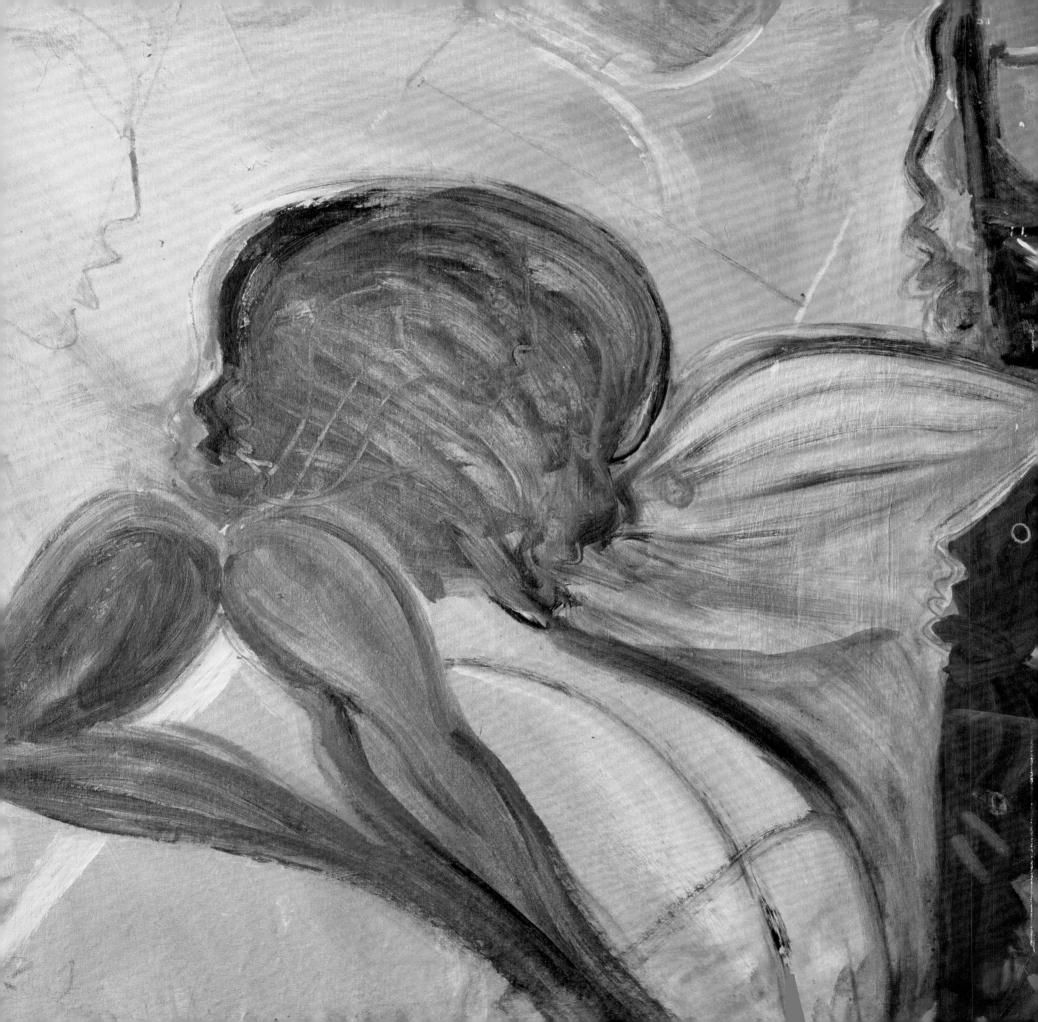

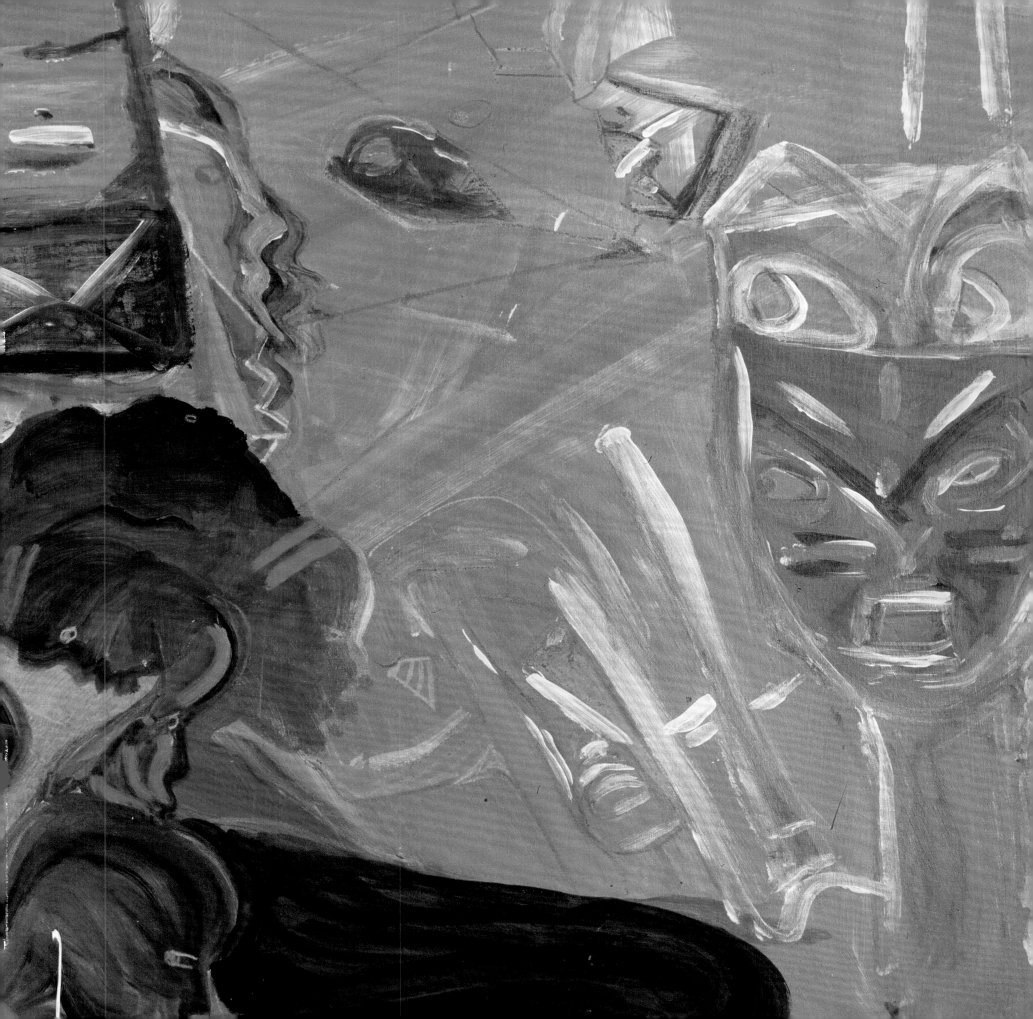

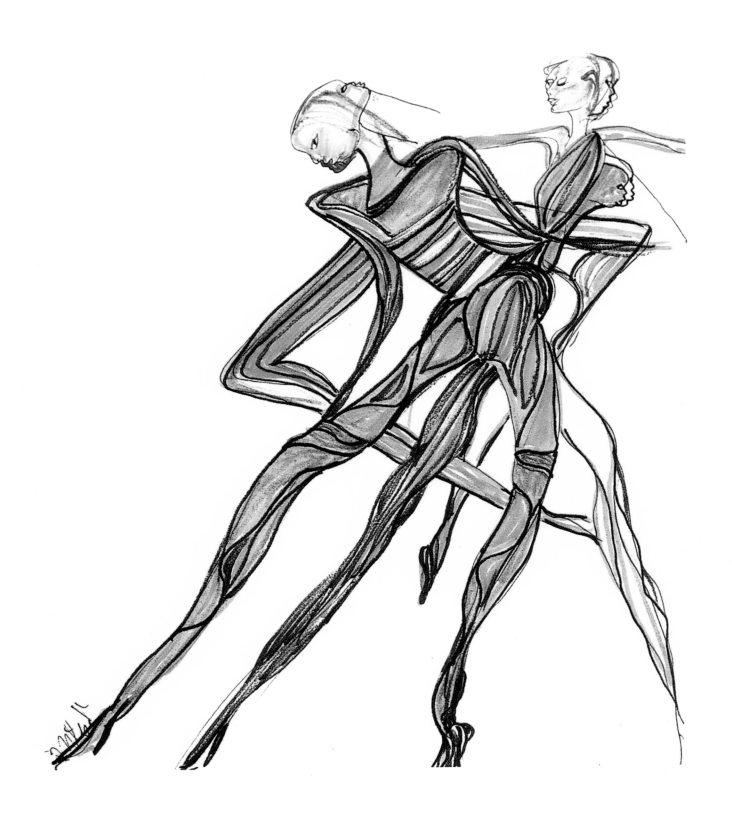

CONTENTS

Quotations Throughout by Miles Davis

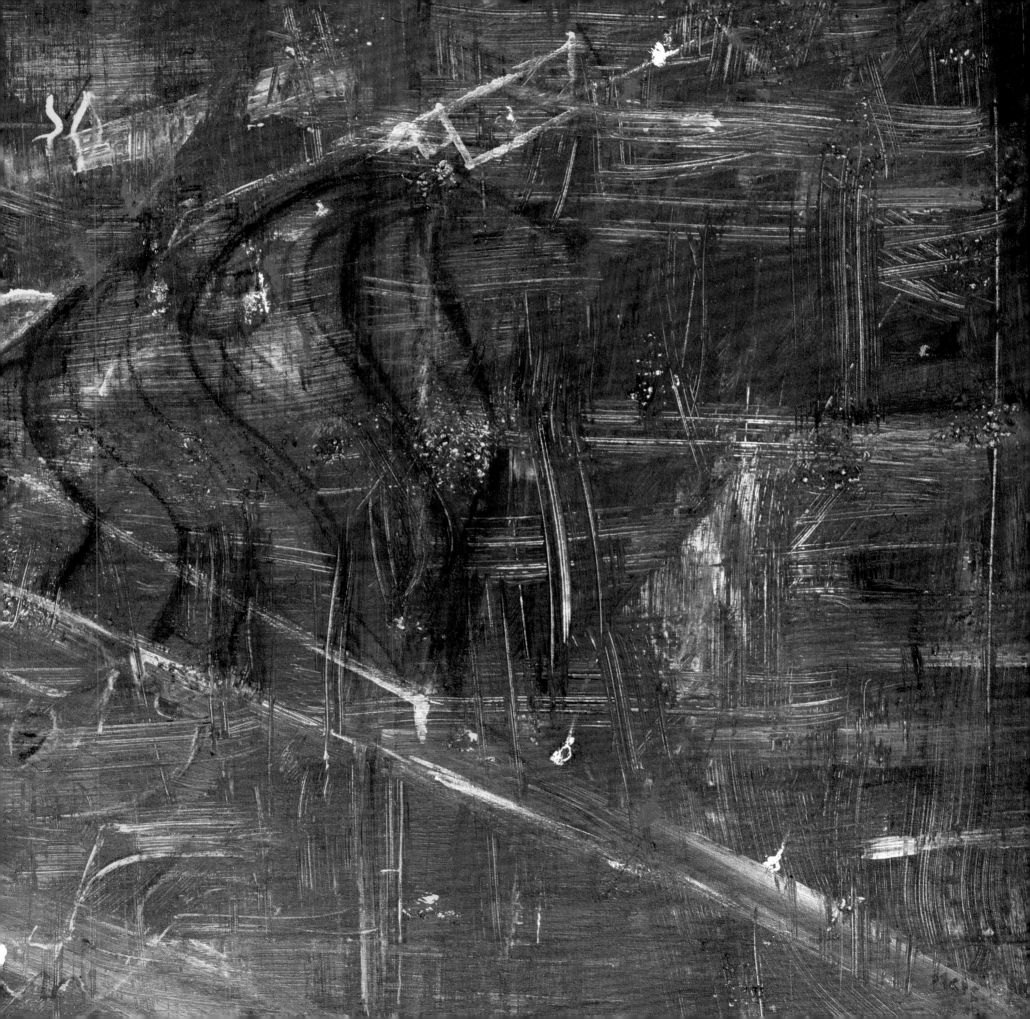

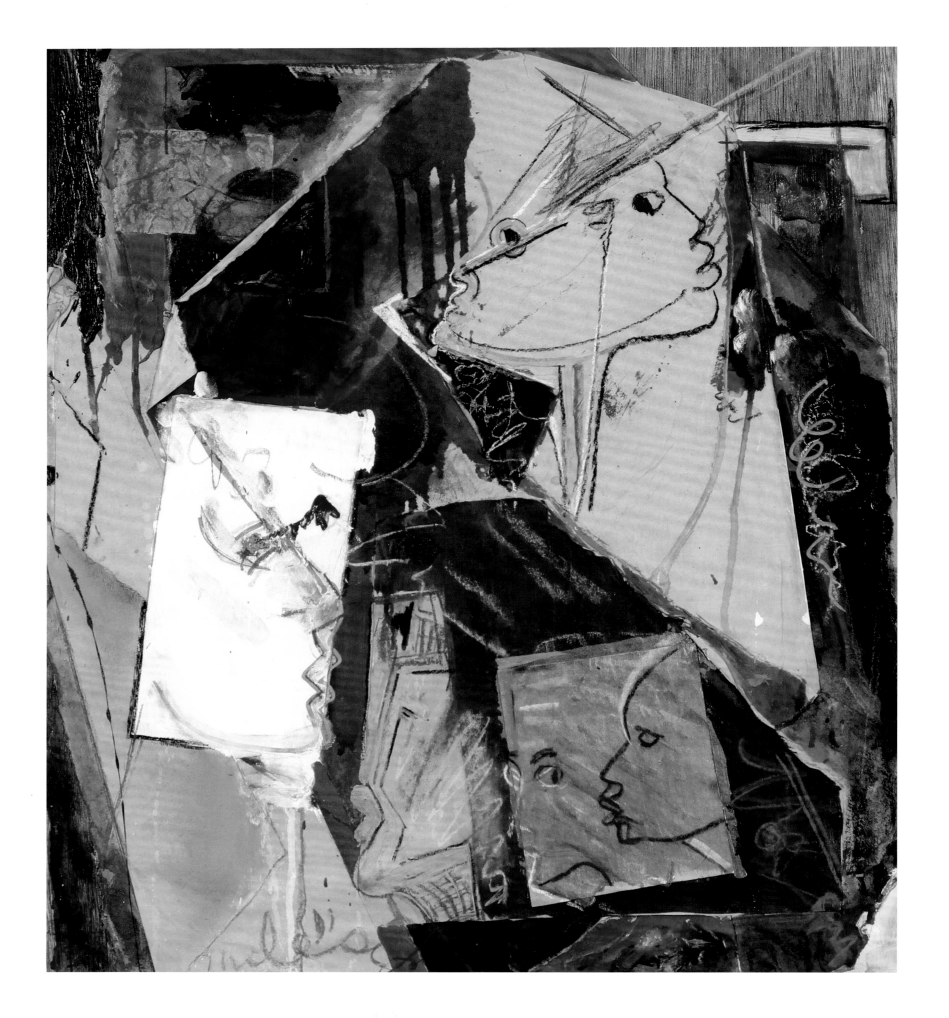

When I first met Miles Davis, I was terrified. He was my idol, and he still is. Miles and I first met at the Downbeat Club when I was around seventeen or eighteen. Billy Hale was playing there with Earl May. Bebop musicians were all over the place, and all of a sudden I heard this unmistakable voice and I knew it was Miles. To put this in context, I had just done my first record with Lionel Hampton, and the whole time I was trying to sound like Miles. And then to meet him—wow, intimidating.

Miles played the way he was as a human being, and he painted and drew that same way. He knew that painting was something that he had to do. He felt things deeply, whether it be anger or amusement. He had to express his feelings. He was an original, and when he felt like doing something, he did it. His creative self wouldn't let him turn his back on any sort of inspiration.

Miles was authentic, nothing slick. He played styles. His art was the same. He didn't want to think like everyone. He knew jazz had an attitude just like his art did. He loved attitude just like he loved lines and color. When he drew faces and shapes, he drew heads in all different directions. It was always an experiment, a chance to break boundaries.

The best of Miles Davis's artwork is compiled in this book, and I'm thankful to the Insight Editions team for digging through the archives and unearthing these treasures. Miles was a true artist, an original. He took the challenge of drawing and painting straight on. I don't believe many people had the chance to see his art back when he was creating it, except for his friends and family. And whenever we liked something, he would just give it to us. That's just how he was, always generous.

One of the last times I played with Miles was at the Montreux Jazz Festival in 1991. I had been trying to get him to play there for the previous fifteen years, and when he finally agreed, I was thrilled. When I saw images of his red trumpet and his monogrammed leather bag in this book, it immediately took me back to that time. The room lit up when Miles walked onto the stage at Montreux. No one could explain Miles's presence; it was magical. He hadn't played the music he played there in many years. Miles went with his instincts. And that night on stage, Miles proved why he had been a leader and a legend for fifty years. That festival was special in more ways than one, because Miles passed away a couple of months afterward.

I miss Miles every day. He was my friend, my brother, and my idol. He's still in my blood.

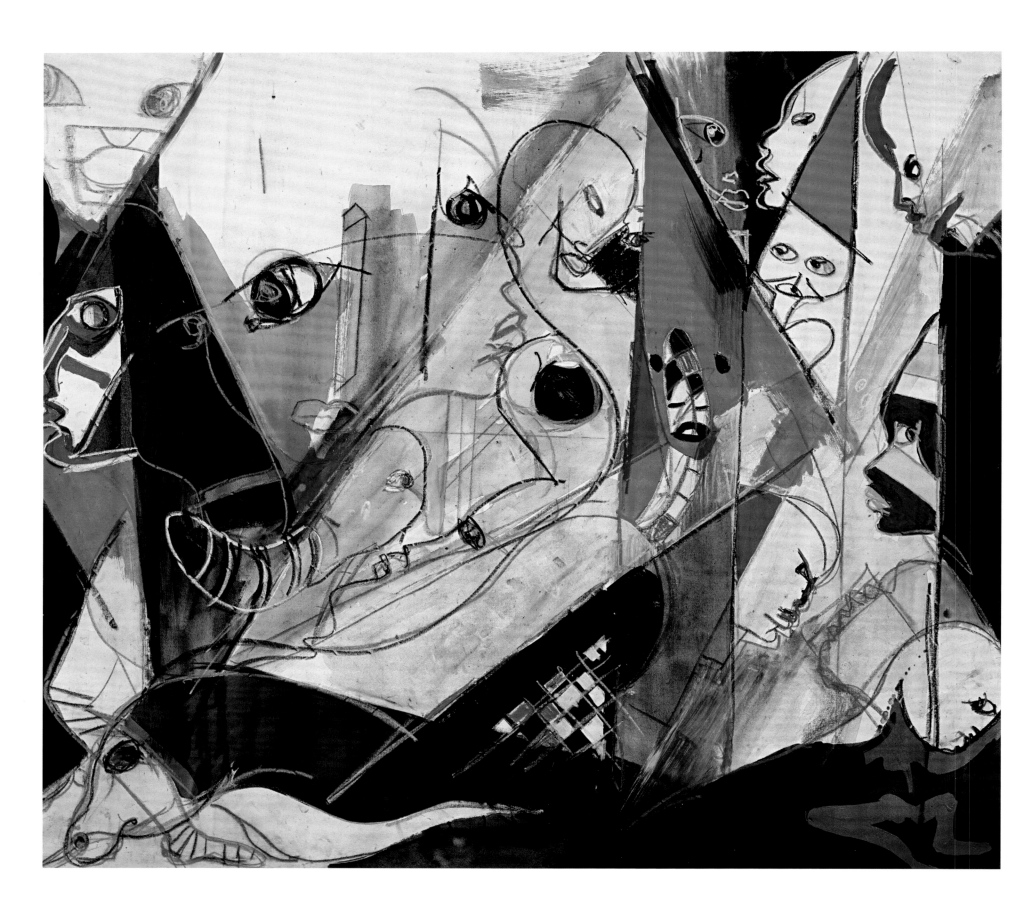

The one constant in Miles Davis's artistic life was change. Never content simply to rework an existing formula, Miles insisted upon new variables, new combinations, new results, whether in his paintings and drawings or in his timeless music. The bebop of the 1940s, with its feverish revisions of existing musical conventions, fascinated and nourished him. Yet, in 1950, he made the seminal recording *Birth of the Cool*, taking the music he loved in an entirely new direction. In the mid-1950s he assembled one of the finest small groups in the history of jazz; it included, at various times, such luminaries as John Coltrane, Cannonball Adderley, Bill Evans, and Philly Joe Jones. The band usually worked its magic on standards and a handful of originals. But around the same time, Miles also appeared in a large-ensemble context and recorded concerto-length albums such as *Porgy and Bess*. In both large- and small-group settings, Miles emerged as a soloist of extraordinary depth, one whose sophisticated sensibility often allowed him unrestricted access to the distant reaches of the human heart.

Miles's experiments with modal playing reached an apotheosis in 1959 with the recording of *Kind of Blue*. The album, organized around a series of musical sketches, took group improvisation to new heights. It is routinely listed among the finest jazz recordings ever made, and its transcendent beauty remains undiminished more than fifty years after the fact. Yet, in *Miles: The Autobiography*, written with Quincy Troupe, Miles says he "just missed" getting the exact sound he was looking for with the record. Such Olympian artistic standards kept him searching for the right sound with which to meet a given historical moment.

In the early '60s, Miles put together another legendary quintet, featuring newcomers Wayne Shorter, Herbie Hancock, Ron Carter, and Tony Williams. Their thirst for new ways of approaching the group's repertoire led Miles to experiment with what had become his signature numbers: "Milestones," "Round Midnight," and "My Funny Valentine." But his music would undergo far greater changes still. In 1969, facing swirling social and musical currents, he responded with the stark electronic instrumentation and harsh dissonances of *Bitches Brew*. As with his previous benchmark recordings, it changed the way the music of the time was played and understood.

In the next two decades, Miles continued to move his work in unforeseen directions. The routes he traveled were always dictated from within. From 1980 until his death in 1991, Miles sought expression not just through music but through visual art. What began as a simple outlet for his creativity developed into an obsession. Miles often spent hours a day sketching and painting. His art, like his music, is characterized by a commitment to true expression and change.

Miles began mostly with drawings, many of which feature elongated fantasy figures spun into dense, linear webs. Not surprisingly, the female form is a recurring motif, in some cases appearing as a cluster of sharply defined angles, in others as a supple series of curves. His other favorite subjects include musicians and quasi–comic-book characters, which he called his "robots." Miles filled sketchbook after sketchbook, especially while traveling. In his autobiography he observes, "It's like therapy for me, and keeps my mind occupied with something positive when I'm not playing music."

In 1988, Miles embarked on a series of abstract paintings inspired by the Milan-based design movement known as Memphis. Founded by Italian designer Ettore Sottsass, Memphis was based on an aesthetic of hot colors and clashing shapes, and its mixing and matching of various historical motifs closely allied it with the developing idea of

postmodernism. Miles drew inspiration from it not because of its theoretical underpinnings but simply because its look appealed to him. He worked in this vein for nearly two years, during which time he created not only a large body of paintings but a stage design making use of the same vocabulary. For sheer dazzle, he also began appearing onstage in bright theatrical clothing that matched the paintings.

When the Memphis spell had run its course, he again changed direction. He began to develop a mature body of work that integrated his playful figures and swirling abstractions with strong African-inspired textures. The work took on a different cast when Miles started adding unlikely materials, such as rope, burlap, copper, and nails. The resulting pieces are both sensual and foreboding, angry and resolved; they staked out new territory for him. Like African fetish objects, they have about them an aura of mystery and power, but Miles's trademark "totem pole" faces, as he called them, add a welcome degree of warmth to the paintings. In early 1990, the work was shown in New York City, where it received enthusiastic reviews, as did the previous exhibitions in Spain, Germany, and Japan.

I was fortunate to conduct several interviews with Miles at that time: in his SoHo gallery, in his 57th Street apartment, and in his studio. Miles always professed a heartfelt desire to move on to the next phase, to take new risks, to create still-undreamed-of material combinations. For such a restless figure, standing still just wasn't part of the program.

Artists, especially popular ones, are often expected to embellish their art with explanations—to speak about methods, intentions, and goals as though their remarks could provide magical keys to their work. But Miles never catered to these or any other expectations, and he was nearly as reluctant to talk about his art as he was to talk about his music. When I first proposed asking him questions about his drawings and paintings, he responded, "I'm not sure how much there is to say. I just do what I do." He shrugged off a detailed preliminary question, saying, "It ain't that serious." He seemed more comfortable leading me on an ambling tour through his new apartment, showing

off paintings he'd bought, often stopping to consider them as if seeing them for the first time.

When he did sit down to talk, he spoke in long, uninterrupted takes, each filled with humor. He often illustrated a point more by way of anecdote than by explanation, and when my questions seemed superfluous or uninteresting to him, he ignored them. During my meetings with him, I never saw his infamous fierceness or bad temper, only his graciousness, his intensity, and his genuine love for the work he did.

Miles's visual sense was always manifested in his personal style, and his clothes, casual though they had become, were still those of the quintessential hipster. At our first meeting he was wearing paint-spattered jeans, a multicolored patchwork leather vest, no shirt, and gold lamé slippers. He spoke at length and with great admiration about those he regarded as fellow artists. Gil Evans, the late composer and arranger who had collaborated with him on some of his finest recordings, including *Miles Ahead* and *Sketches of Spain*, remained a strong source of inspiration. Evans himself was a great admirer and defender of Miles and once said of him, "He is a leader because he has definite confidence in what he likes and is not *afraid* of what he likes. A lot of other musicians are constantly looking around to hear what the next person is doing, and they worry about whether they themselves are in style. Miles has confidence in his own taste and he goes his own way."

The same independence of spirit that infused his music also animated his art. Miles was utterly unconcerned with the trends and countertrends that dominate the contemporary art world. He followed no school of thought and sought no consensus of opinion; rather, he pursued his work separately—absorbing impulses and influences from the world around him, interpreting them visually, and trusting the results. His drawings and paintings are less the result of working within a tradition and expanding on it than of working outside a mainstream tradition and enjoying it.

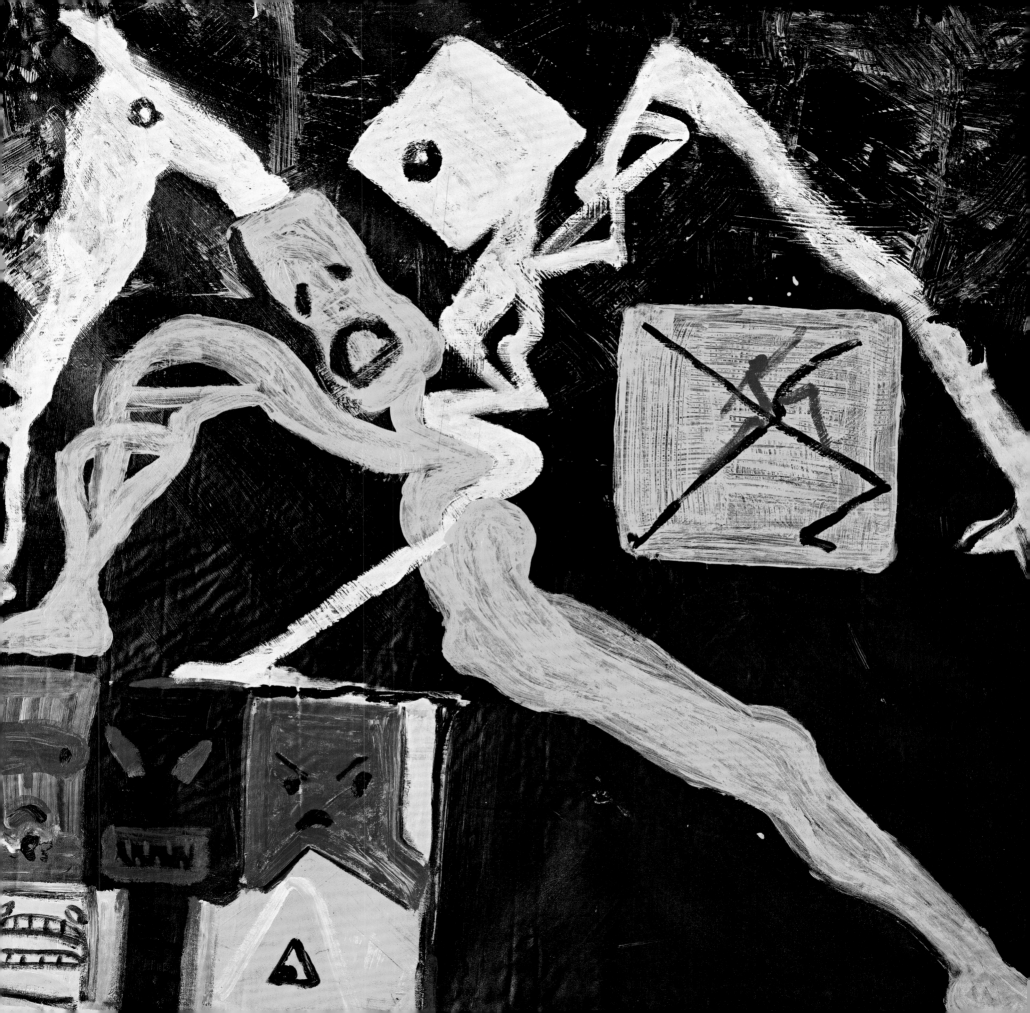

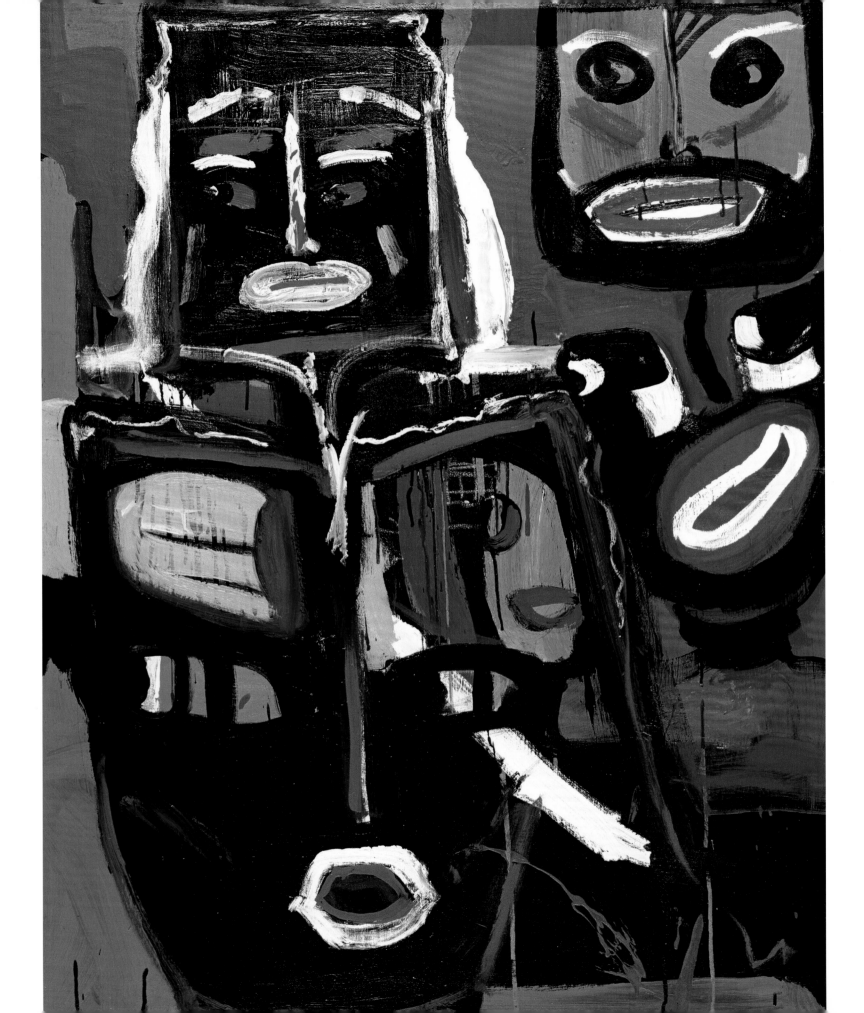

One of the most fundamental aspects of being an artist is the development of an individual style, something that manages to remain constant despite changing contexts. For his music, Miles spent a lifetime developing a style and a sound like no other. Muted and without vibrato, it is at once solitary and inviting, subtly hesitant and absolutely sure—very much like the human voice, after which it is modeled.

In his art, a distinctly individual style emerged over time. The hallmarks of Miles's visual style are a bold, uninhibited use of color; a loose, improvisatory, yet definite sense of structure; and a delight in the expressive possibilities of the face. When Miles worked on a piece, he would question the direction of the work, asking: Does this section need something else? What color do I use here? Is this starting to look too slick?

All art is about making decisions, and seeing Miles working out formal questions made me think of the hundreds of individual decisions that go into a single musical performance. Listen to any of Miles's recorded works and you'll hear decisions being made in time: how to shift the emphasis within a musical line, how to build a solo dramatically, how to use space as an integral part of structure. Even on a seemingly straightforward number, Miles wrought fine art out of intelligent choices.

Take the 1954 recording of "When Lights Are Low" from the album *Blue Haze*. The playful, mostly two-note melody is pushed and pulled, shaded and newly delineated, to brilliant, expressive effect. In one chorus, Miles drags the beat just enough to create tension; in the next, he hits it squarely and cleanly, like a boxer stepping in and taking his shot. The same control is evident on his 1989 recording of "Hannibal," from the album *Amandla*. Miles articulates the melancholy theme with his usual clarity and grace. He then plays against the song's loping momentum, spinning out stuttering lower-register riffs. An arcing alto saxophone enters, steering the melody to a stop-time bridge. When it

gets there, Miles leaps in with a hard high-note punctuation. A short-phrased conversation grows between trumpet and saxophone, steadily becoming more intense, until it escalates into a careening, sometimes overlapping call and response. When it has run its course, the lead voices ease back into quiet dialogue. The lyricism and restraint evident throughout are pure, unmistakable Miles.

I once asked Miles to help me with writing captions for his work. The plan was that I would hold up an image of one of his paintings, and whatever he said would become the caption. He looked at the first one, a typically free-flowing abstraction with hints of a dancer's body at its core, and said, "I don't know what the fuck this thing is." So the material in this book is structured loosely, according to its content. Miles didn't date or title any of his art. Here, his works are divided into Drawings and Paintings. But the best way to look at all of them is as further expressions and explorations from an unbounded artist.

The art historian E. H. Gombrich once said, "There is really no such thing as Art. There are only artists." This logical conundrum has always made a good deal of sense to me. Critics will never agree upon what constitutes the best art, or even what constitutes art at all. But artists will continue doing what they do: channeling their perceptions, feelings, thoughts, and sensibilities into their chosen crafts. Their work may be categorized and ranked, defined and redefined by succeeding generations, but it is first of all an activity.

Miles Davis was an artist in the simplest and truest sense of the term: He respected his impulse to create, and he tempered that impulse with discipline. His art may be rife with figures and faces or wholly abstract, rendered simply in markers or studded with nails and shards of copper. It is doubtless the work of an abundant imagination, one that transformed the world of sound and time and made inroads into the world of shape and color.

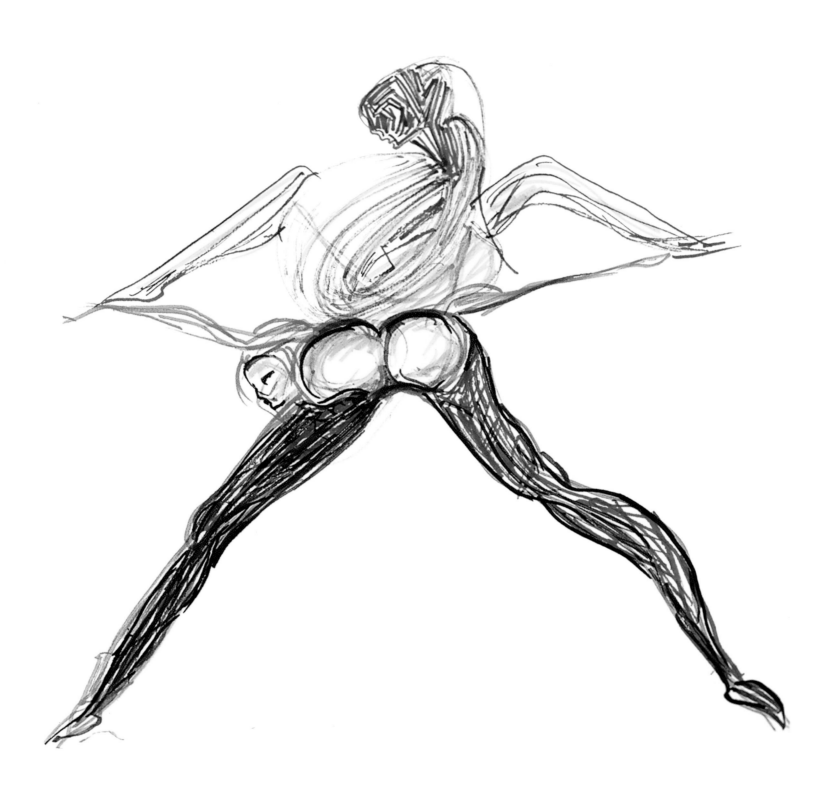

PART 1
DRAWINGS

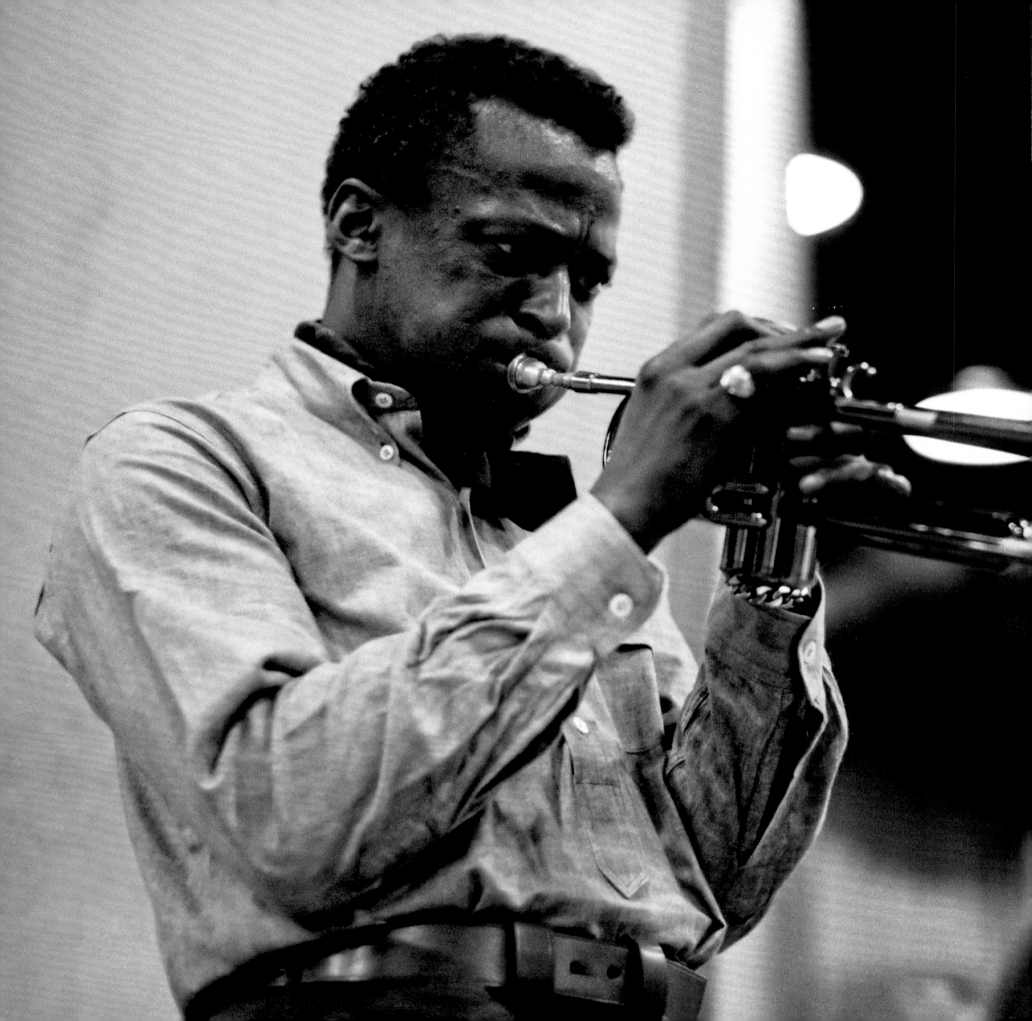

REFLECTION | VINCE WILBURN JR.

In the late '70s, when my uncle Miles was in semi-retirement—(his decision)—I would visit his house on West 77th Street during my summer breaks. It had this dark, Moorish look to it. I still lived in Chicago then, and he would listen to my band rehearse by calling me and having me put down the phone while we played. One time he asked me if I wanted to play on his next record, and I said "Hell, yeah." The rehearsals for that album, *The Man with the Horn*, took place in the living room of his house in New York. Not too much light, but a lot of great music came out of that place.

During the recording of *You're Under Arrest*, the drummer Al Foster decided he wanted to move on. Uncle Miles asked me to play on the track "Human Nature" for that album. After that, the drum chair became mine. That's how I started playing and touring with Miles.

He called me "neph," for nephew, and I called him "Chief." I loved being around my uncle. He always made you curious about what was going to happen next on the bandstand. He asked me personally never to take my eyes off him while he was on stage. That was a big challenge, since he had a wireless mic and could move anywhere. You just had to follow his direction, because the music could change at any given moment. It kept you on your game.

Miles had jumped in with Bird and Dizzy at the age of twenty, and that's what I had to do—just jump right in and hang on. I affectionately called it Miles Davis University. At our shows, there was an opening, then we'd go into a blues. The audience followed his every move.

After the show, the sound guy would come up to him and he'd say, "Hit me." That meant, give him the cassette of that night's show. Back at the hotel, he would listen to it and call each member of the band individually to his suite. We'd sit there listening, and he would give each of us a critique of our performance: "You sounded good on that last cut, stay more in the background on the end section"—he was listening to everything. If you really played your ass off, he might ask you to stay and have dinner with him.

The energy he had—if you were around him—had to rub off. It was infectious. He'd give you tough love, but he knew how to get the best out of you as a musician. And being the great teacher he was, you always wanted to give your best for him. If he said, "You played your ass off," that was all the reward I wanted in the world.

He used to sketch a lot on the plane when we were traveling. He'd draw something in his book and ask, "What do you think of this?" He liked to be creative, on and off the bandstand. He had these different areas all over his house that my cousin Erin and I called his stations—a canvas on the dining room table over here, a trumpet over there—where he could just shift from art to music to whatever was interesting to him at the time.

I always thought he was telepathic. My mom used to say that my great-aunt Corinne had been clairvoyant, and he may have inherited some of that. He was very perceptive about musicians and at times could be very funny. Of course, everyone knows he could be brutally honest. Uncle Miles was very fashion-conscious, and he might change clothes five or six times in a day. I remember at one show I had on some Nike gear. He took one look at me and said, "You look like a fucking walking billboard." After that I got my stage look together. But we were never as clean as the Chief.

I was just happy to be a part of his genius. He was larger than life to many, but to me he was just Uncle Miles. I love and miss him and think about him every day.

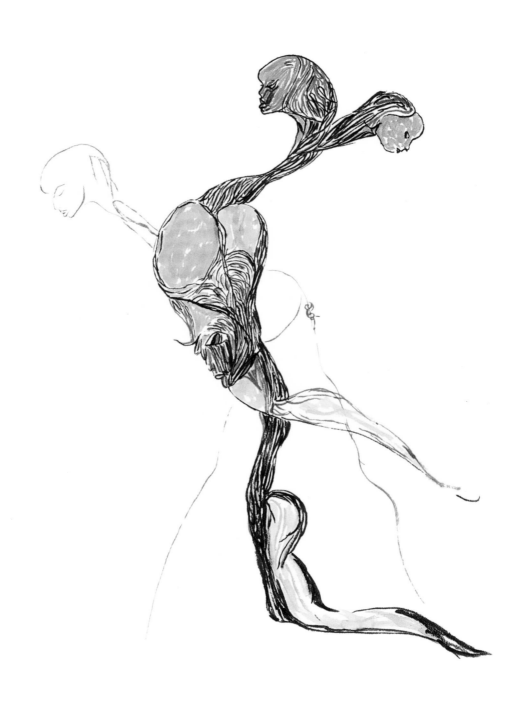

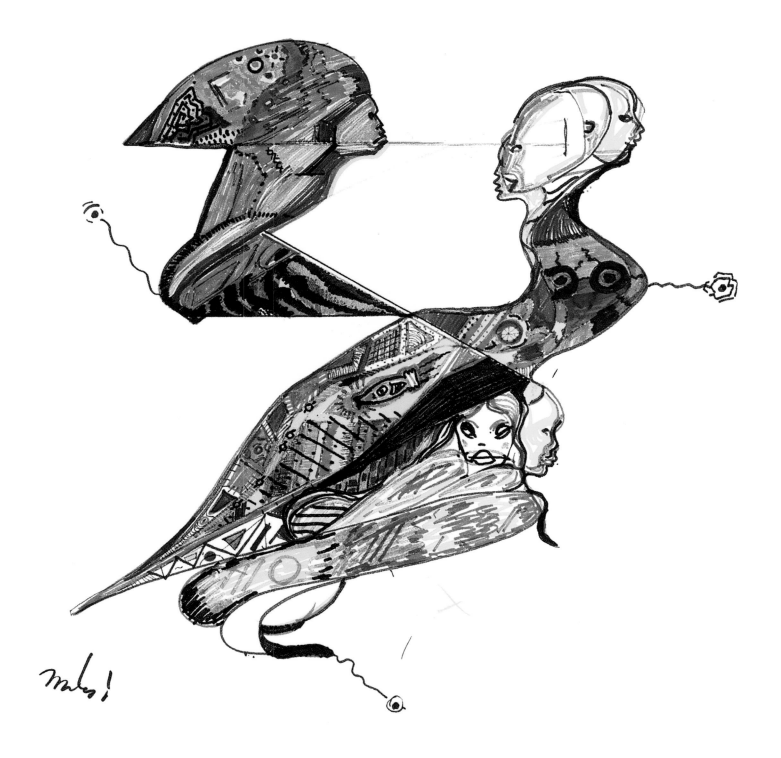

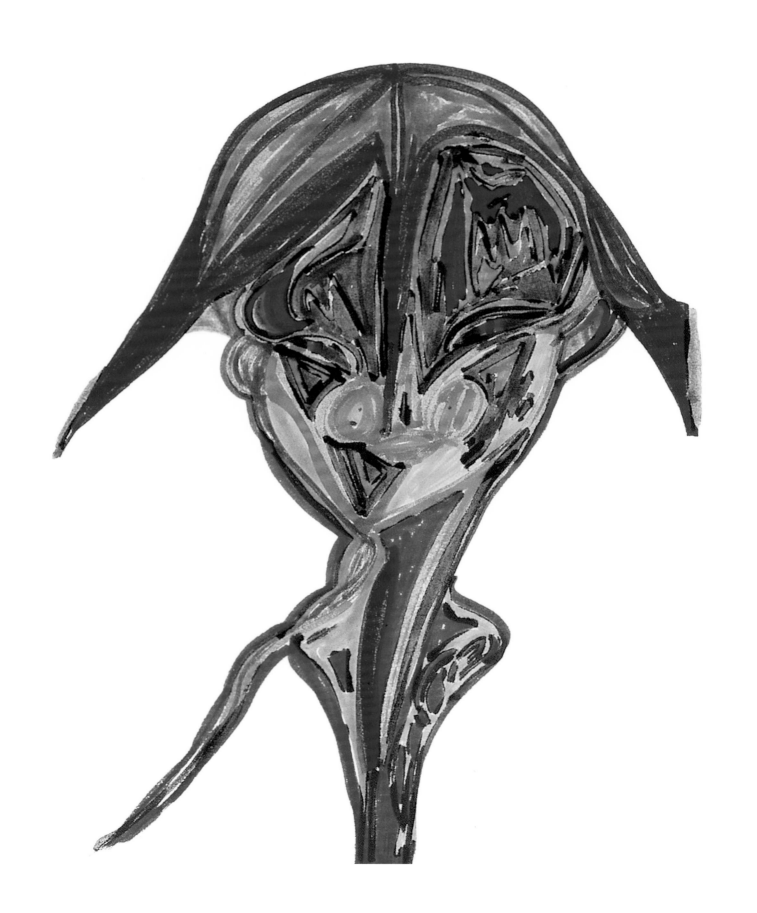

"I've been painting and sketching all my life. As kids we used to do comic-books, faces that could be turned upside down to get something different. And all through growing up, I'd always be sketching. I would do drawings and stuff in the studio and I'd give them away. Once, I remember, I did a sketch of Gerry Mulligan. Looked just like him, too. Also, for my tailor I used to draw my suits, 'cause he couldn't speak English."

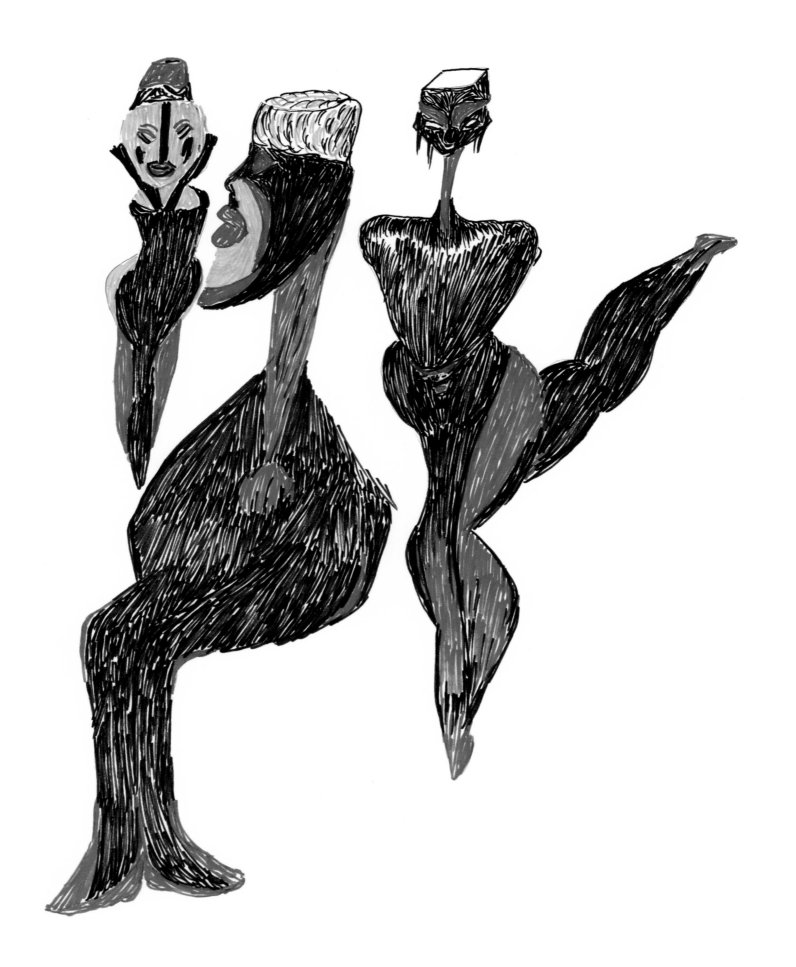

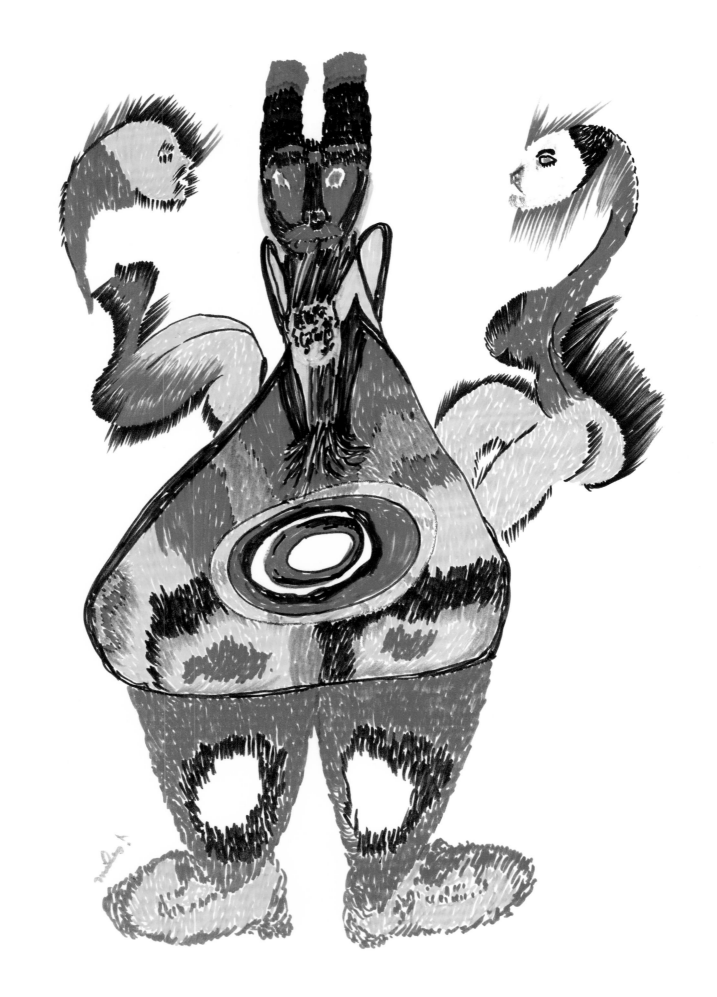

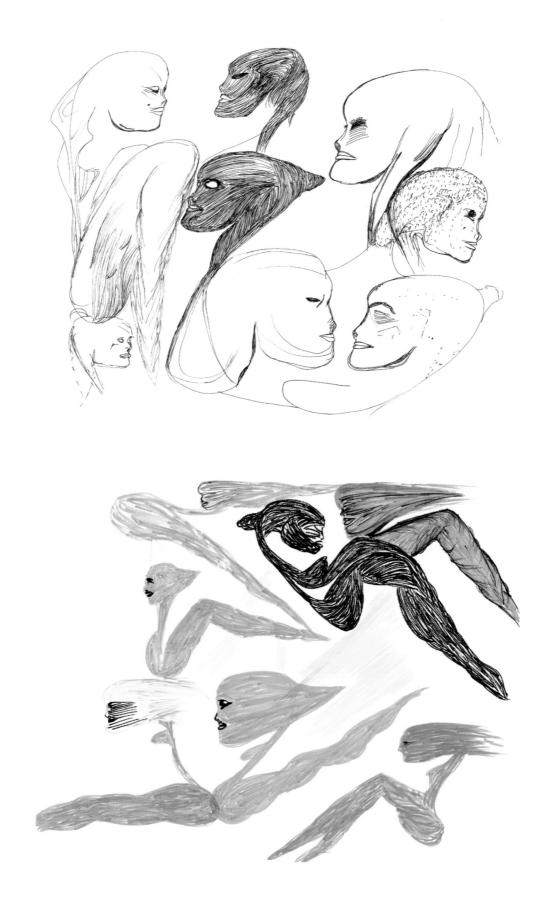

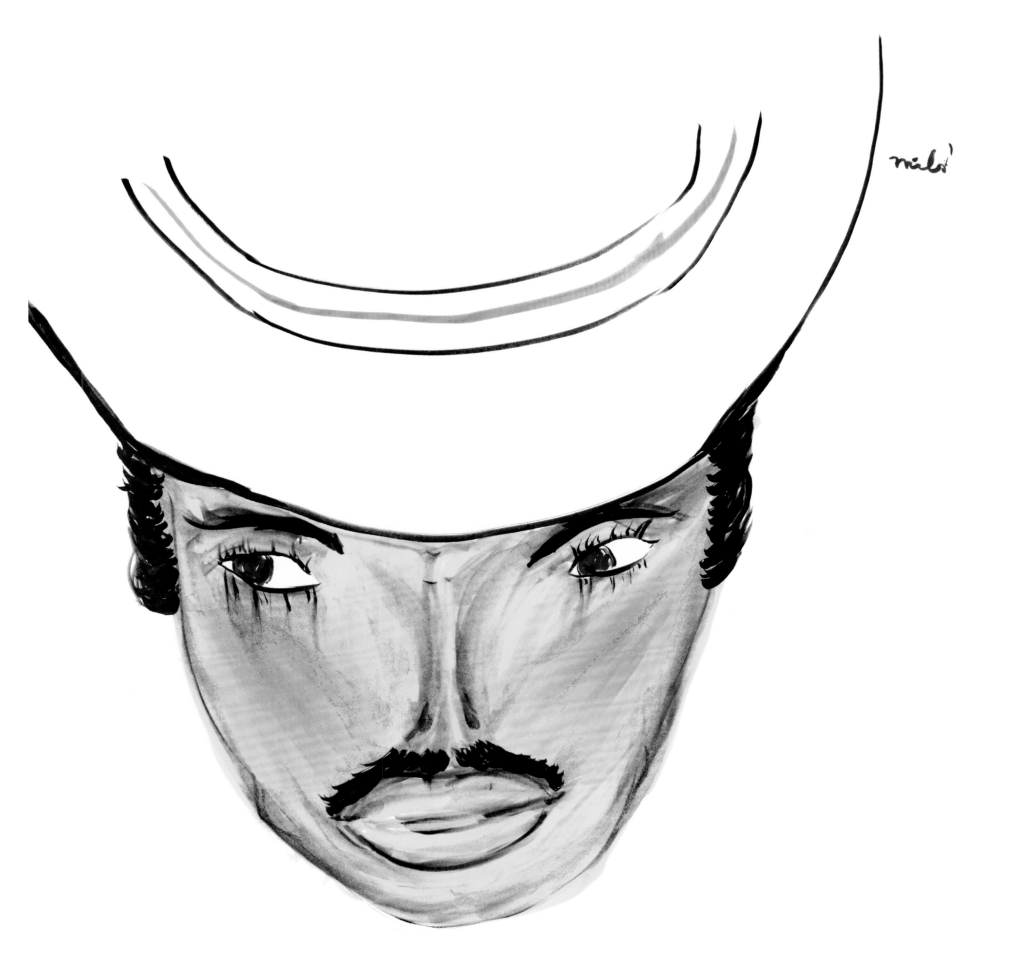

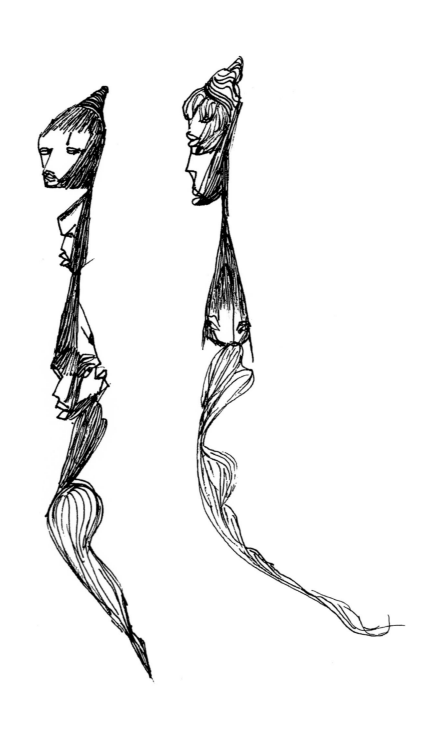

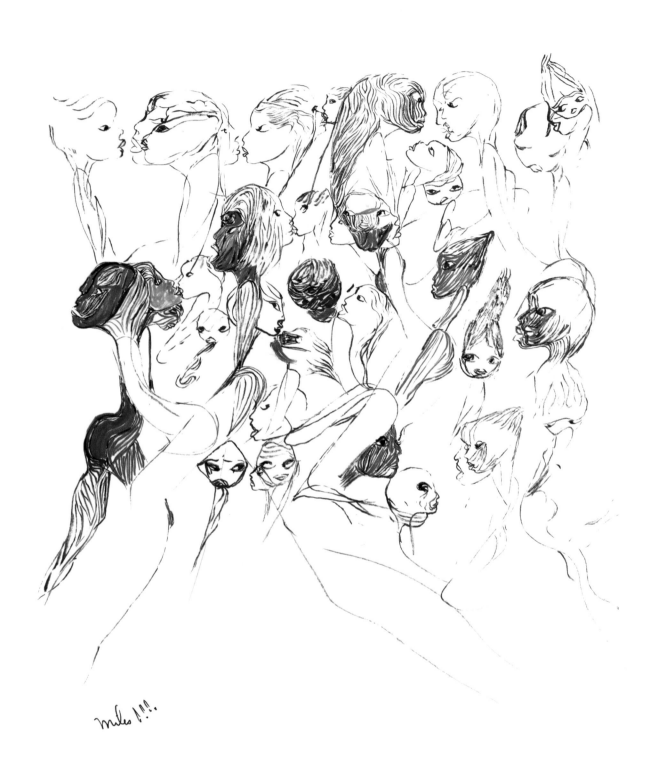

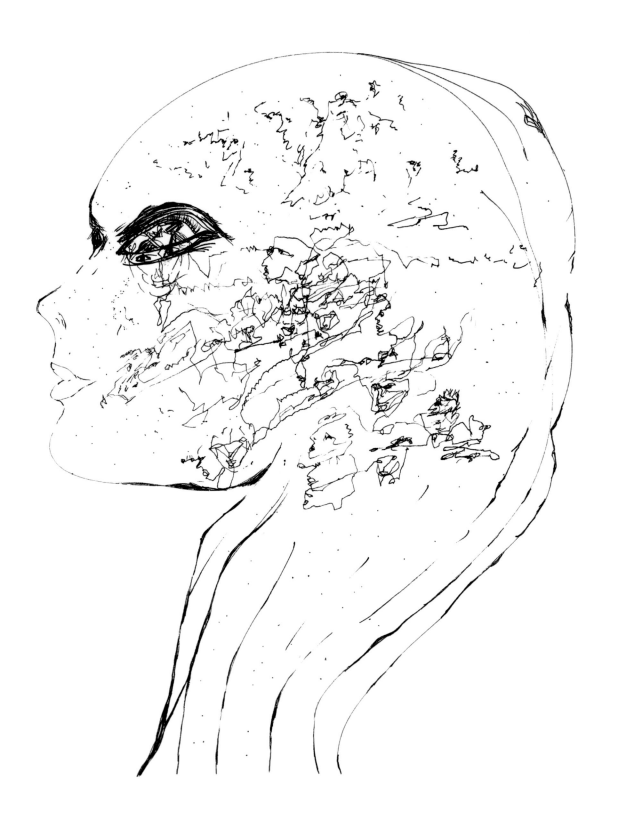

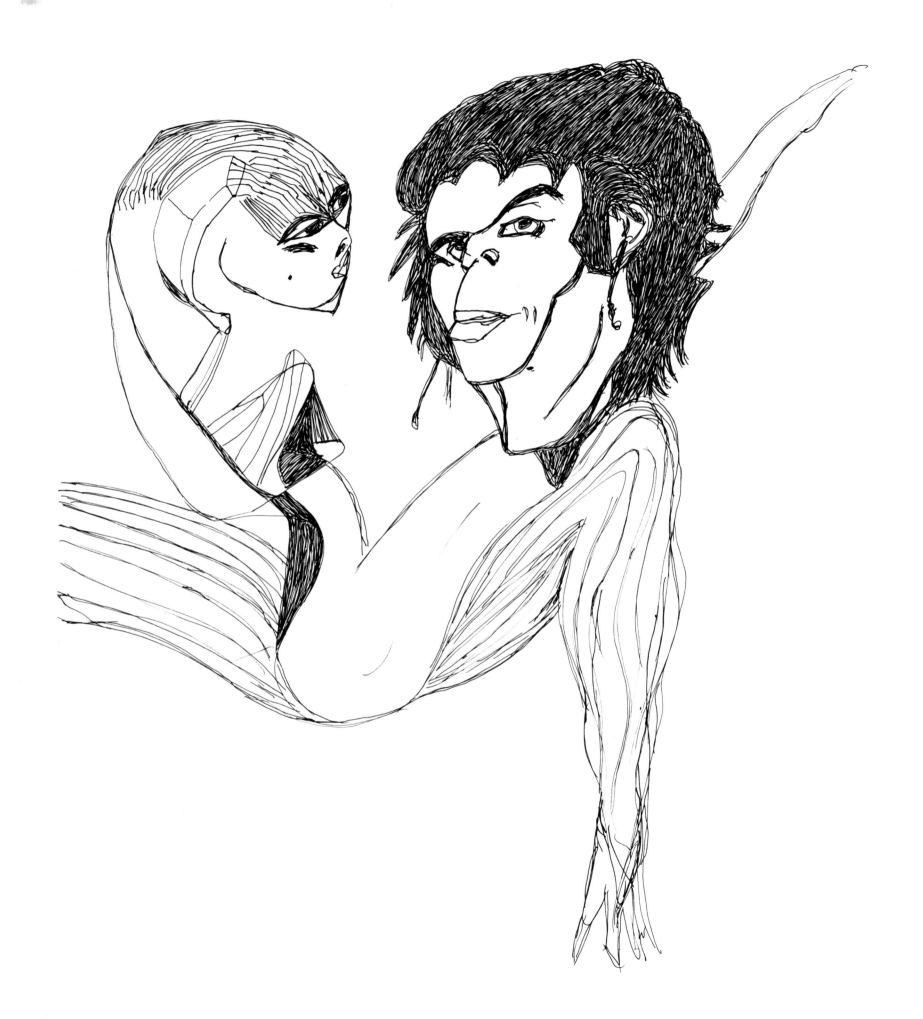

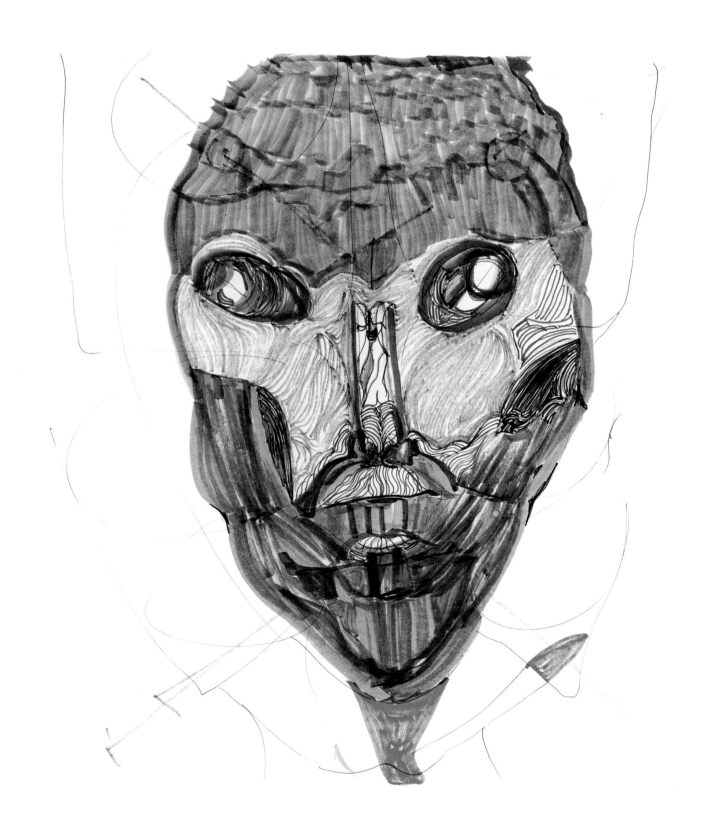

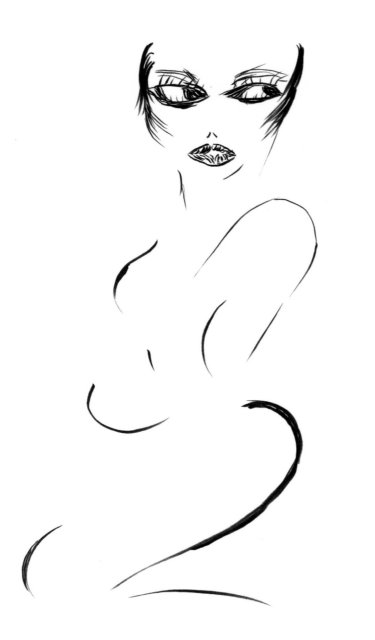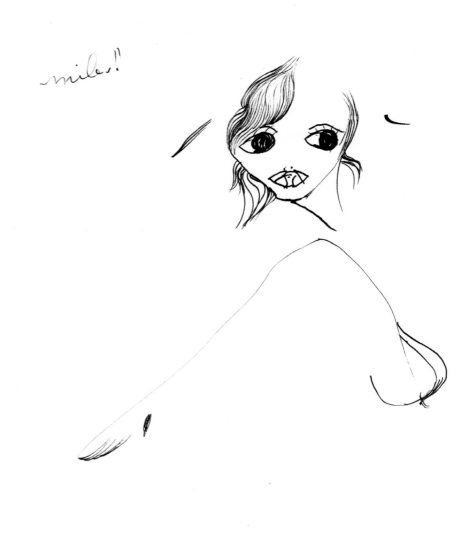

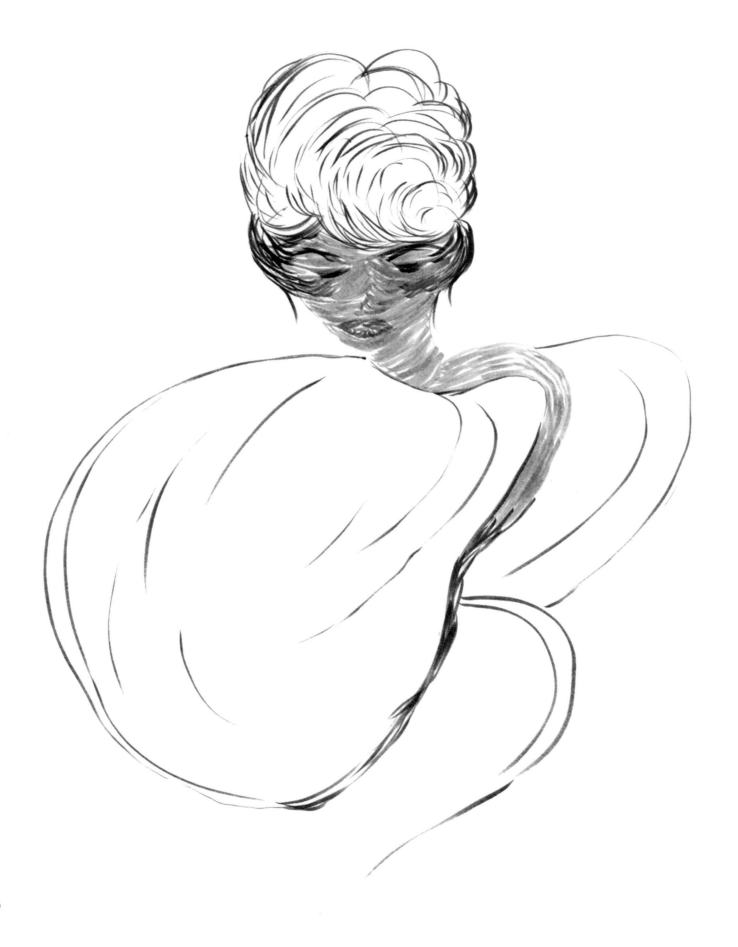

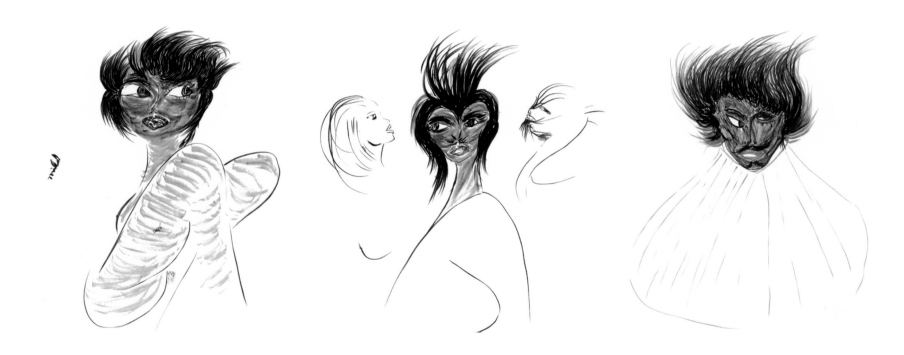

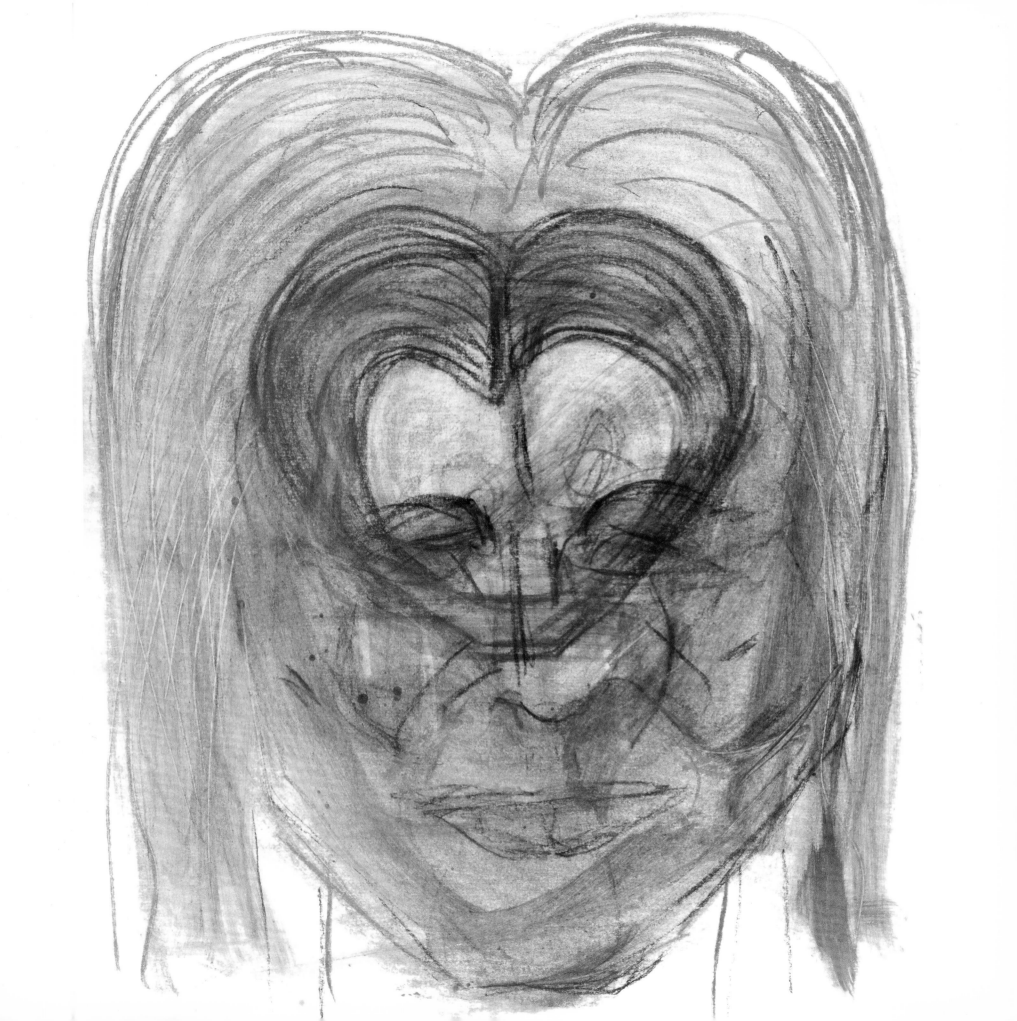

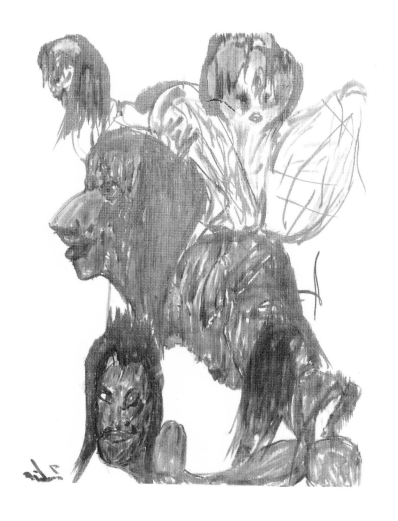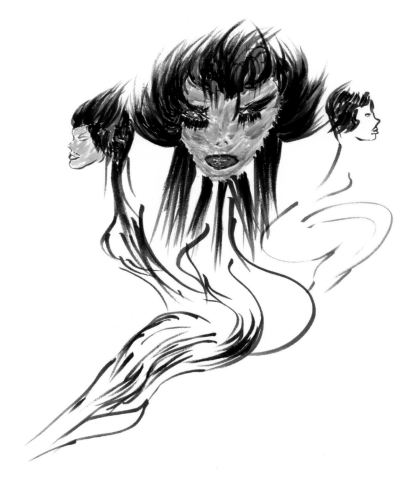

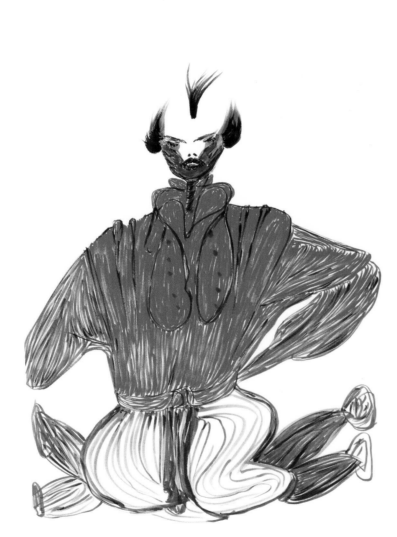

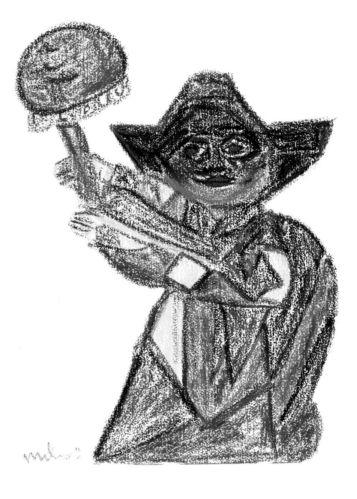

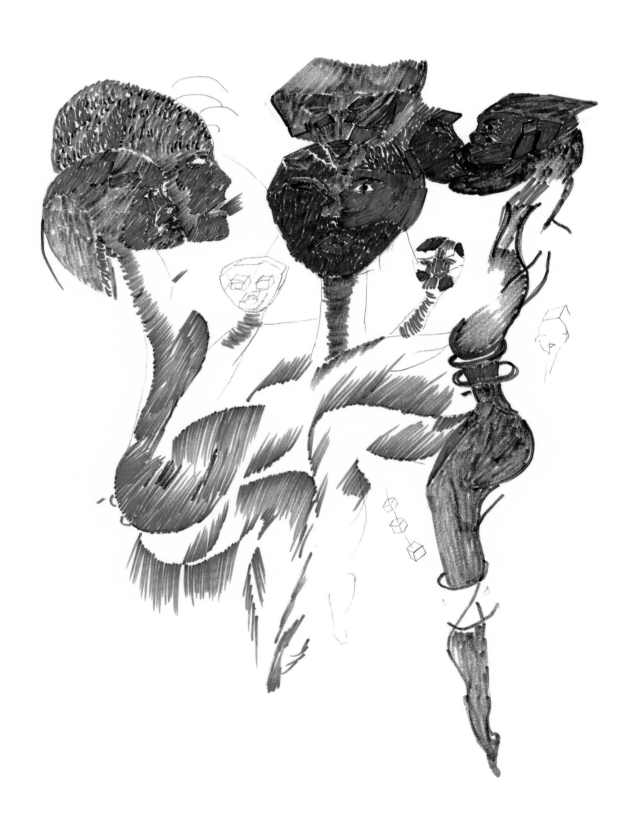

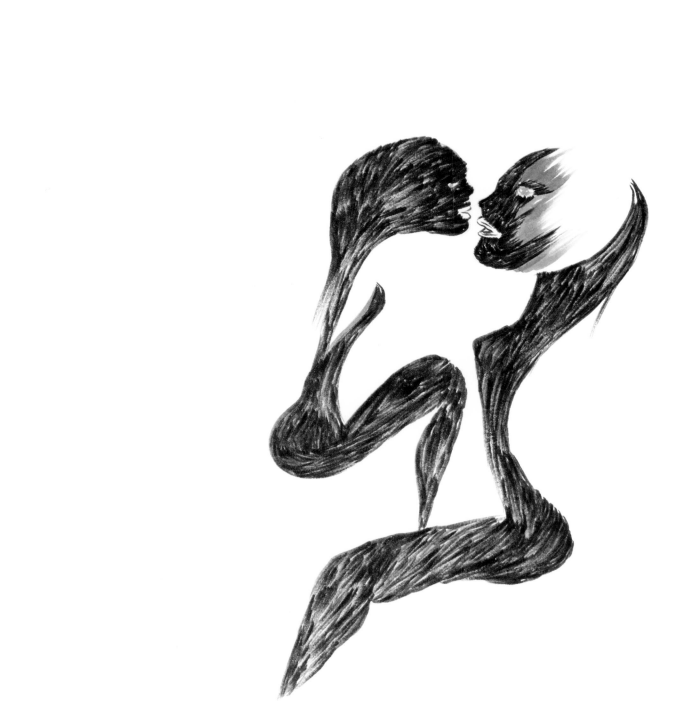

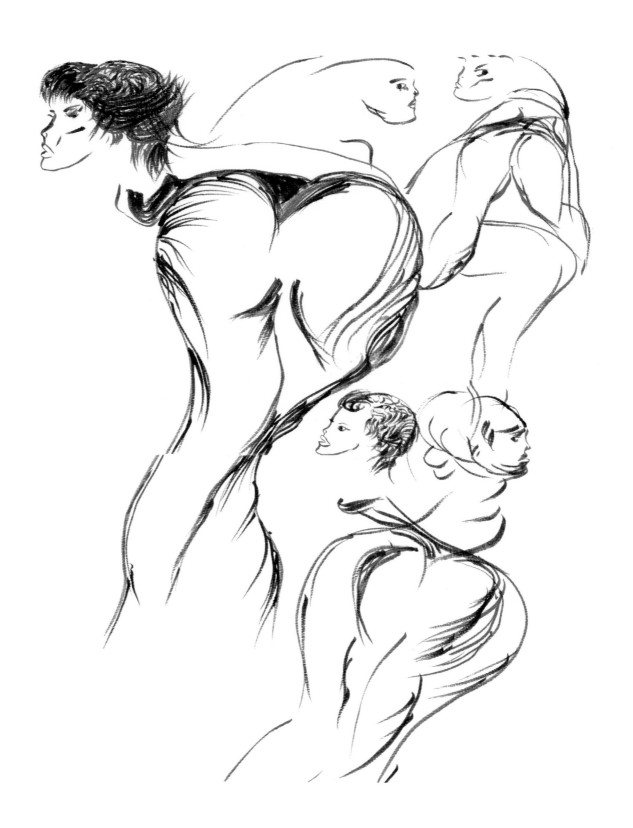

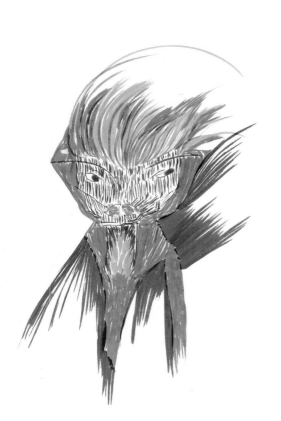

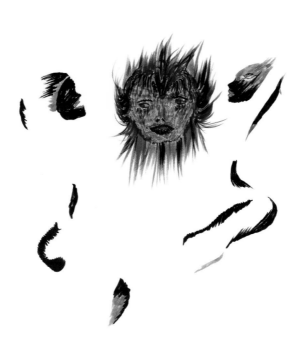

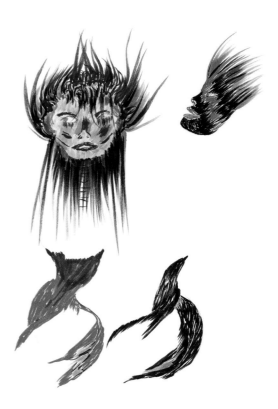

"Mostly, I work at night. Yeah, it comes in the night. But I get the pleasure, when I wake up in the morning, of seeing what I did. A lot of times I'll do something, draw circles or something, and not even realize I'm doing it, but when I look back, I'll see it. That happens to me a lot. Sometimes, when I see what I did the day before, I'll just look at it and go 'Shhhit . . .'"

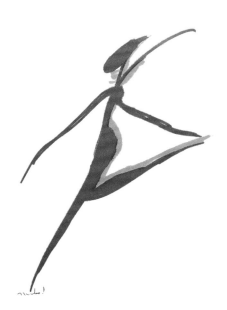

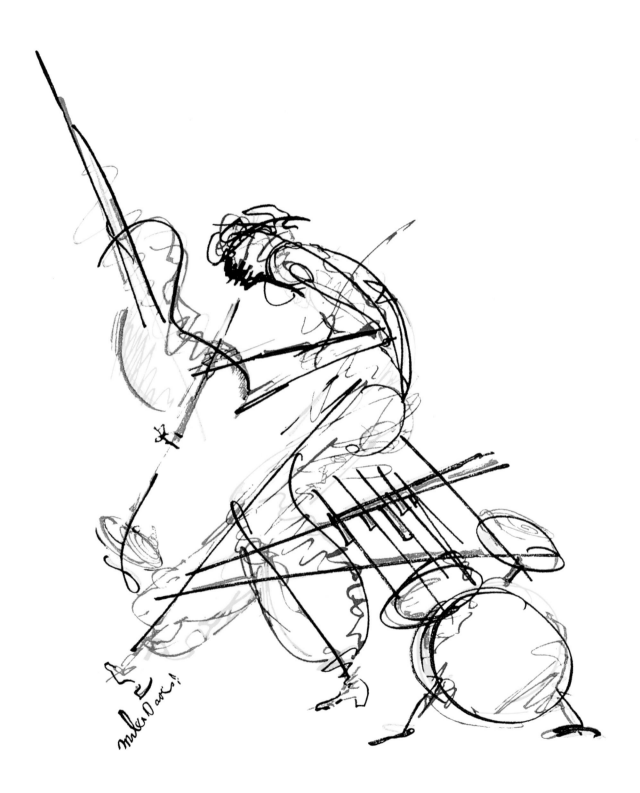

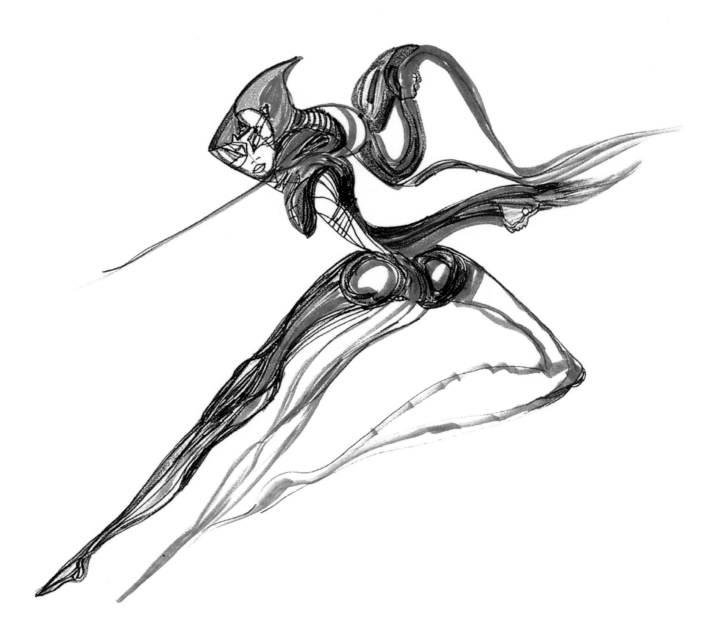

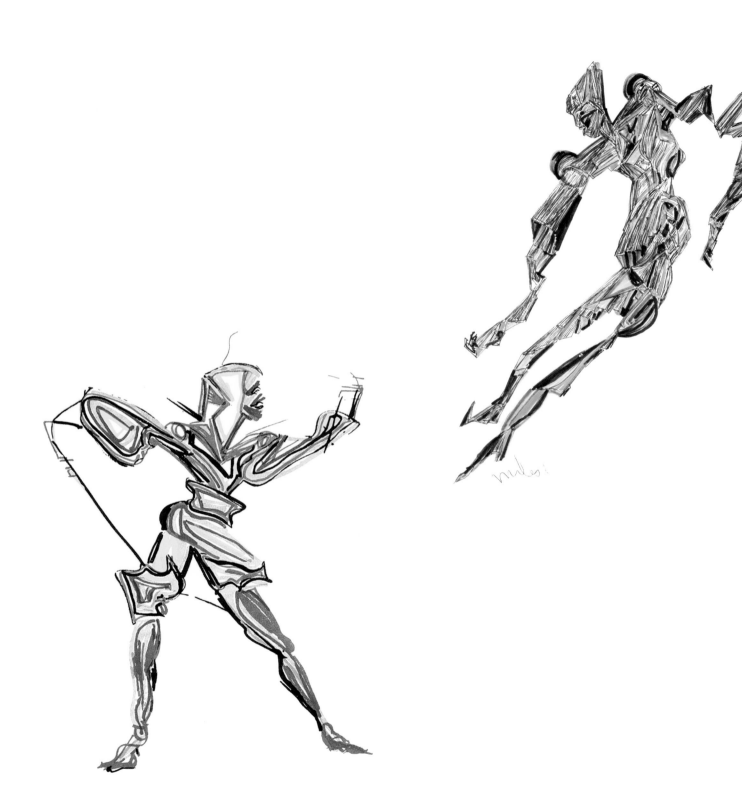

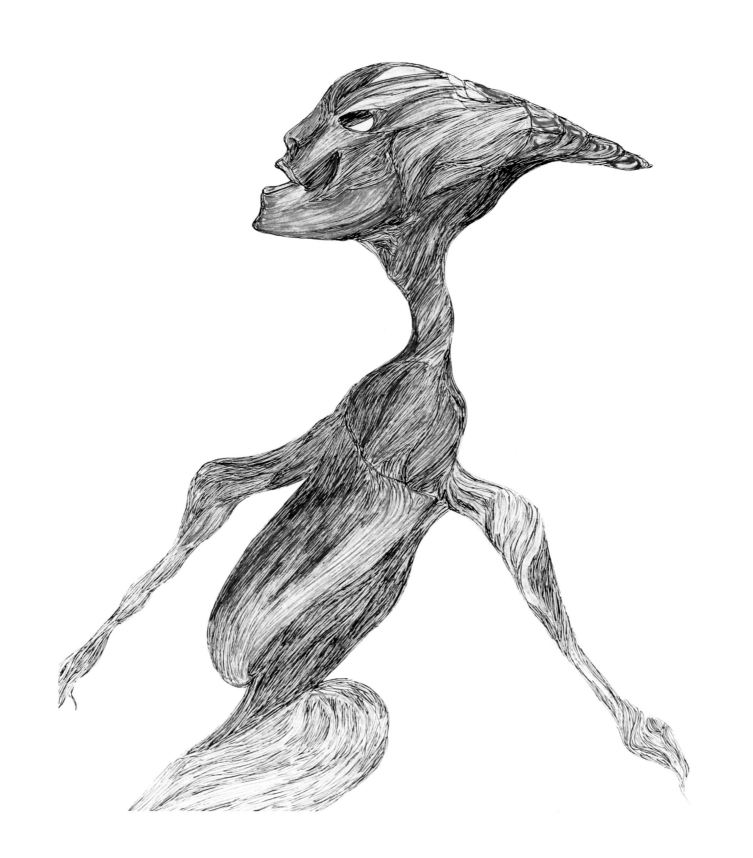

"But you have to keep looking at 'em. Leave 'em around. Usually I'll find something that interests me. I may not see something right away, but later I will. After about two days and nights, if I don't see anything, I'll get out the gesso and cover it up. And I'll just keep going on with something til I finish. You got to know when to stop, though. If I finish a painting in my mind, it'll stop itself."

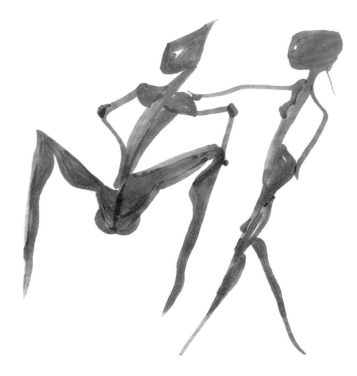

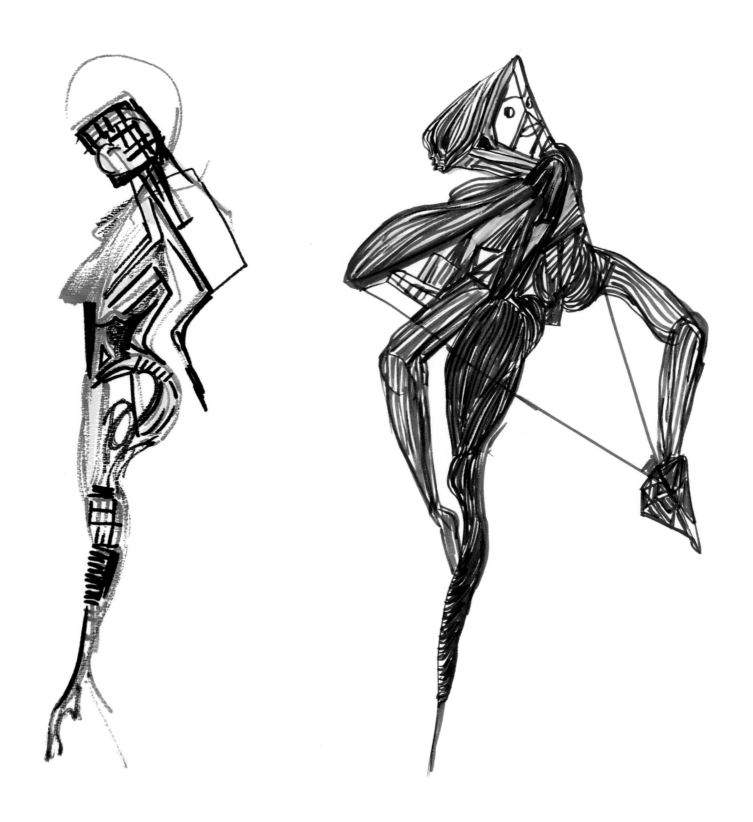

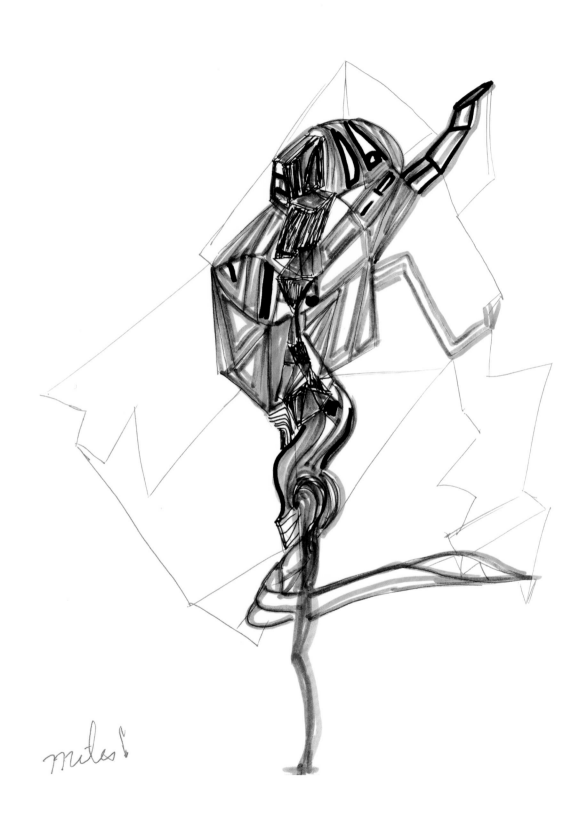

miles'

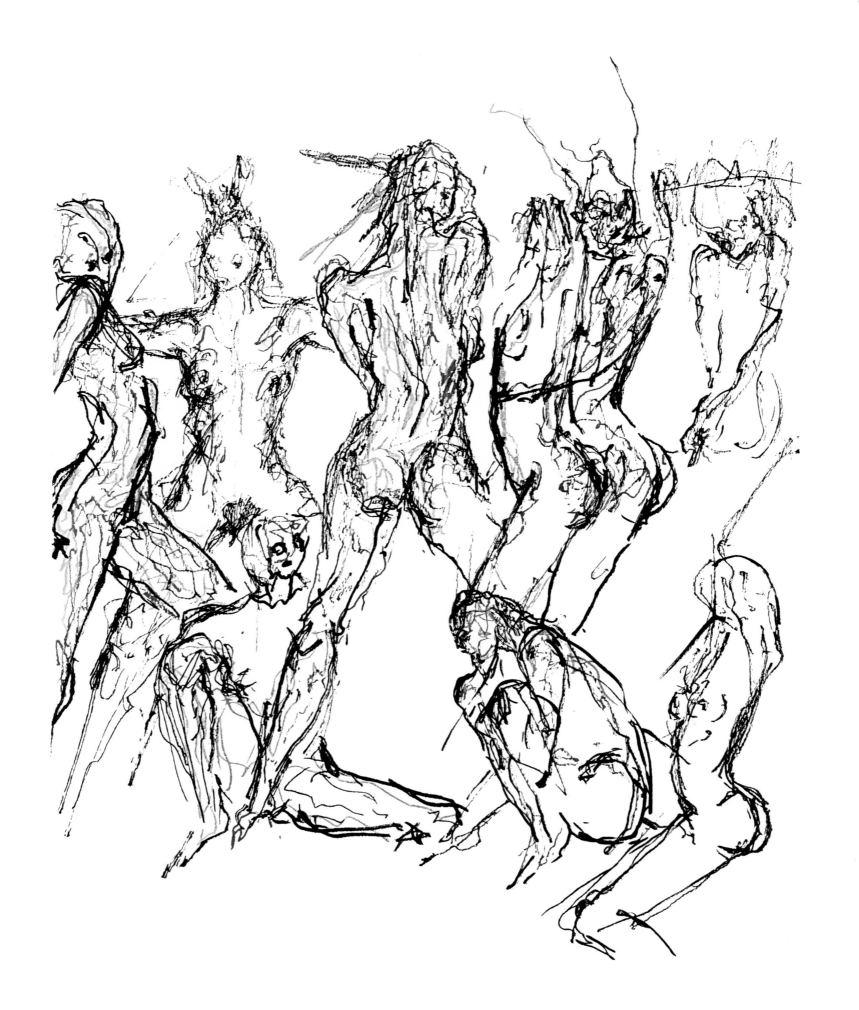

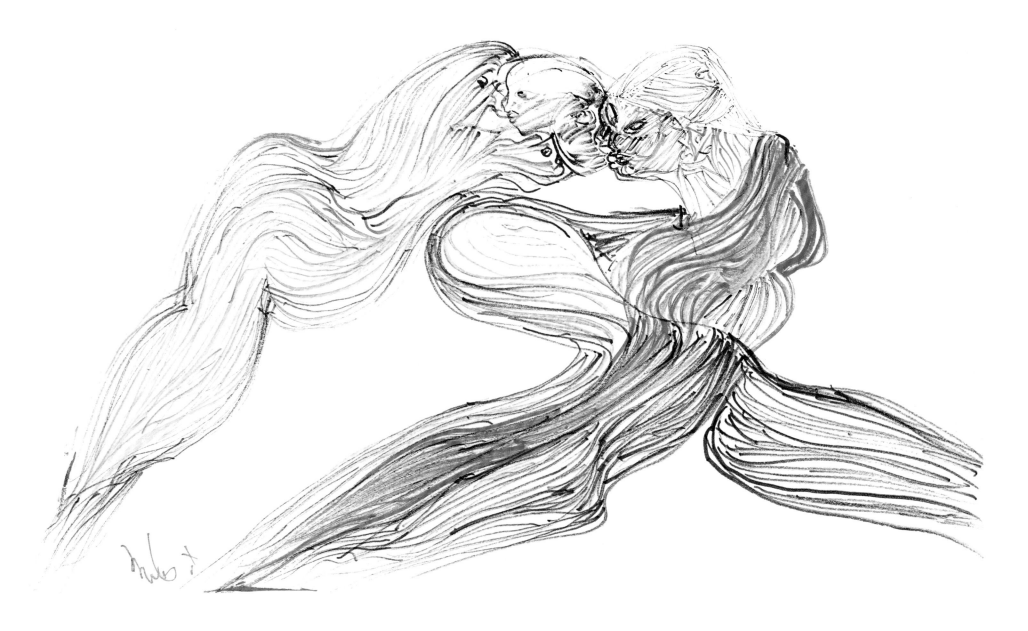

"People can really mess you up with what they say, especially if you're sensitive to it. My mother could lay some terrible shit on people. Like her girlfriend would say, 'I hear you've been telling people that the hat I got is a copy.' And she'd tell her girlfriend, 'Well, I know what I have, and you know what you have.' And my mother's rolling her eyes. Or she would ask my sister, 'How long have you had on those clothes?' And my sister would call me, crying, and I'd ask, 'Well, how long did you have 'em on?' And she'd say, 'Just two days!'"

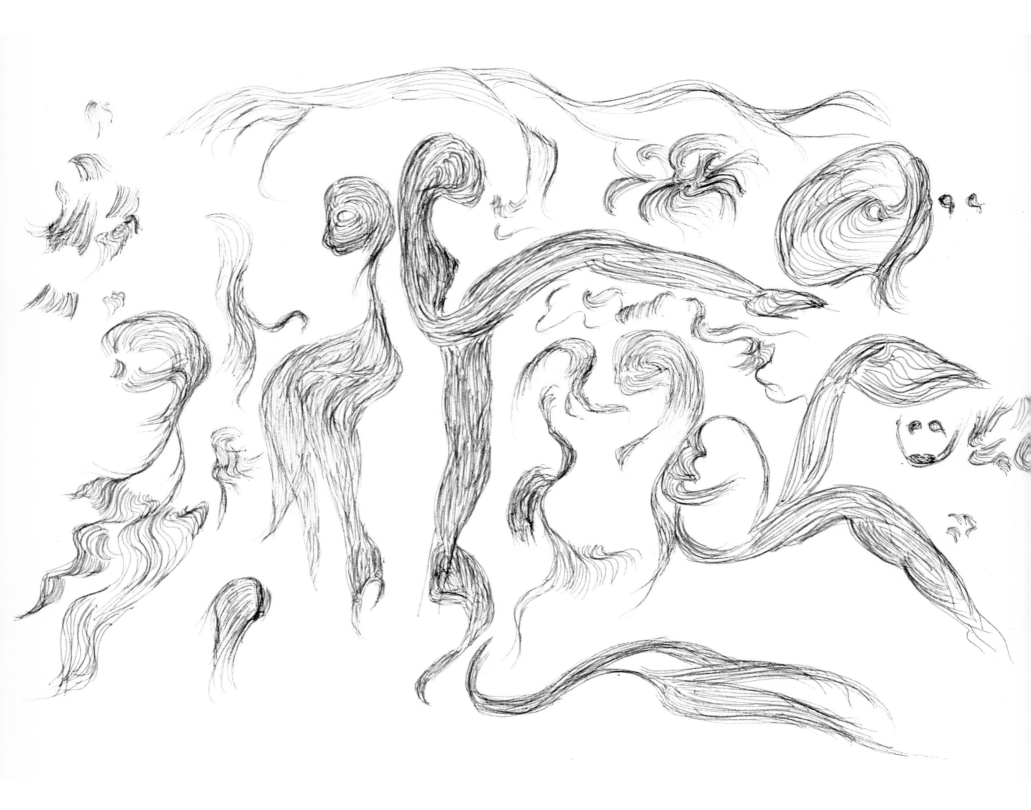

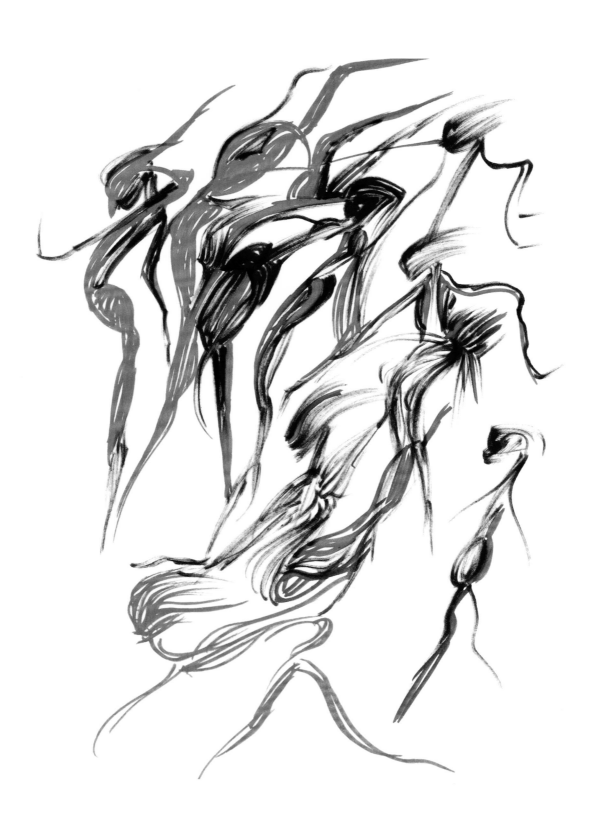

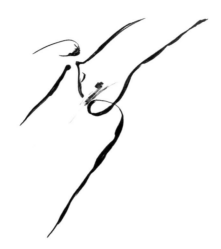

"Most of the time I use acrylic paint, although I also use pastels, markers, pencils, or whatever else interests me. They're all different. What I do with pastels or pencils is not what I do with paint on canvas. Some of these materials are like poison. There's one that comes in a vial; you just sprinkle it on. If you ever want to get rid of someone . . ."

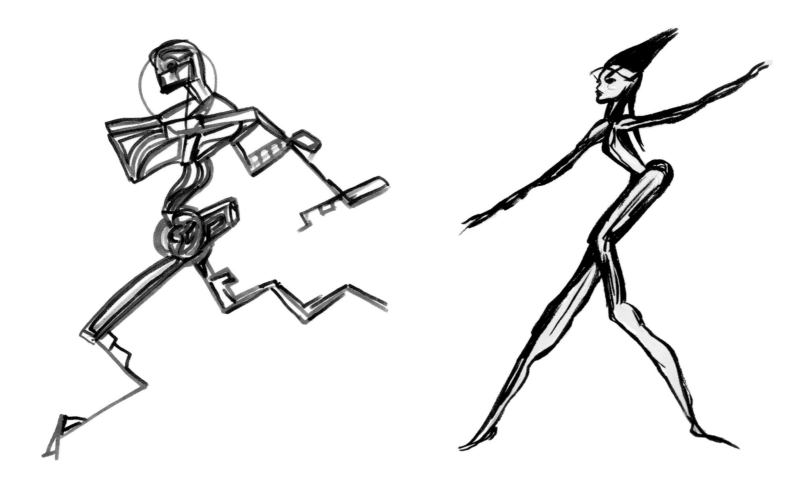

"I don't do self-portraits. I see my face too much as is! It scares me. Somebody says 'Miles,' I'll jump. What did I do, who do I owe? No, I never tried to draw my own face. I can't do that. Guys don't like themselves, they'll distort their faces. That's good for them, but I don't like the way I look—I figure I'm just stuck with it."

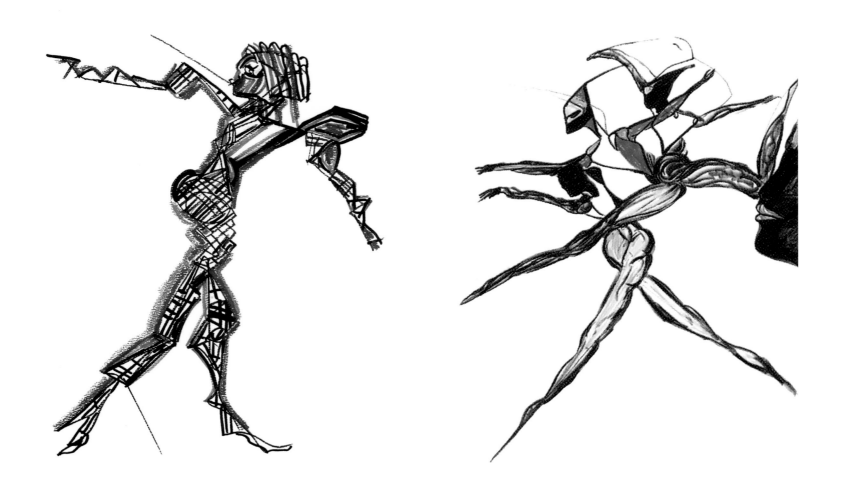

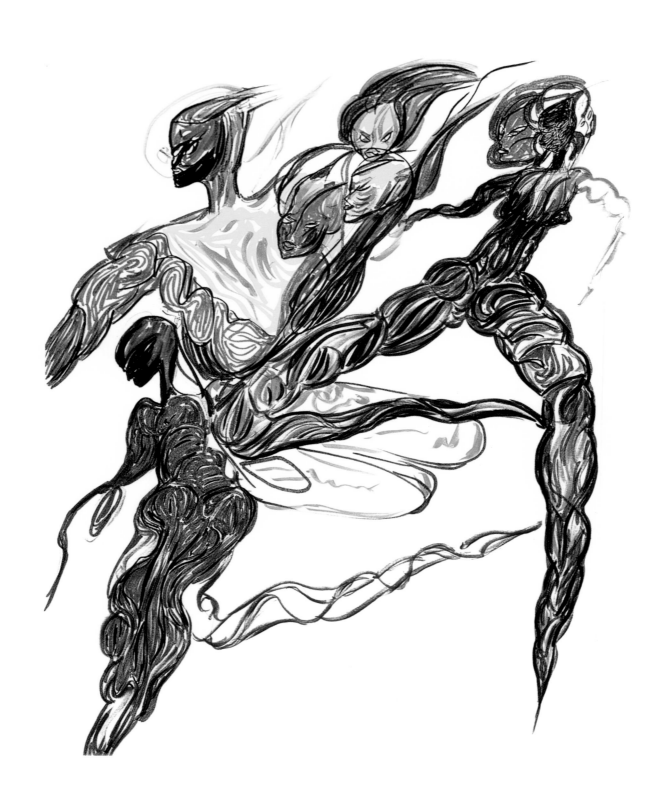

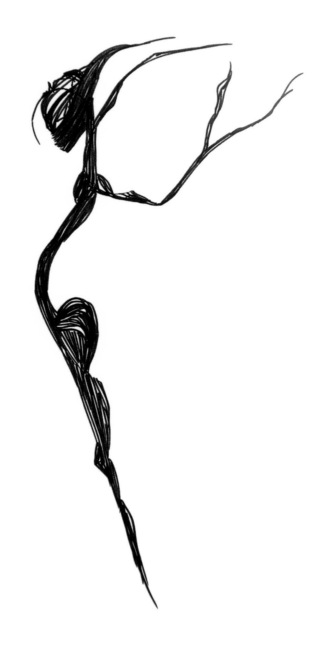

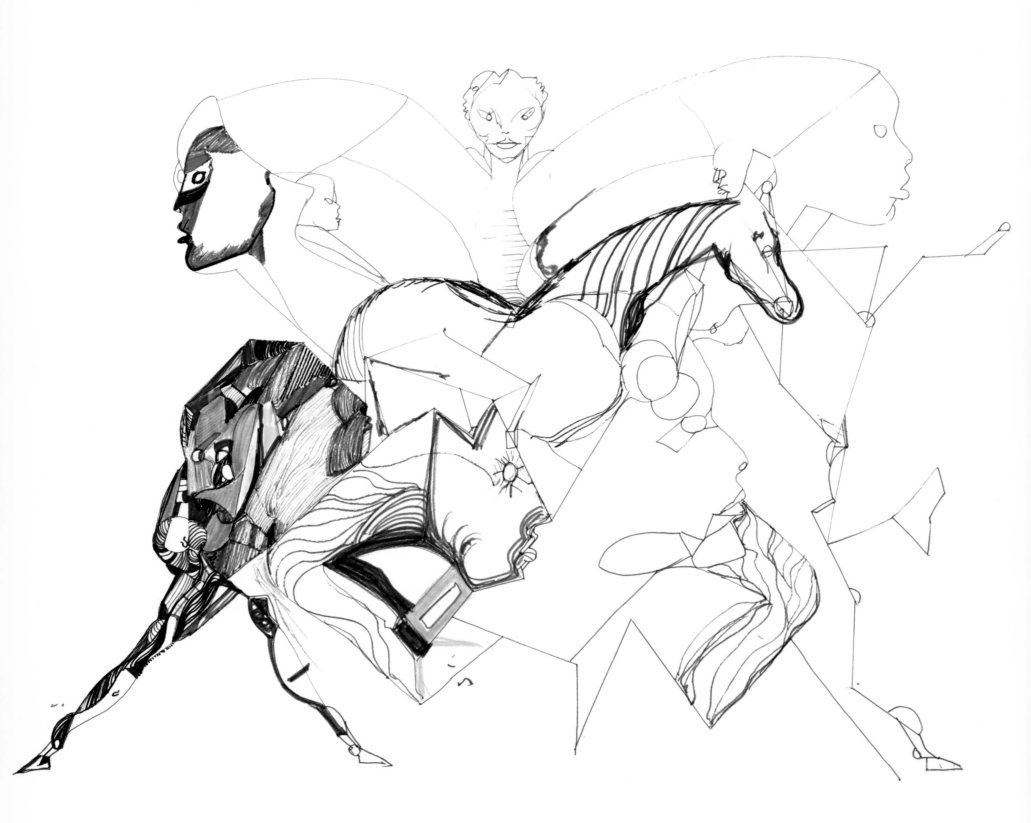

"I wanted to use some of this comic-book art for one of my albums, so I found one of the guys who does it—he's French—and I told him, 'I'm doing a record, I'm going to call it *Rubber Band*. And I want you to draw this cover the way you did your comic-book.' He came to the show that night and saw that I had a woman in the band, and he told me later that he wanted to draw a picture of me beating her. I said, 'What?' Damn, we just jumped from the album cover to that. So I said I'd do it myself, and I started it. It had a guy raising his fist and saying, 'We want Rubber Band!' It had thunder cracking, cliffs breaking all around and everything. But the cliffs looked real small, 'cause this guy's bigger than life. And he had on this jumpsuit, with guns here and guns there and a cape out the back. It was some heavy shit. So I kept working on it and I kept fucking it up. It ended up looking more like a woman than a man. I tried to show the guy with bullets crossing his chest, but the way I did it, it looked like he was wearing a brassiere. And this is after about two weeks! Still, I thought it was a hell of a jumpsuit. I just found that picture the other day, and I'll probably start working on it some more."

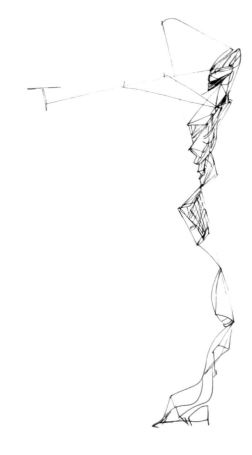

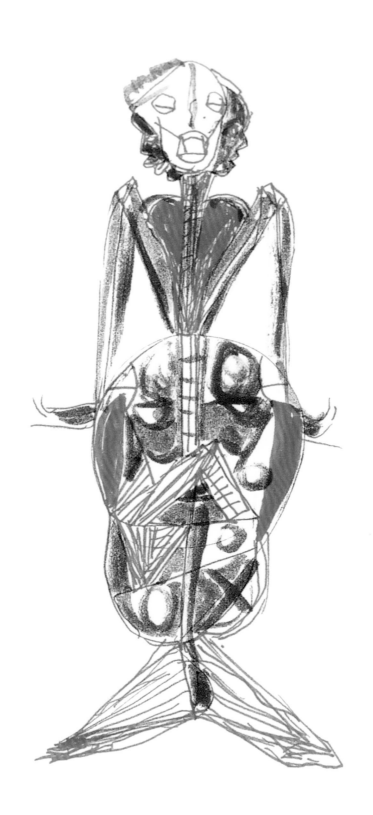

"I just can't believe the different periods of my face and my body. There's a picture of me in my autobiography where my bottom lip is all round and muscular and stuff. Now it's shrinking. I look completely different. Some people say my old pictures look just like my youngest son, Erin. I don't look at those old pictures now. If I did it would shock me, scare me to death."

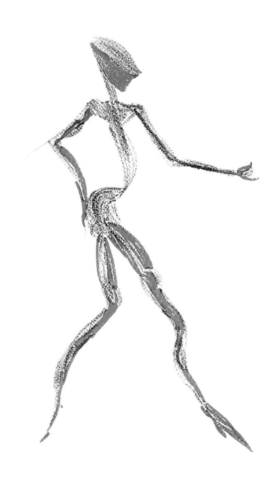

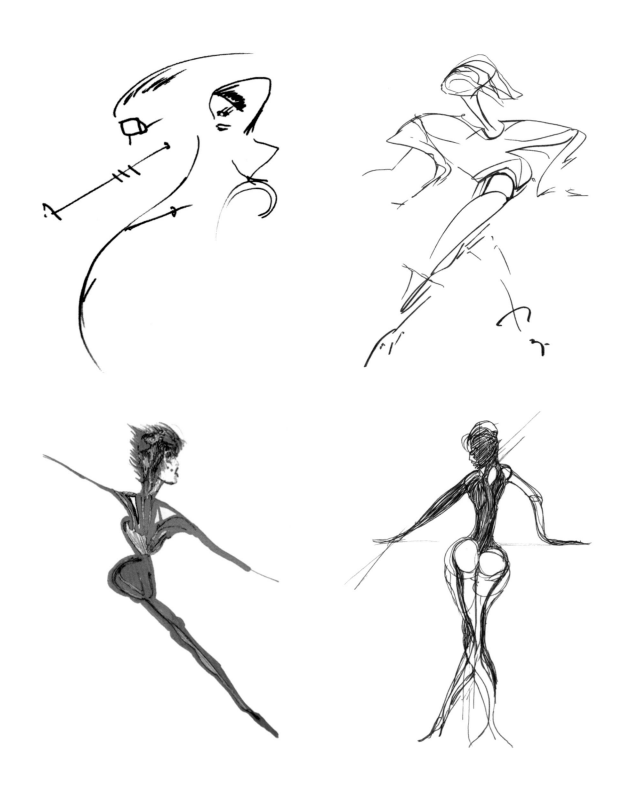

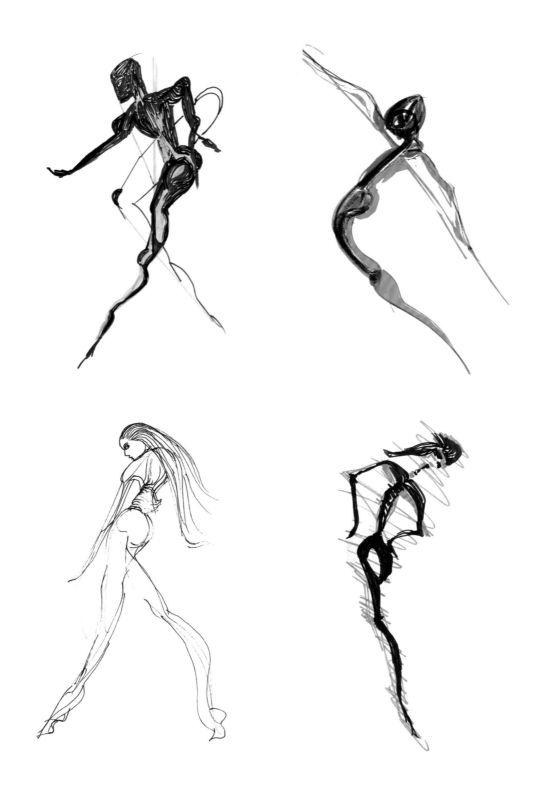

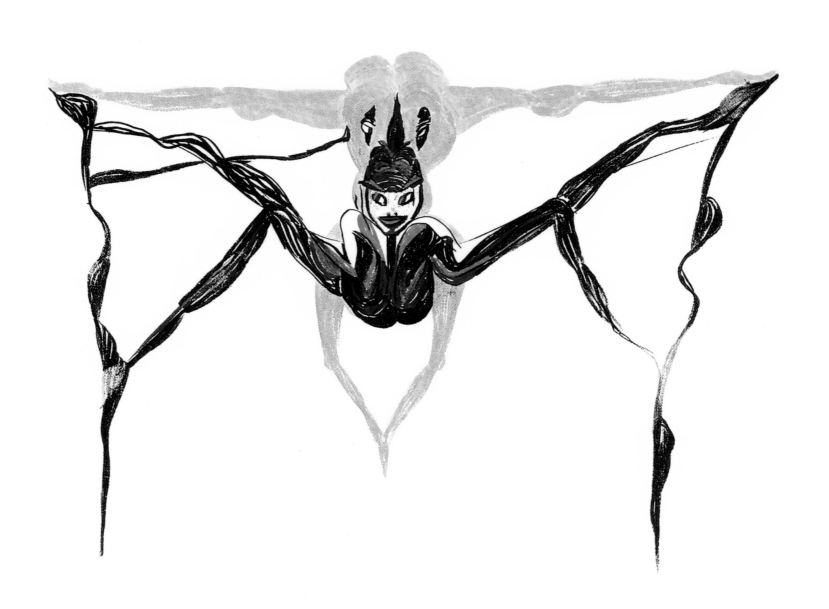

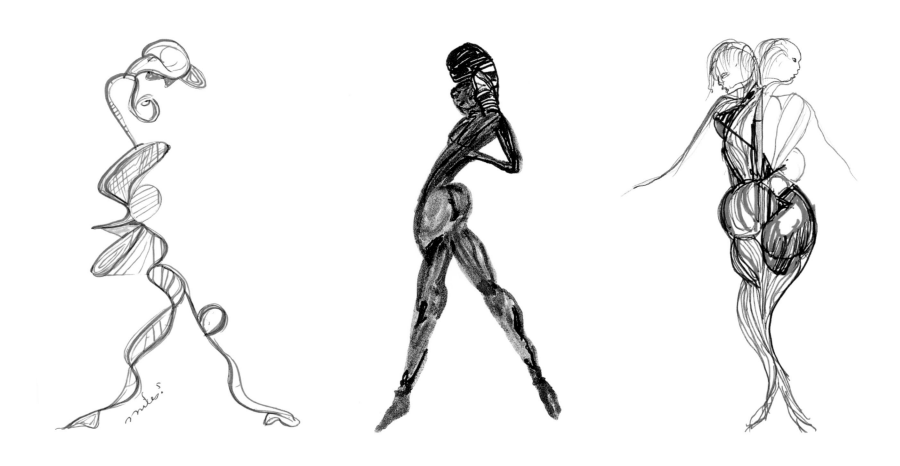

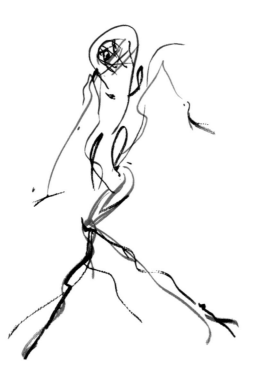

"I really started painting a lot in the beginning of the eighties, and now I'm spending quite a bit of time doing that. If I don't play the trumpet, I'll do that. It's always one of the two; I can't do them together. I still spend a lot of time sketching. I don't even think about it; it just kind of pops out. But if you looked through my sketchbook, you'd think I was some kind of sex freak or something. It's full of naked women! Once, when I was on tour, one of the guys in my band told me, 'Man, I miss my girlfriend, draw me something!'"

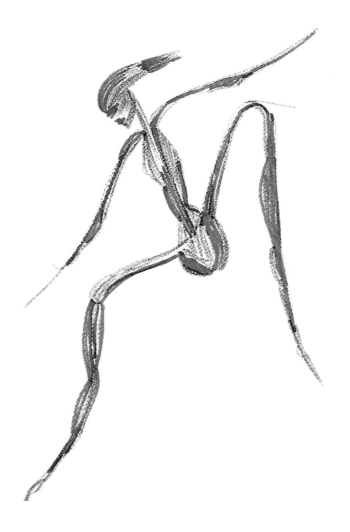

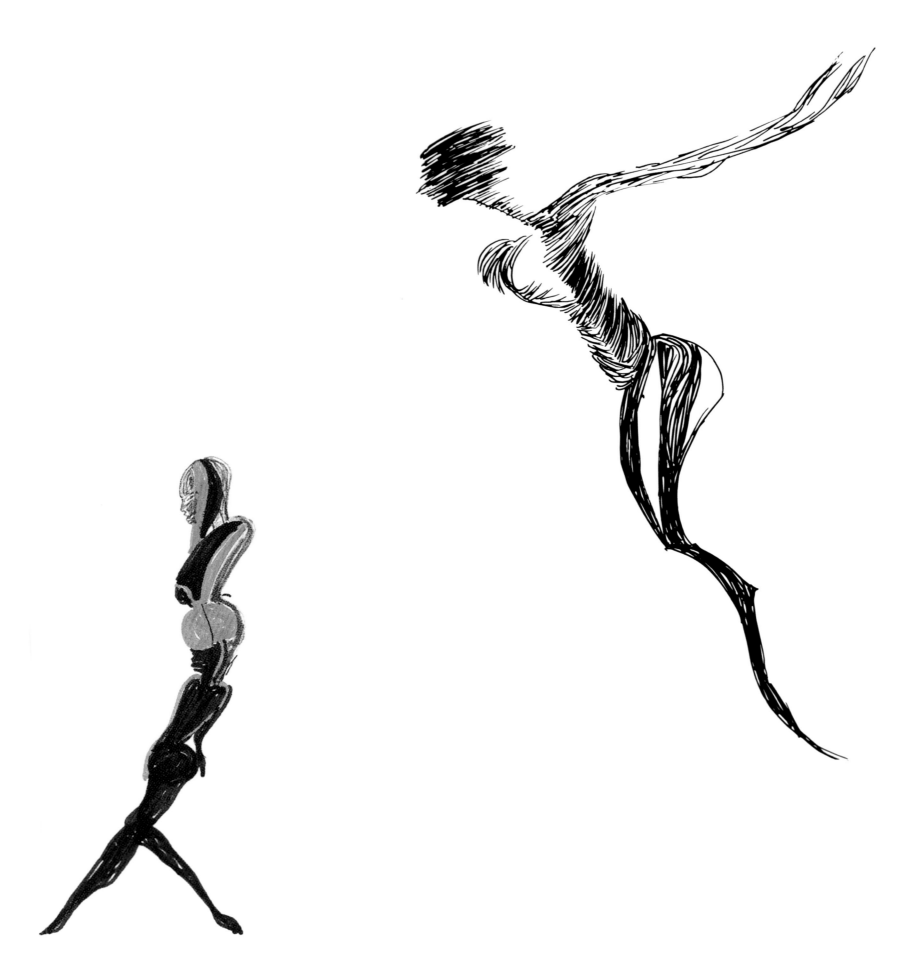

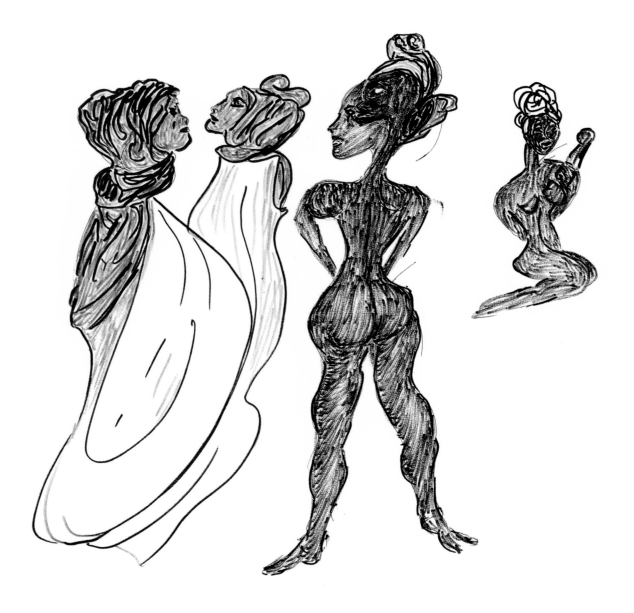

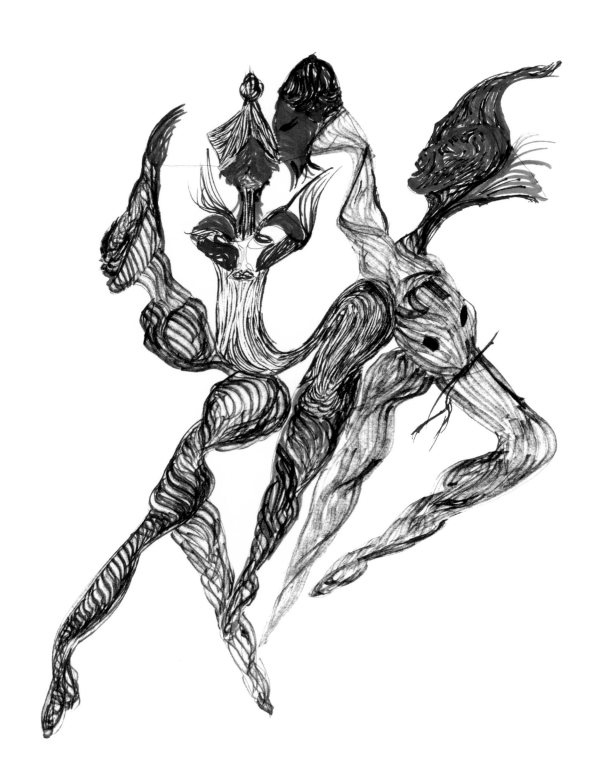

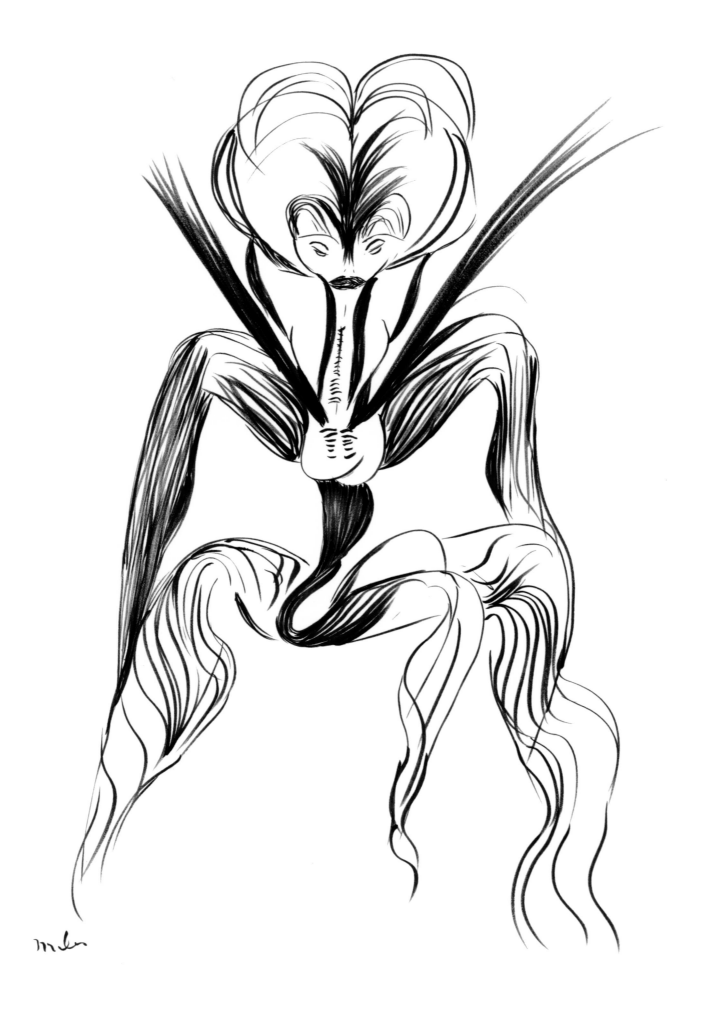

"I sketch or paint wherever I am—at home, on the road, it doesn't matter. I usually work on a glass table or on the floor, never at an easel. I don't use models for my figures. It's more from my imagination. But I did see something the other day that I wanted to tear out of a book, a picture of a couple of dancers. She had her leg over here, and he had his over there. But it wasn't freaky or anything, 'cause they were ballet dancers. Only dancers could do something like that."

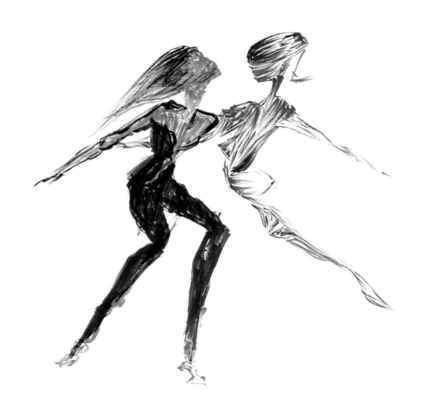

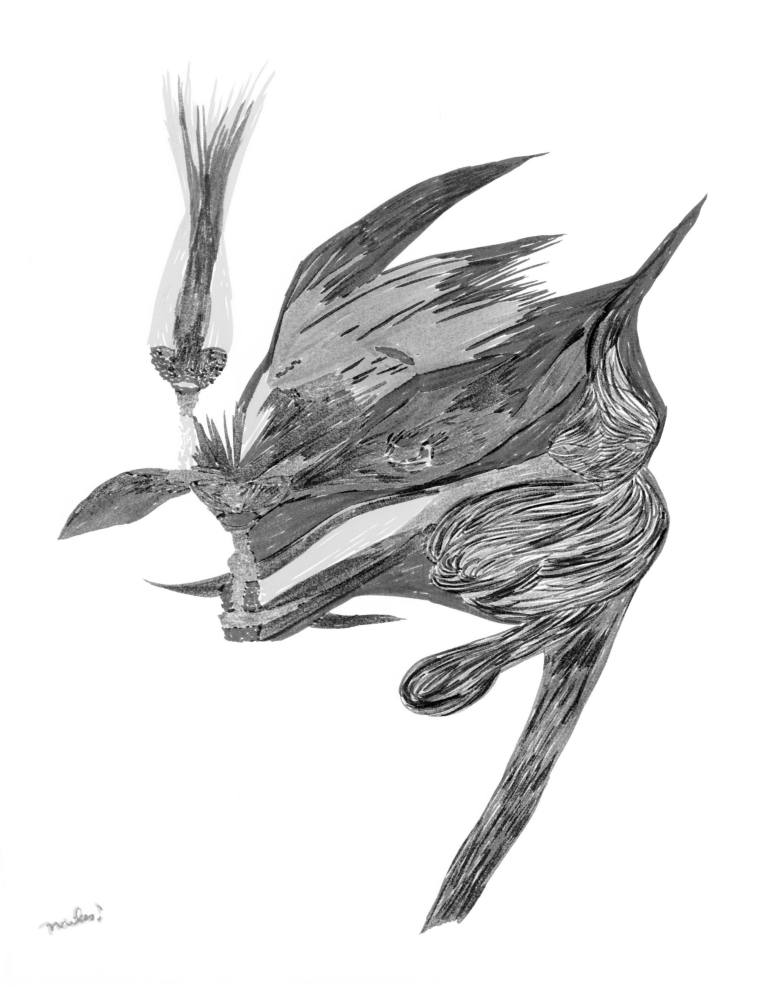

"One thing I like to look at a lot are those comics magazines that you buy in Europe, with the sex and all that weird stuff in 'em. I think them guys are geniuses. They draw a whole city so it fits into one panel. Or they'll draw somebody getting out of a taxi with an attitude. Or somebody with half a head, or with hair blond on this side and black on the other, and no hair over here. And they'll draw a whole crowd around them. That's some hard shit! I had dinner at my friend Billy Friedkin's house in California—he did all those wild movies like *The Omen*—and he said, 'You like this stuff, too?' and started showing me all his books. One guy he showed me did this stuff that was just so grotesque. It makes Frankenstein look like a baby! It's got all this stuff about blowing up loved ones and that kind of thing. But it's got a lot of depth."

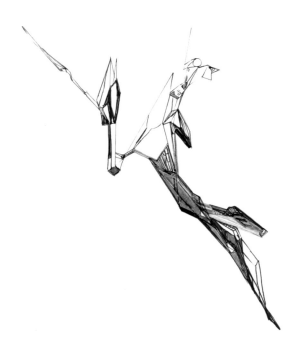

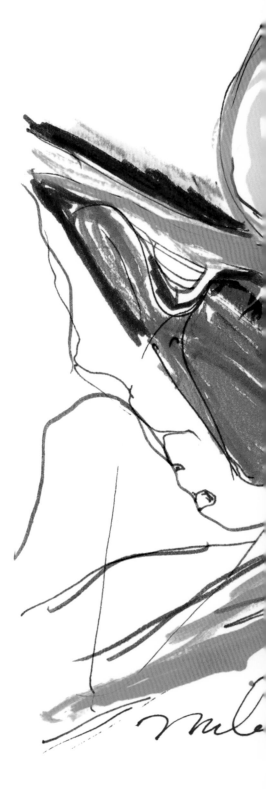

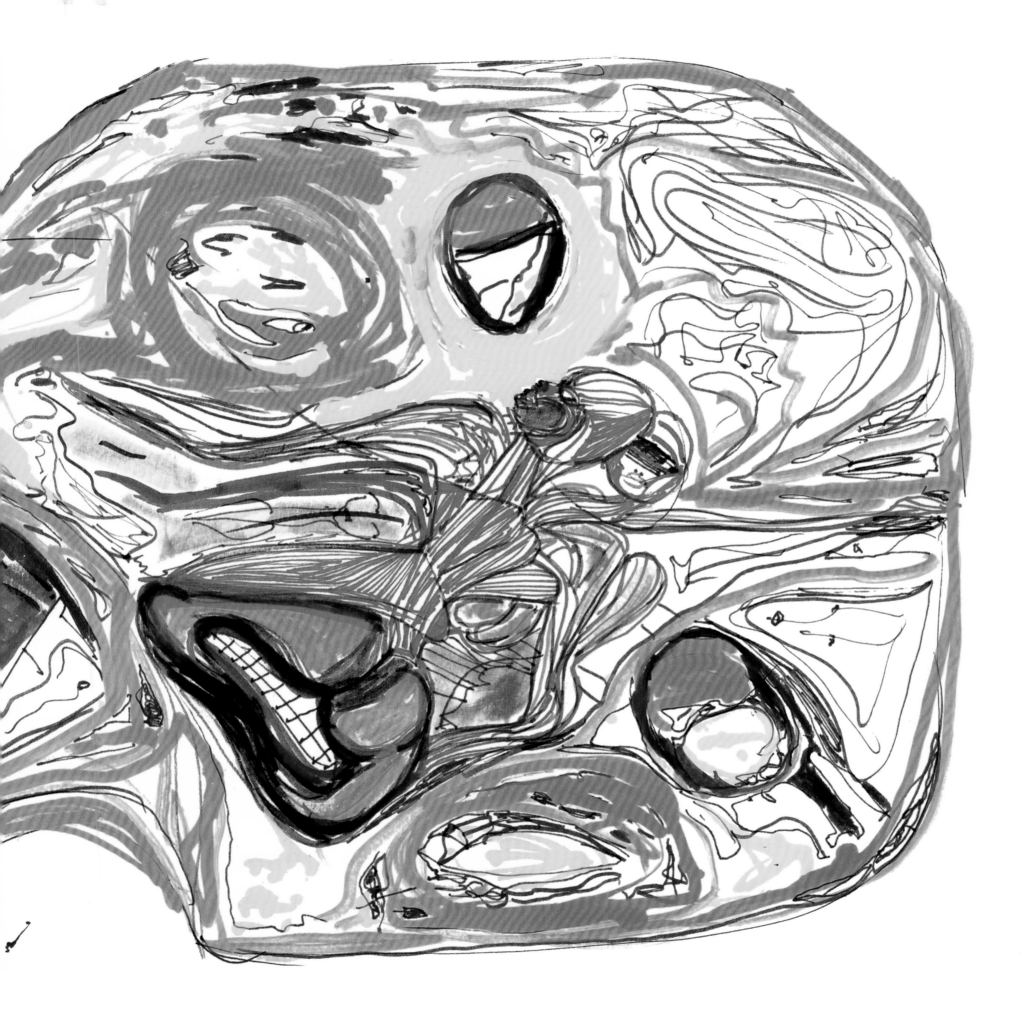

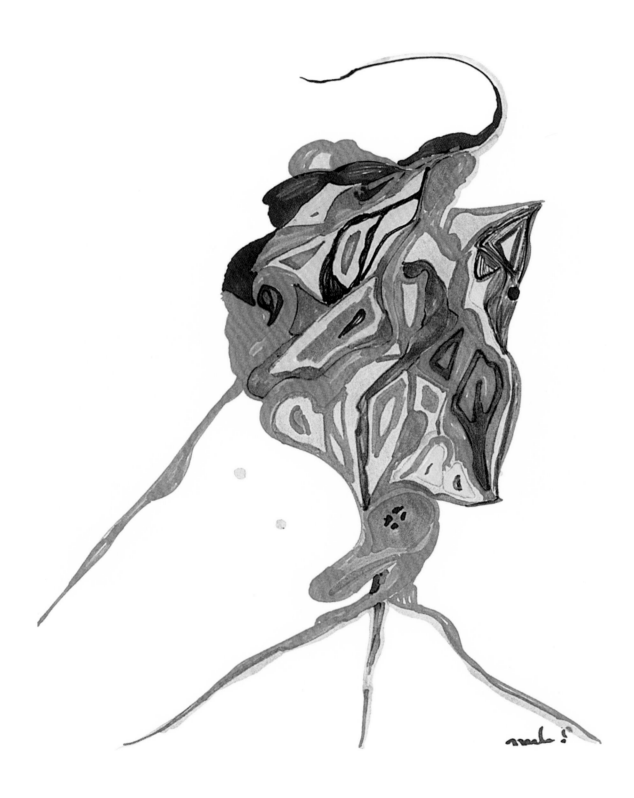

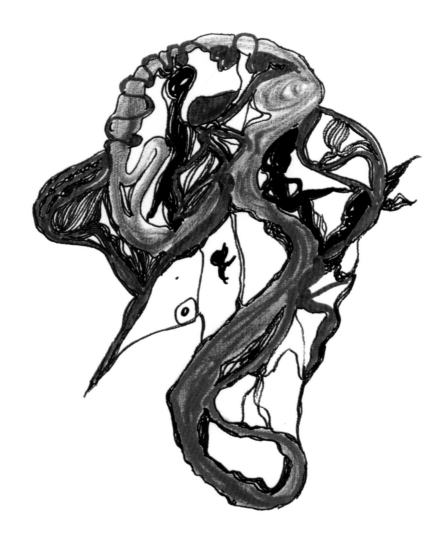

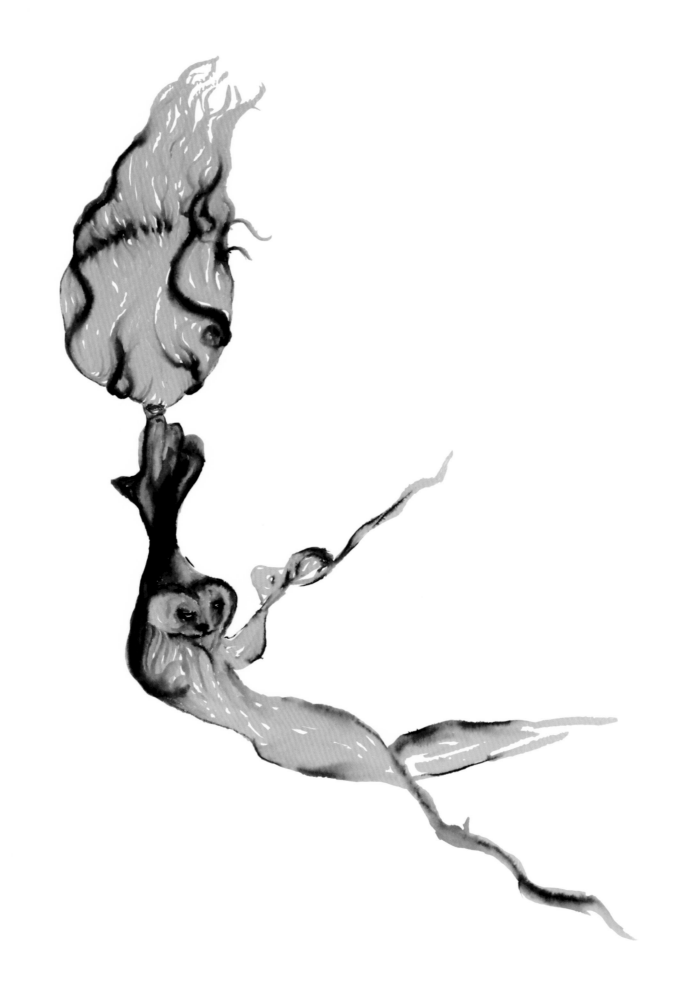

"The two guys who were making my clothes, they were finding me all these African materials, and they said, 'You've gotta see this art, Miles, only you're gonna have to go to Africa to see it.' But I didn't go to Africa; they sent it to me. I like the textures, the materials. I keep a lot of my own works in my apartment, but they're mostly the ones I don't like. For instance, one of them may have nice colors in it, but it's not working right. They just turn out like that sometimes. But there are some that either I don't like or I was too lazy to finish. Some drawings I know aren't going to work as soon as I do them. I don't even bother flattening those out. I just roll them up and stick them in the corner."

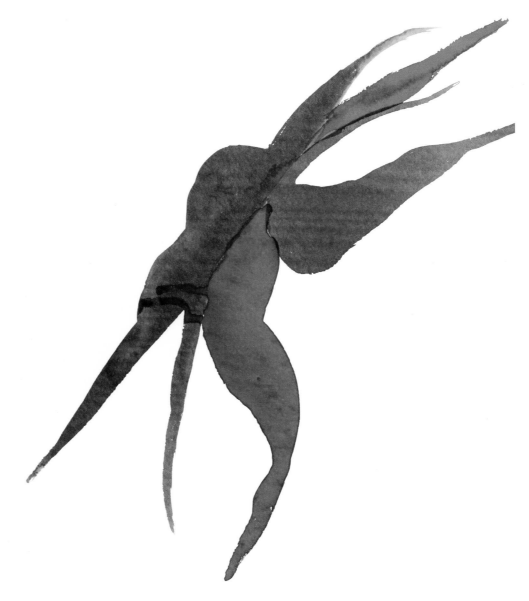

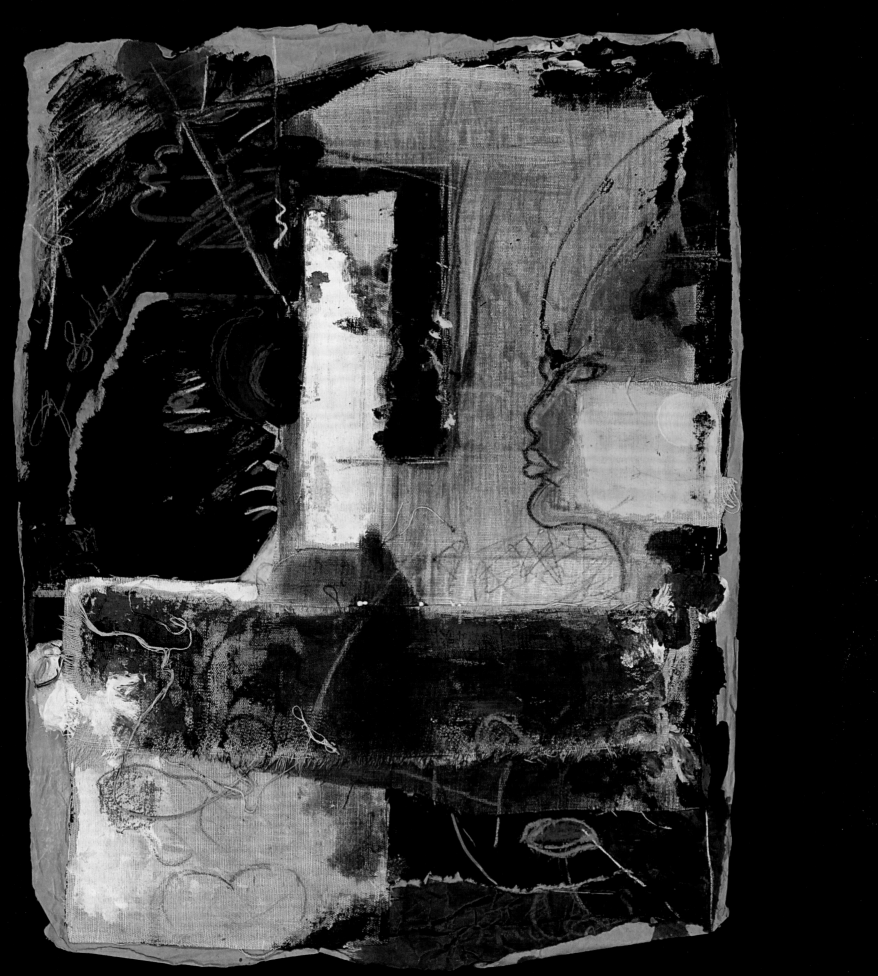

PART 2

PAINTINGS

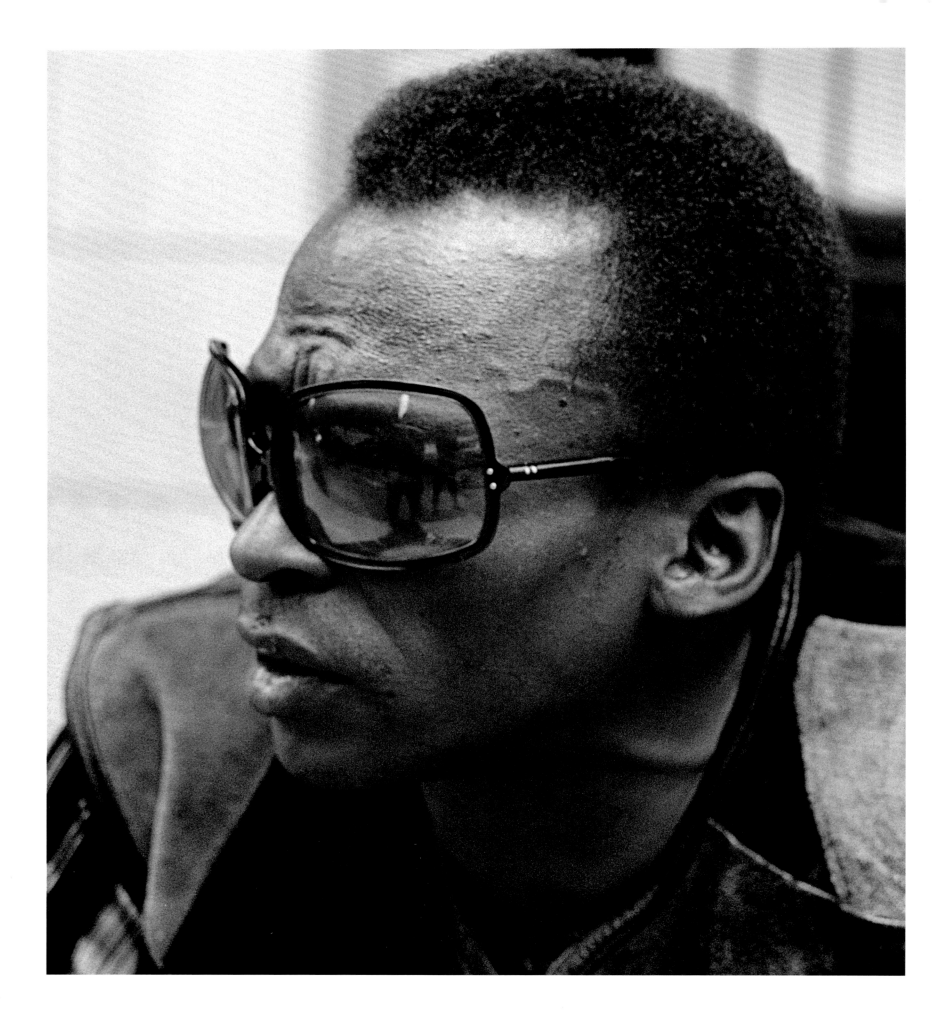

REFLECTION | ERIN DAVIS

I'm the youngest of my father's kids, and I started to hang out with him a lot when I was ten or eleven. He was always sketching and painting, and I found it interesting. After his stroke in 1981 he found drawing to be therapeutic, and he used it as part of his recovery.

When I would visit him in New York as a little kid, he would have all these sketchbooks around the house. And by the time I moved in with him, when I was fifteen, he had started painting a lot.

I used to run down to the paint store for him, with my cousin Vince, all the way from North Malibu to deep in L.A. We'd get him rolls of canvas, paints in all these iridescent colors, brushes, everything. He didn't want to wait—he needed to have those things nearby, so he could jump right in.

He would paint on canvas that he'd laid down on the dining room table. Then, when he was finished, he'd hang them like banners all around the house. He'd have them stretched later on.

When I was on tour with him, he was sketching all the time: in the car, on the plane, backstage. He was always very generous with his drawings. He'd draw a sketch of someone and just give it to that person.

He tried to get me into painting, but I didn't take to it. Same thing with the horses he kept up in Malibu. But I see that it changed him. It helped him see things differently.

He had shows at several different galleries, and he always enjoyed seeing his paintings on display. He really wanted people to appreciate his art as another expression of his creativity. His audience in Europe understood that.

He would find out about different artists and get into their work for a while. One of the first was Wassily Kandinsky, who's often called the father of abstract art. Then there was Jean-Michel Basquiat. That's when my father started using different textures in his paintings, like burlap and nails.

I think my dad's artwork is not looked at enough. He's so known for his music, and even his style, but this is something that was very important to him—he did so much in the last ten years of his life. I'm still discovering all these sketchbooks of his. The art in this book will allow people to appreciate a whole other side of him.

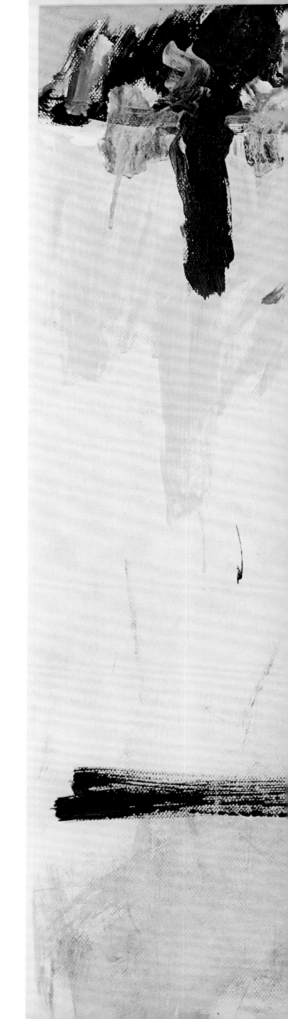

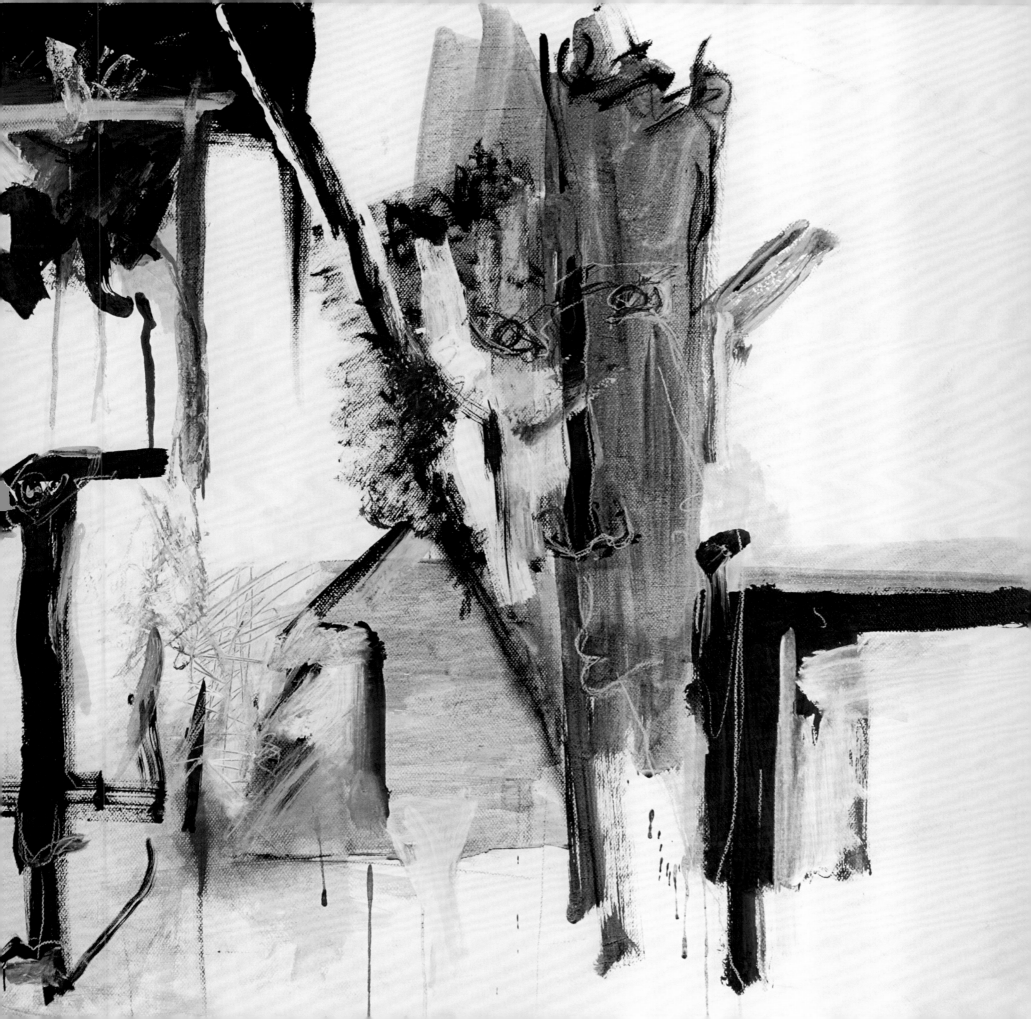

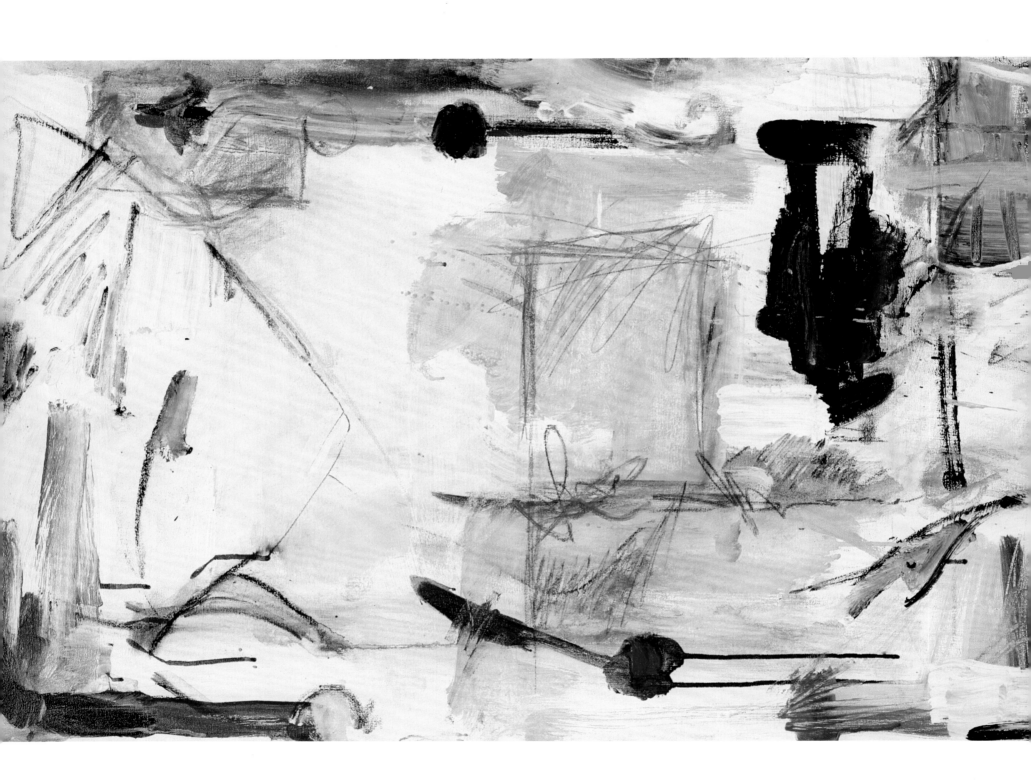

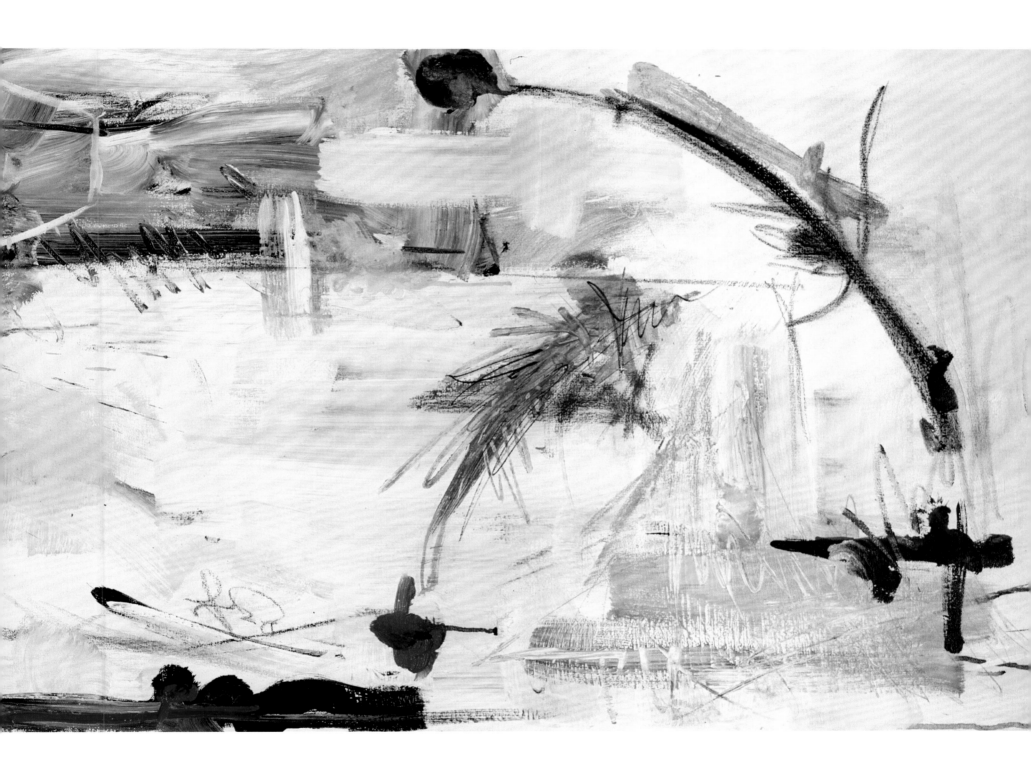

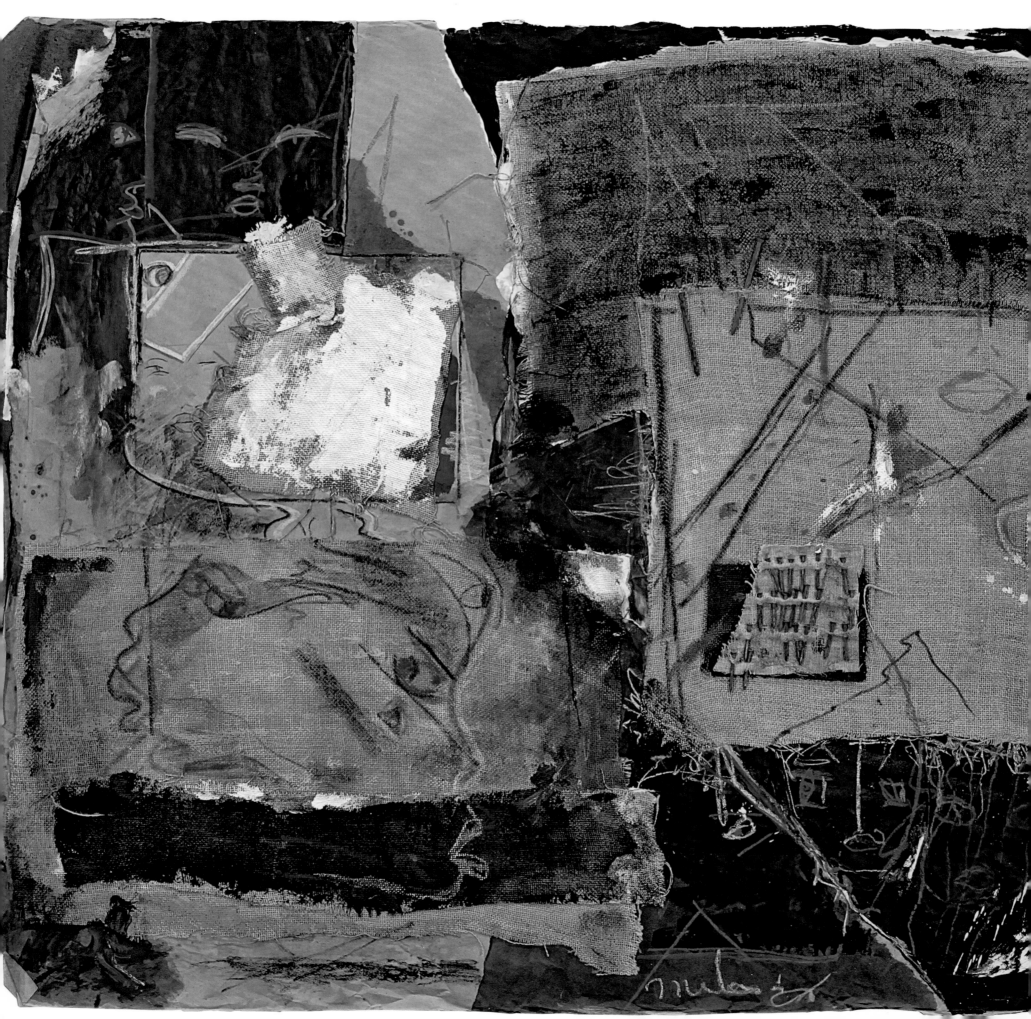

"I did a painted dish once—that kind of thing is easy for me to do. I have one piece that feels like rubber. I coated it about three or four times with some mixture of paint. That's the kind of thing I like to do. I've also done some work on plain brown paper. See, if you do it on brown paper, your ideas are reversed."

"I have one painting I like that I just did. I would have put it in my New York show, but I didn't want to turn it loose. Also, I started drawing on the other side, but I got tired of it and stopped. I said, 'Aw, no, no, no. It's gonna take me too long to do.' It could have been a masterpiece! What if somebody wants to buy this? Do you say, 'On Wednesdays you can turn it around'? Of course, somebody might say, 'Oh, he left something unfinished on the back, so I'm getting a bargain.'"

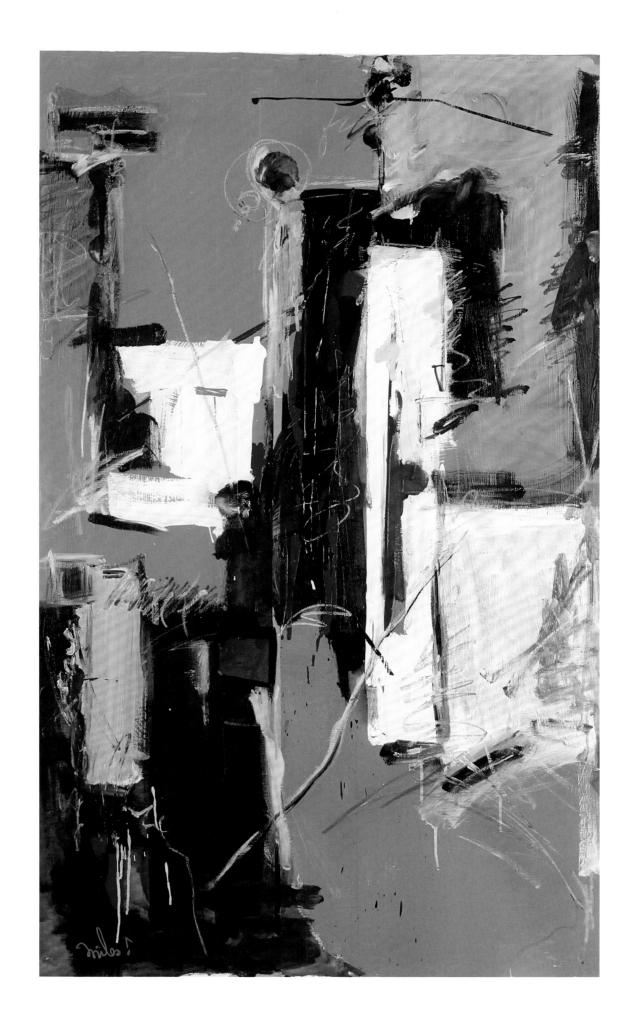

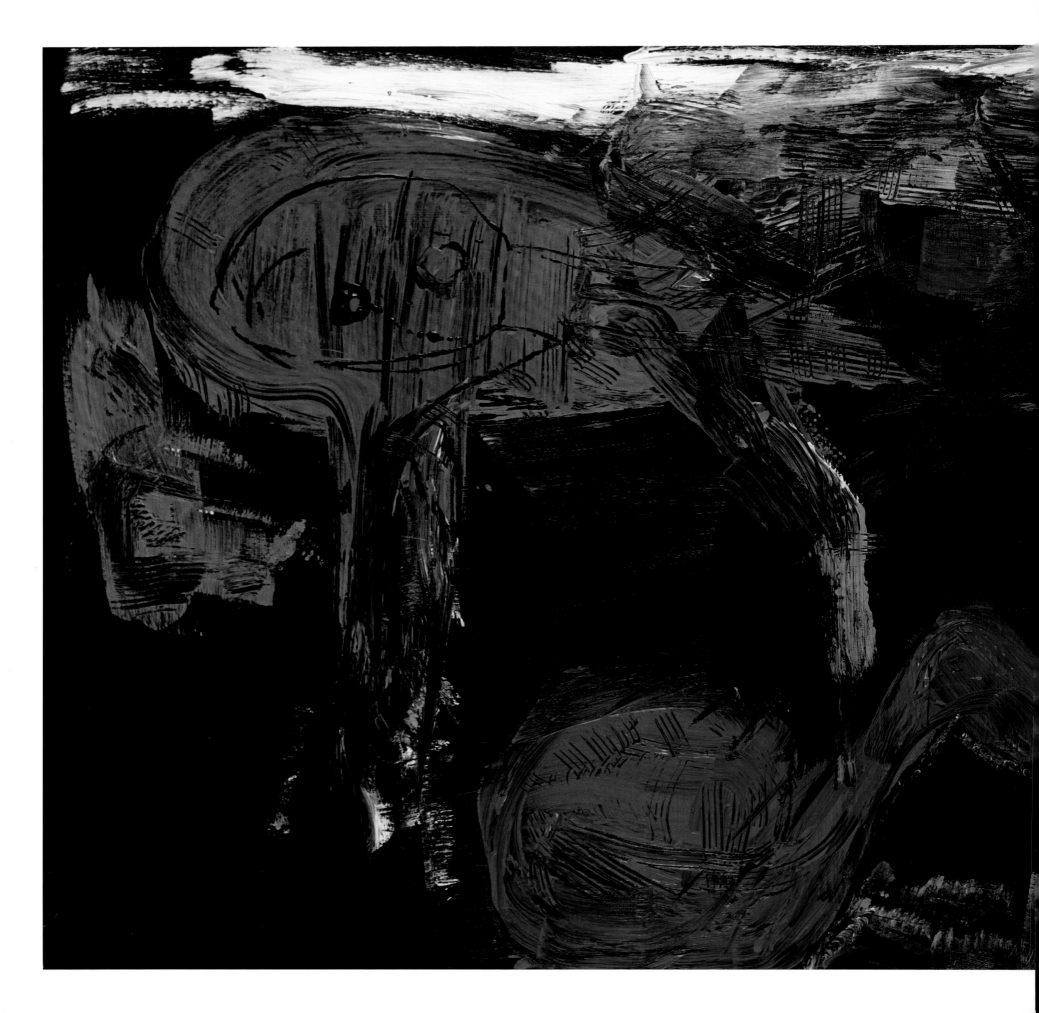

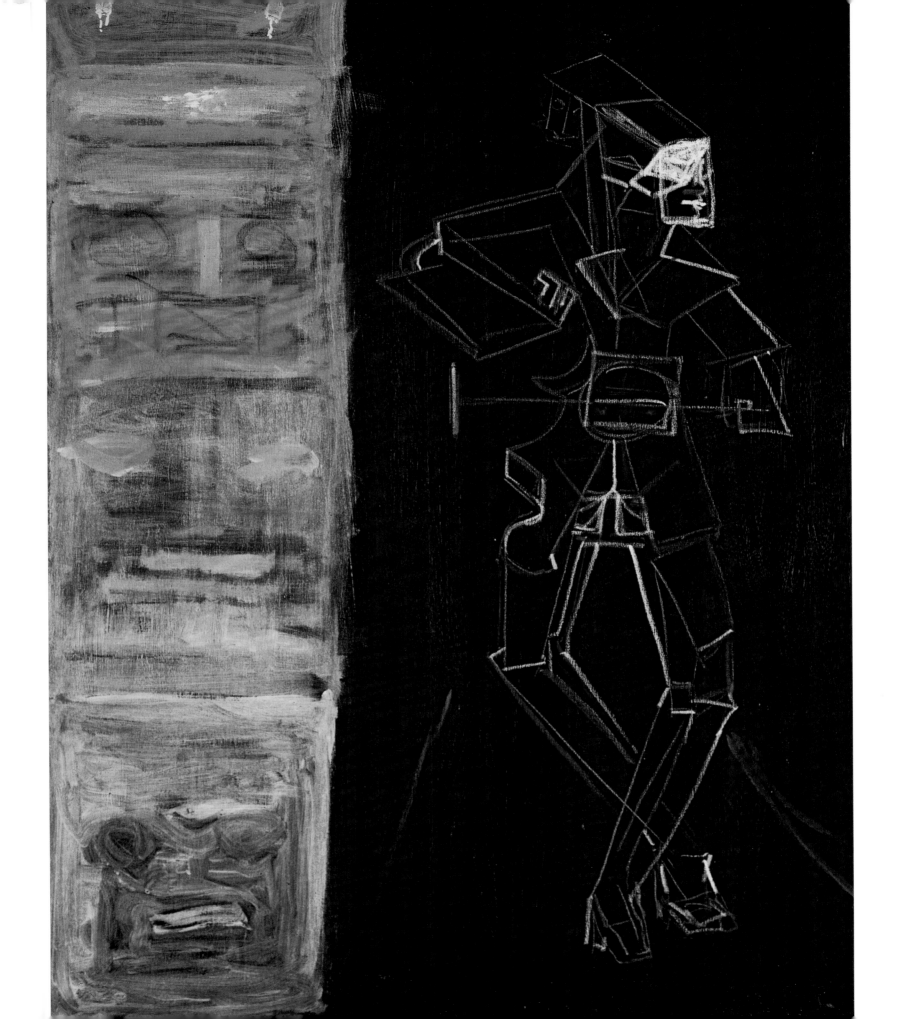

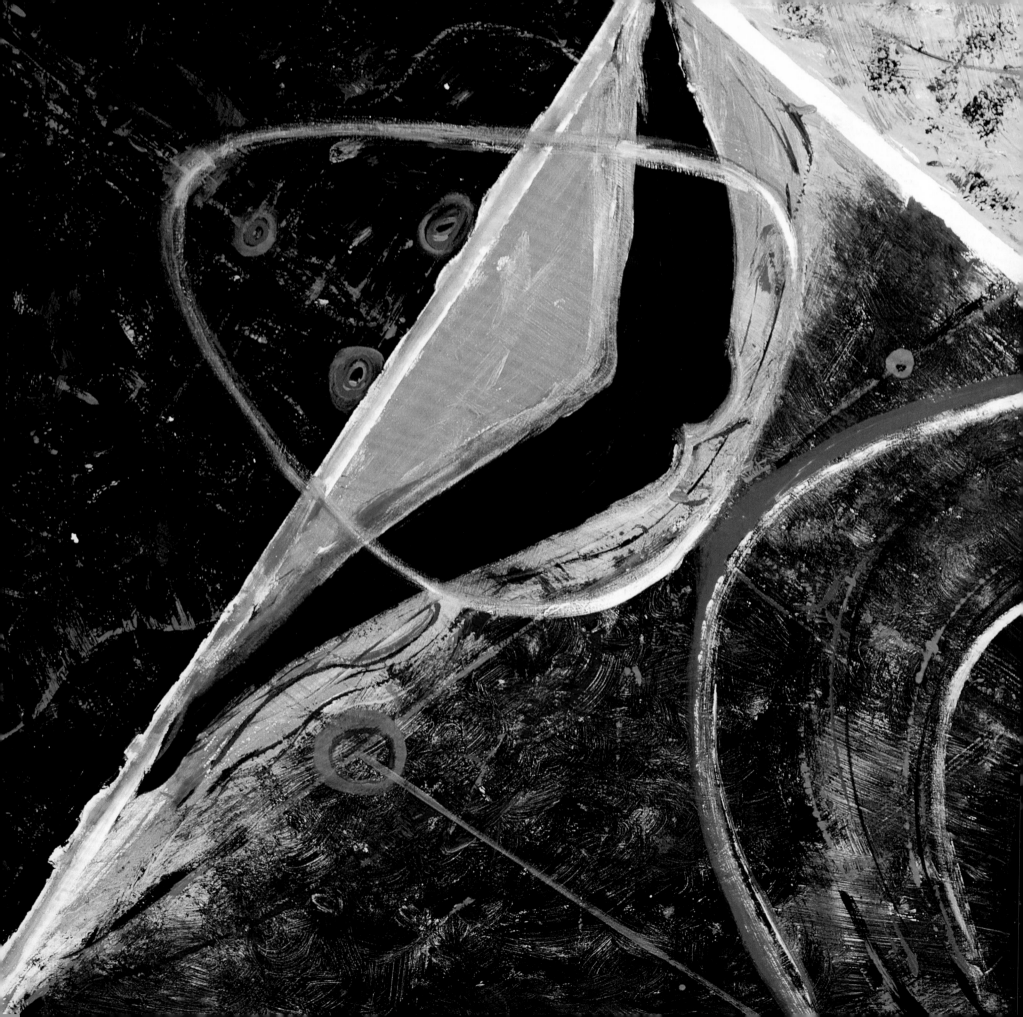

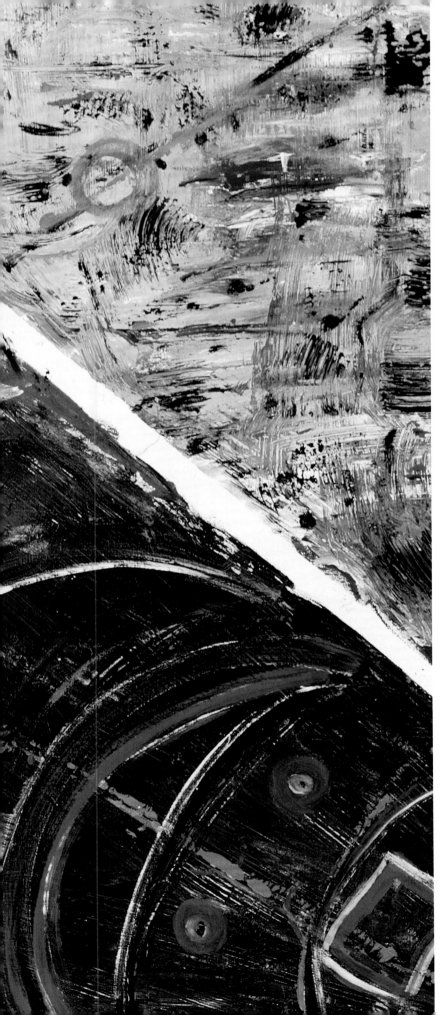

"One thing that's nice, you can see things better in my new apartment than in my old one. It gets a lot more light. A certain light will make you look at something in a different way. It's nice to come into my apartment or my studio in New York and to see all my paintings. It's like seeing old friends. I even find that I miss certain works when I'm away from them. Like when I'm in California I'll find myself thinking about some paintings of mine that are in New York."

"You'll see a lot of eyes in my work, 'cause eyes make the whole character. I like 'em when they're looking up. You know them old, slick churchwomen, when someone is talking and they're pursing their lips and rolling their eyes? I try to draw that. My ex-wife, Cicely, used to do that. Somebody'd be saying, 'Yeah, I done this and I done this,' and she's listening but she's not looking, she's rolling her eyes. I've tried to do faces like that. I like it when the eyes are looking straight ahead. One eye's great, too. I also love to draw faces, put 'em at different angles. If I'm doing one of my totem poles, I might have different faces looking different ways. In some of the works, I got so caught up in the colors and everything that I forgot to do what I usually do with the face."

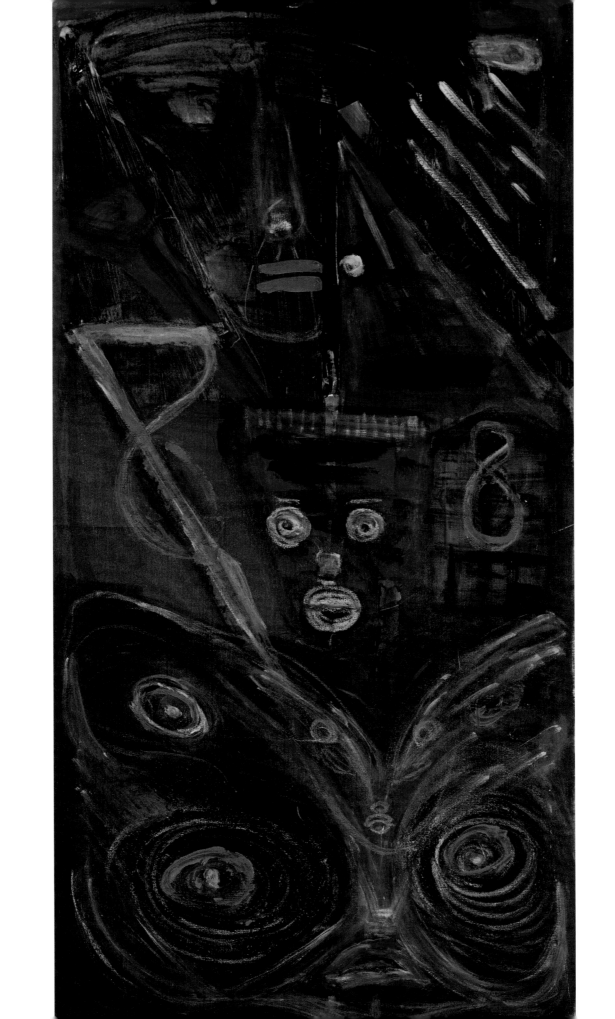

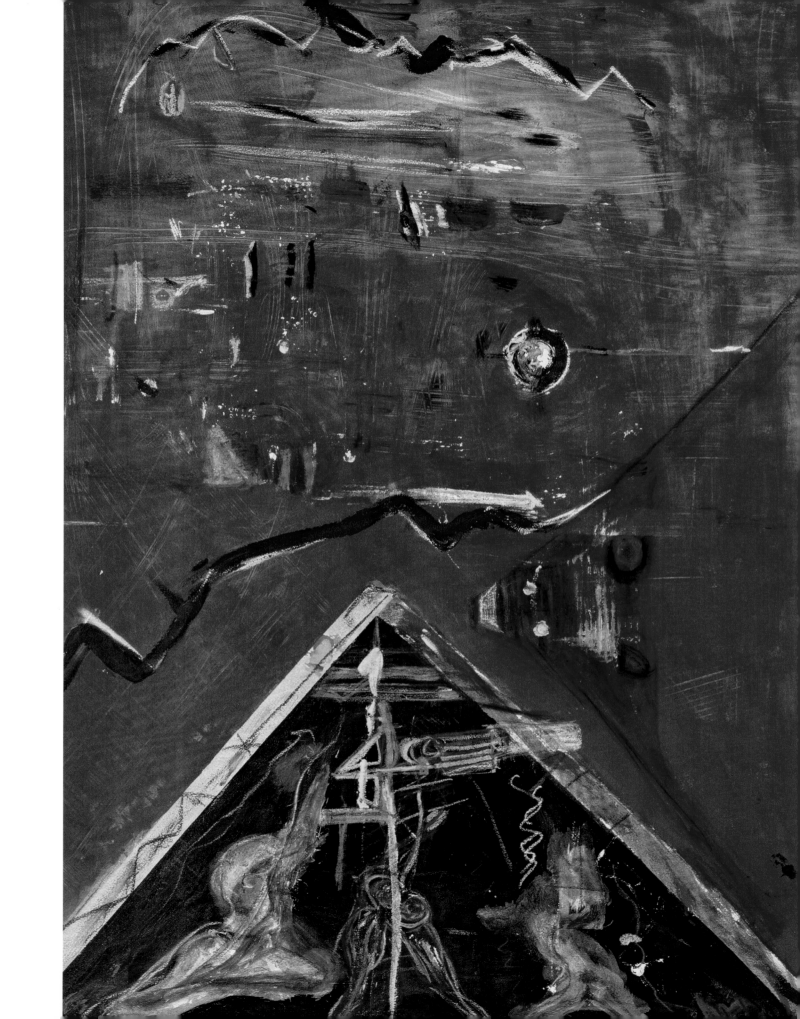

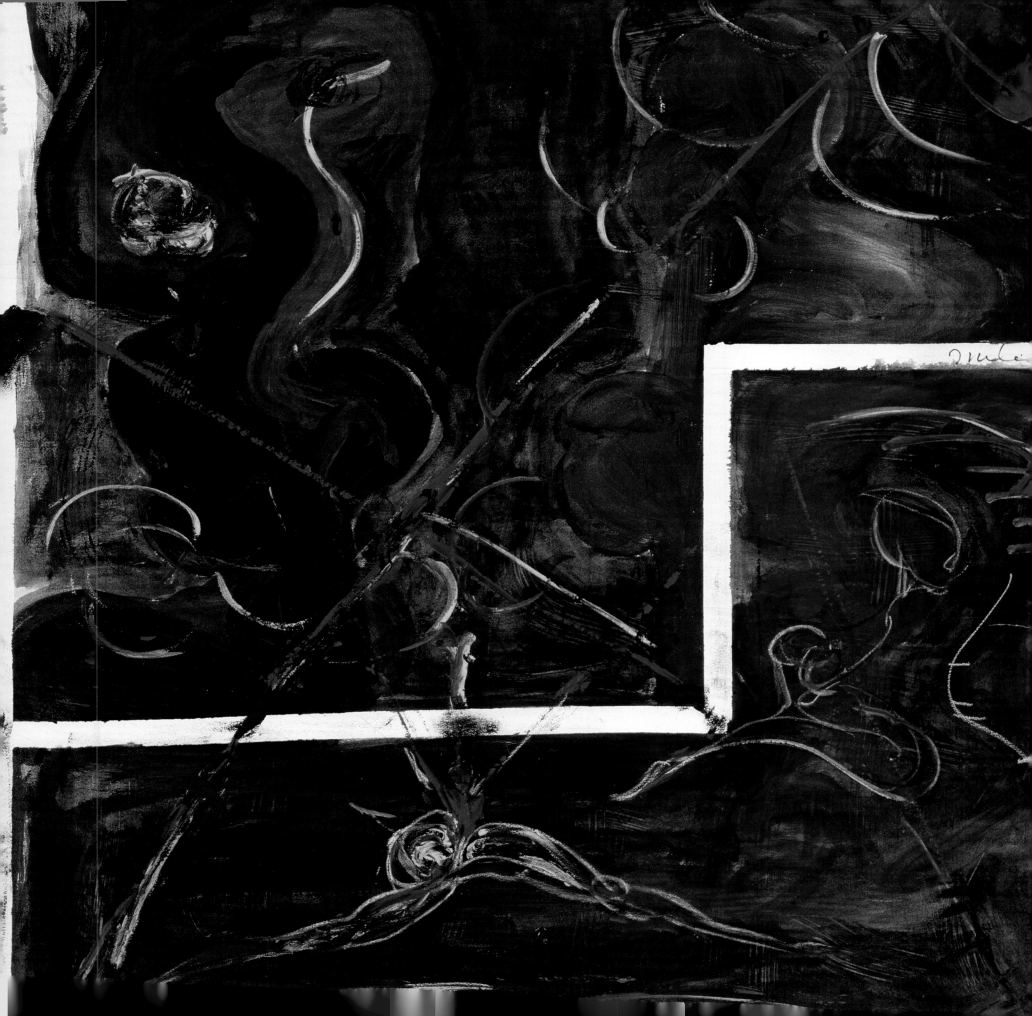

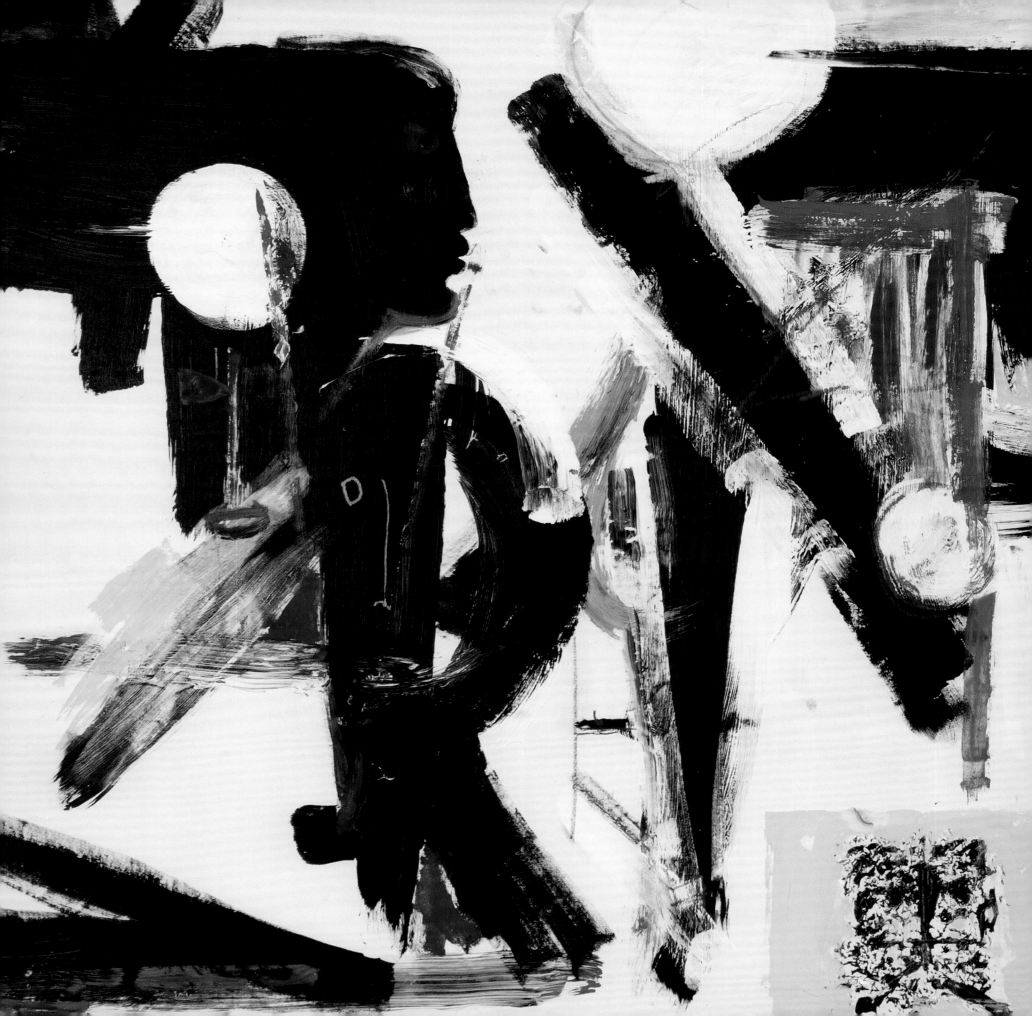

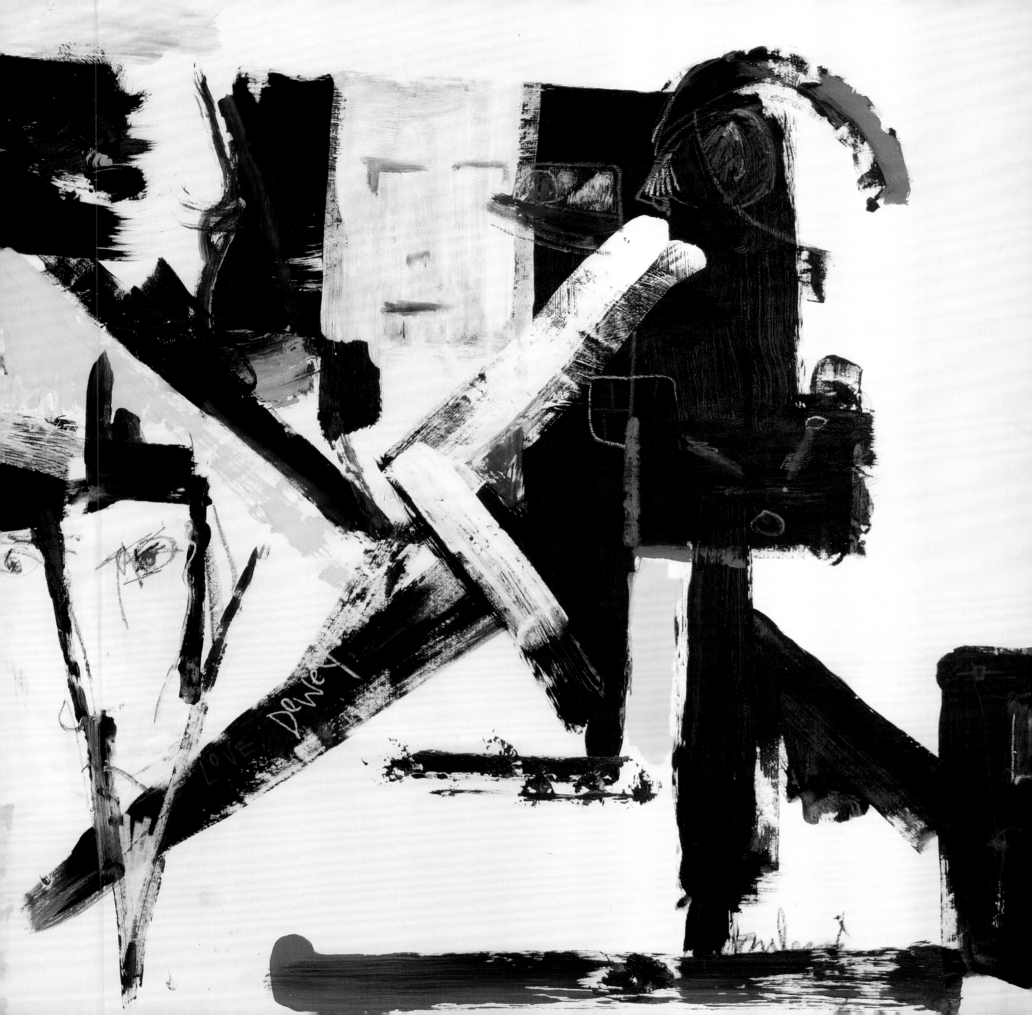

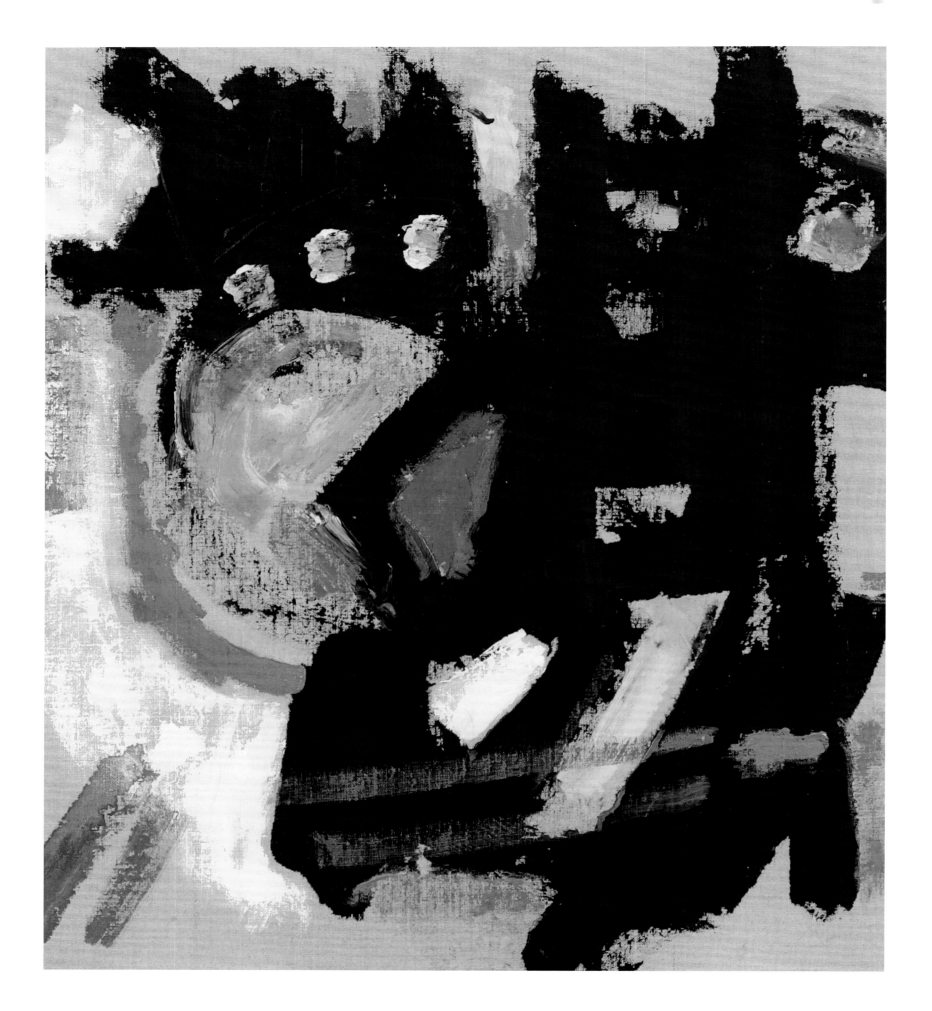

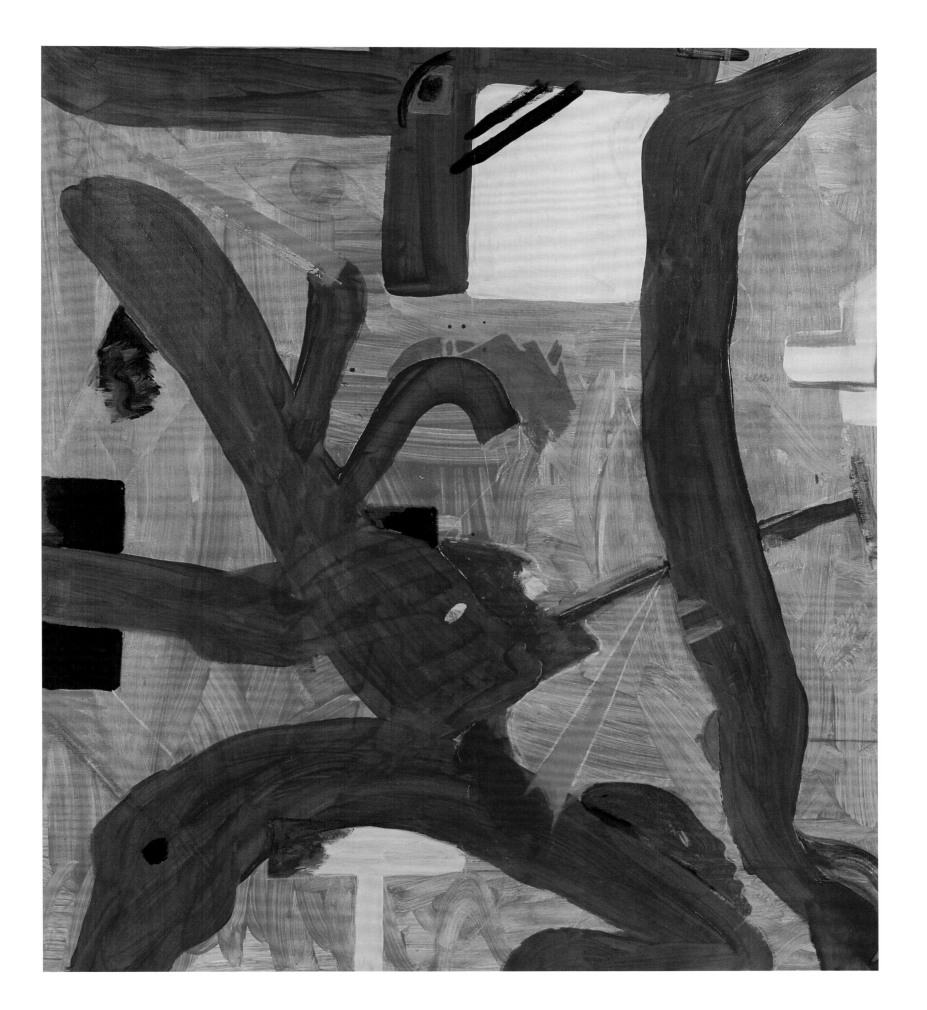

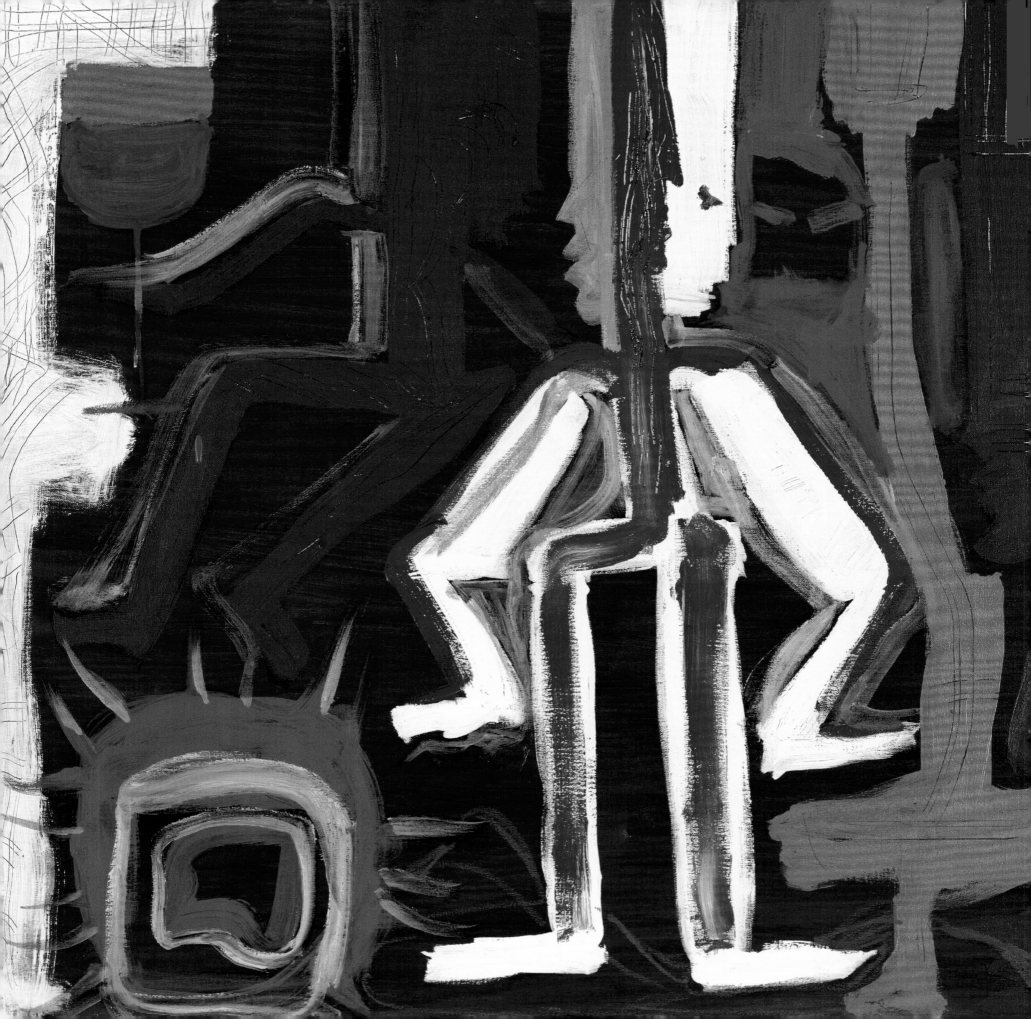

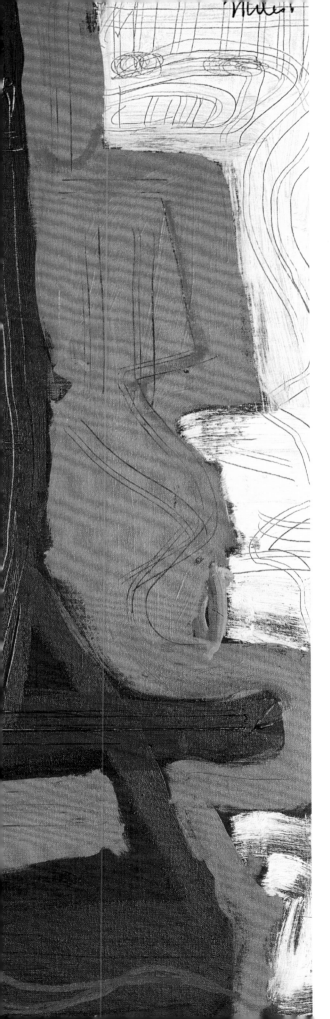

"I also got one painting from a girl in Madrid. It has a lot of movement in it—a plane, a train, a bridge. And I got a piece I keep near the door made out of soft metal. It's so soft, you can make an imprint in it. I don't know what it is, I just like it. When I was in Istanbul, I bought four paintings by the same guy. One of them's almost like a sheet. You can look at any of his stuff and just turn it any way. What he does don't look like anything else you've seen before. I've been looking at one of them for more than a year, and I'm just noticing some of the things the artist did. I have one painting that's from Morocco, I think. It feels like it's made of enamel, but it's just heavy paint."

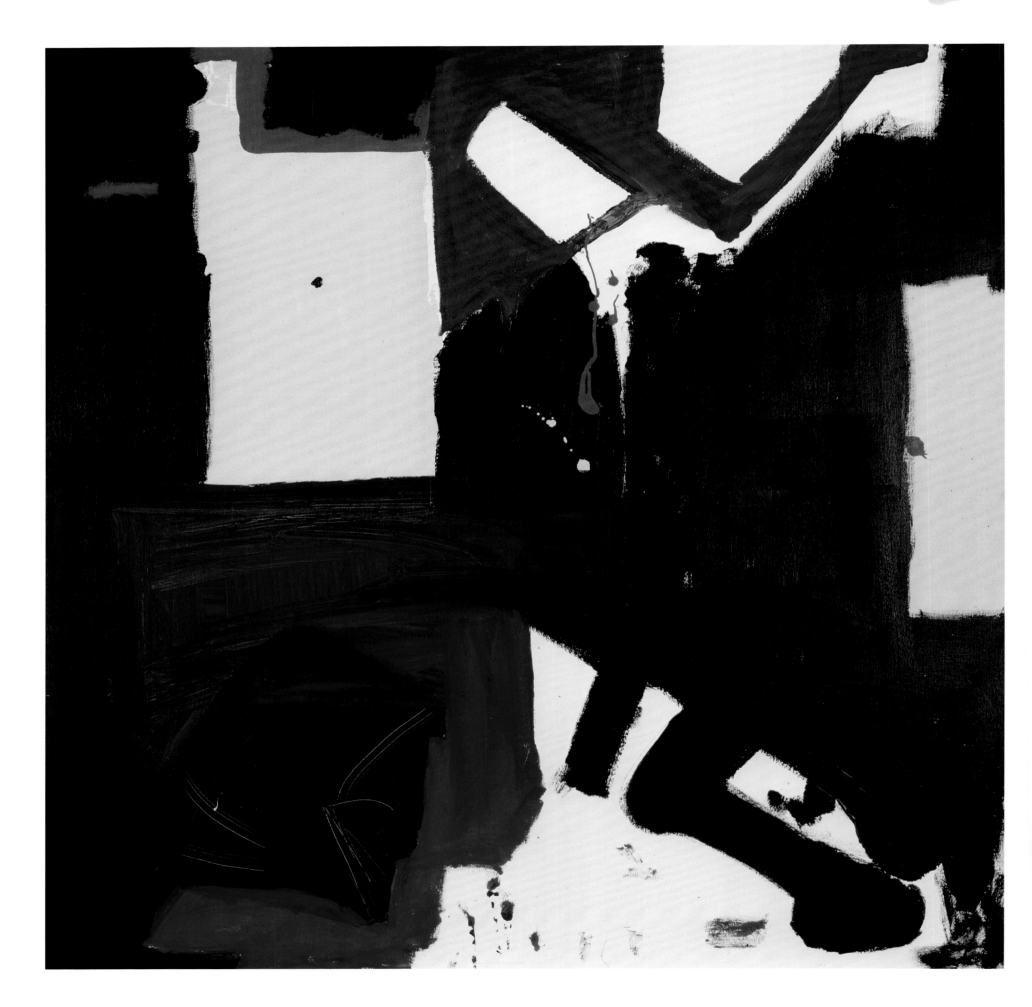

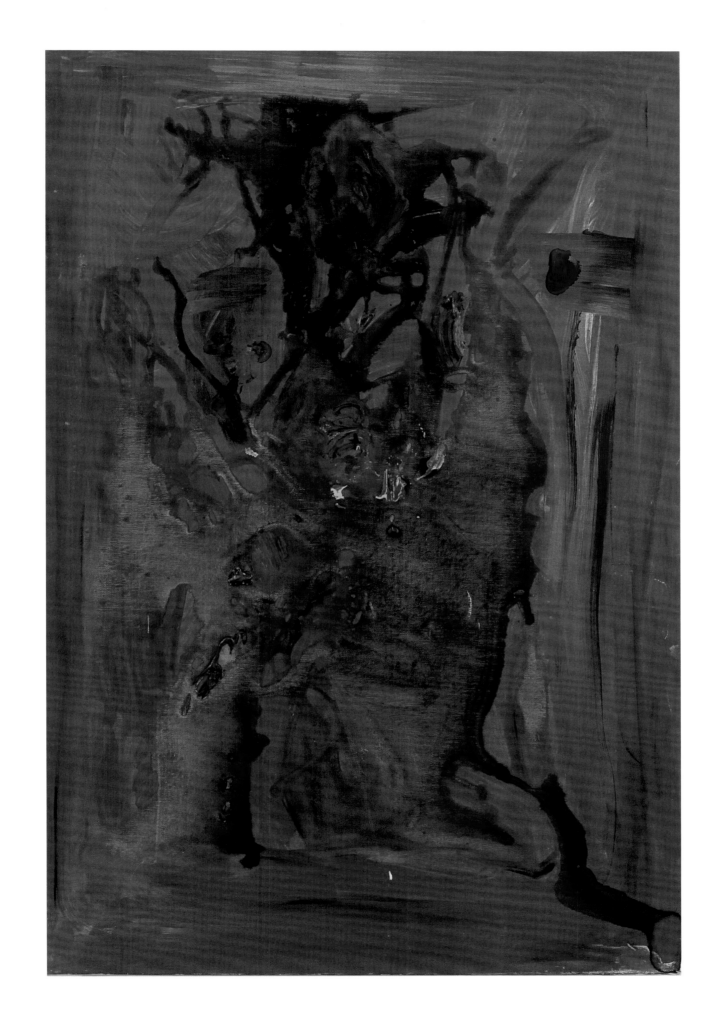

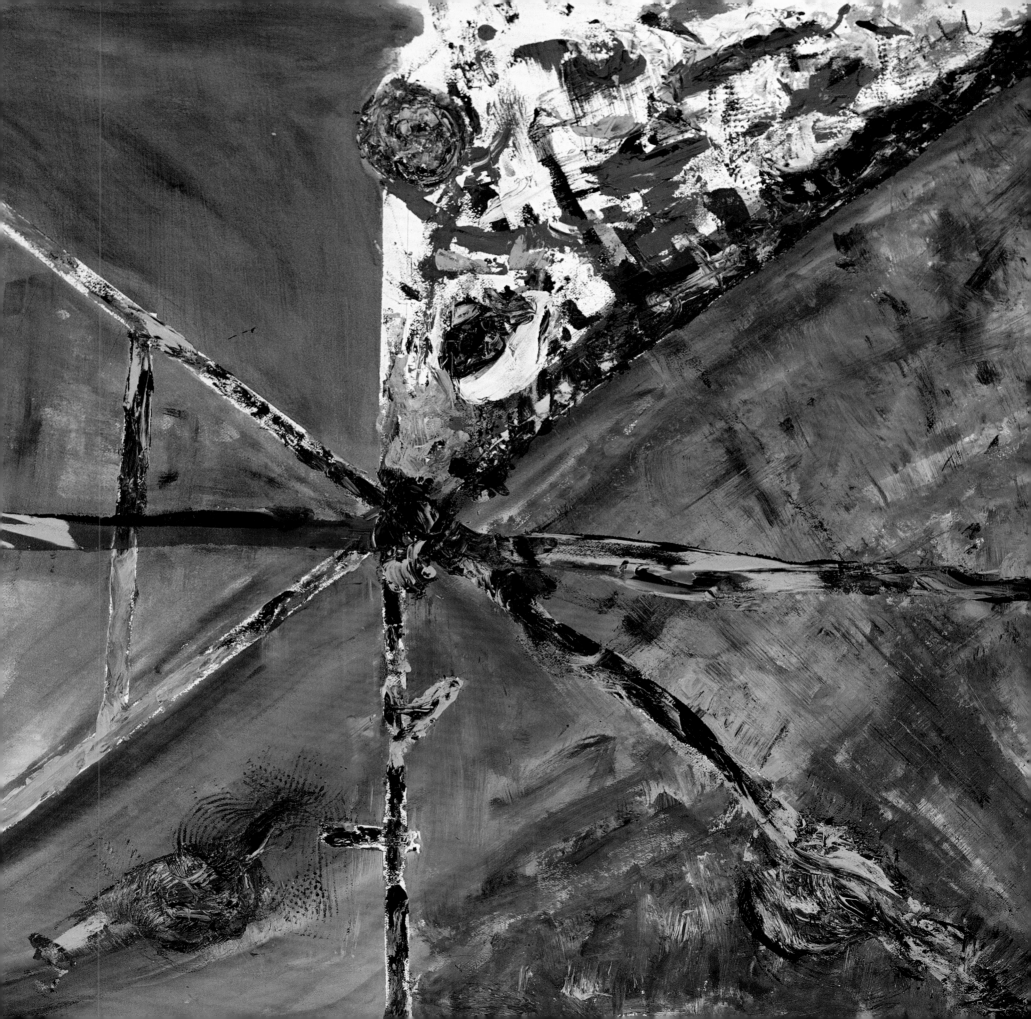

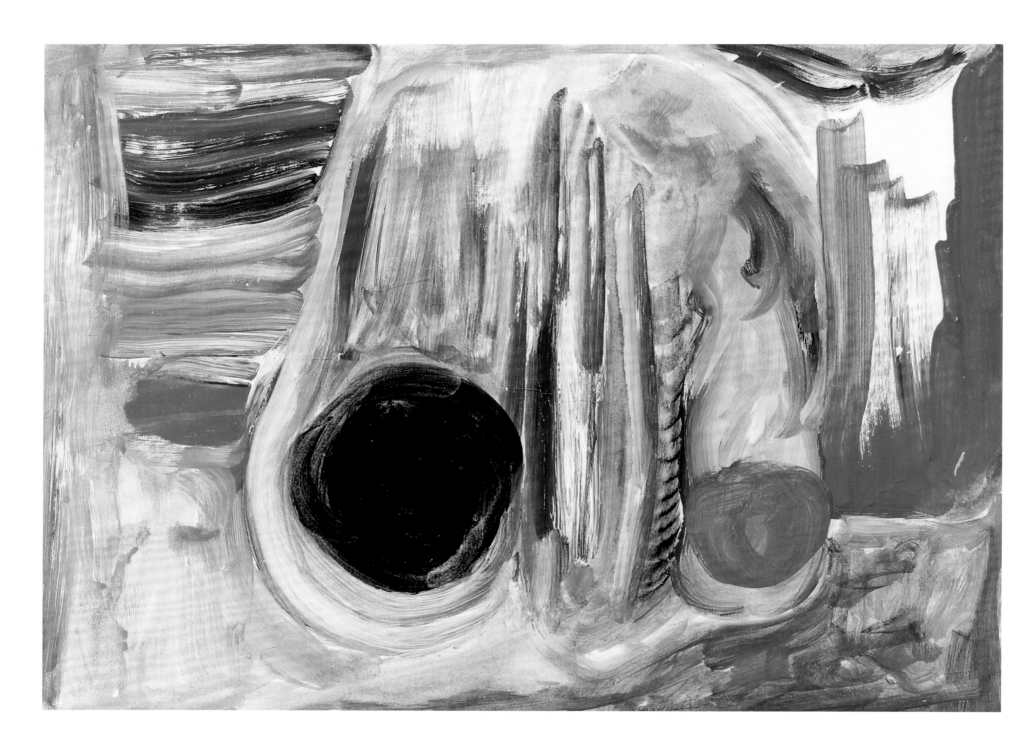

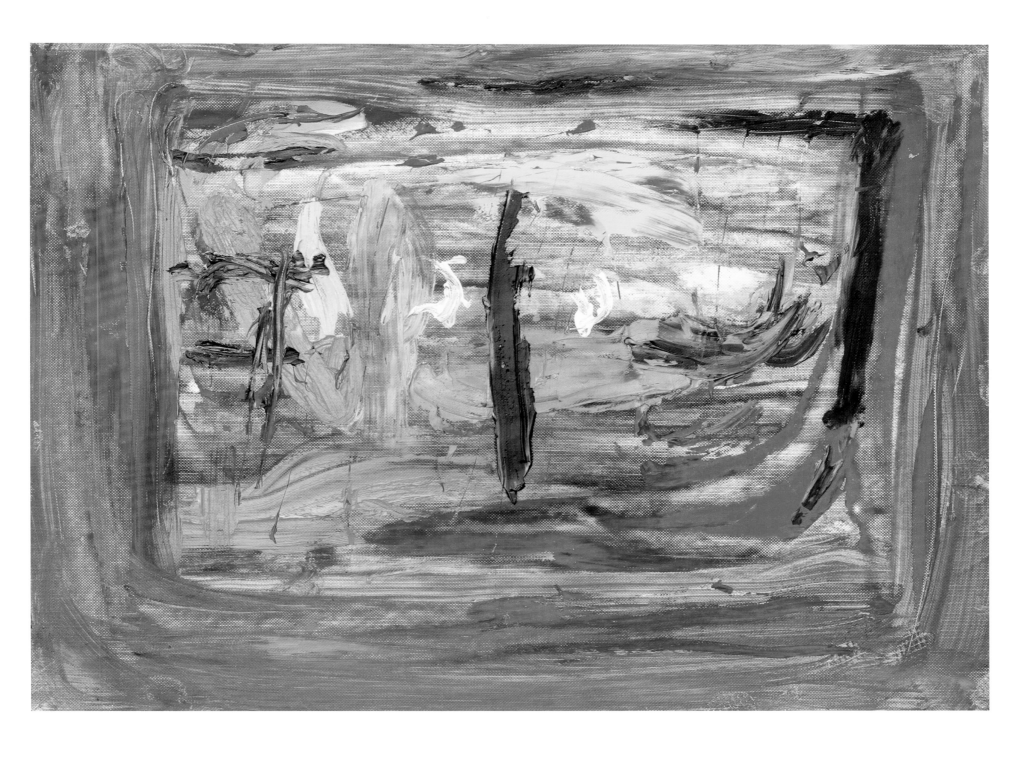

"But I've been through all those transitions. At one time, I was all puffed up. I weighed 155. My ass was big and round. So I started training as a boxer, and I would put on this rubber suit. I thought I was gonna die in that suit. And I would go, like, six rounds and my trainer would say, 'Give me one more with the rope, and one more with the heavy bag.' I would take off the suit top and sweat would just come pouring out. It took me six months to lose the weight. But that was a different body. Now it's the body with the bad hip and other things. You come to see certain signs. I went to the foot doctor, he said, 'You have to have this cut.' I said, 'Man, I know. Just fix it so I can walk!'"

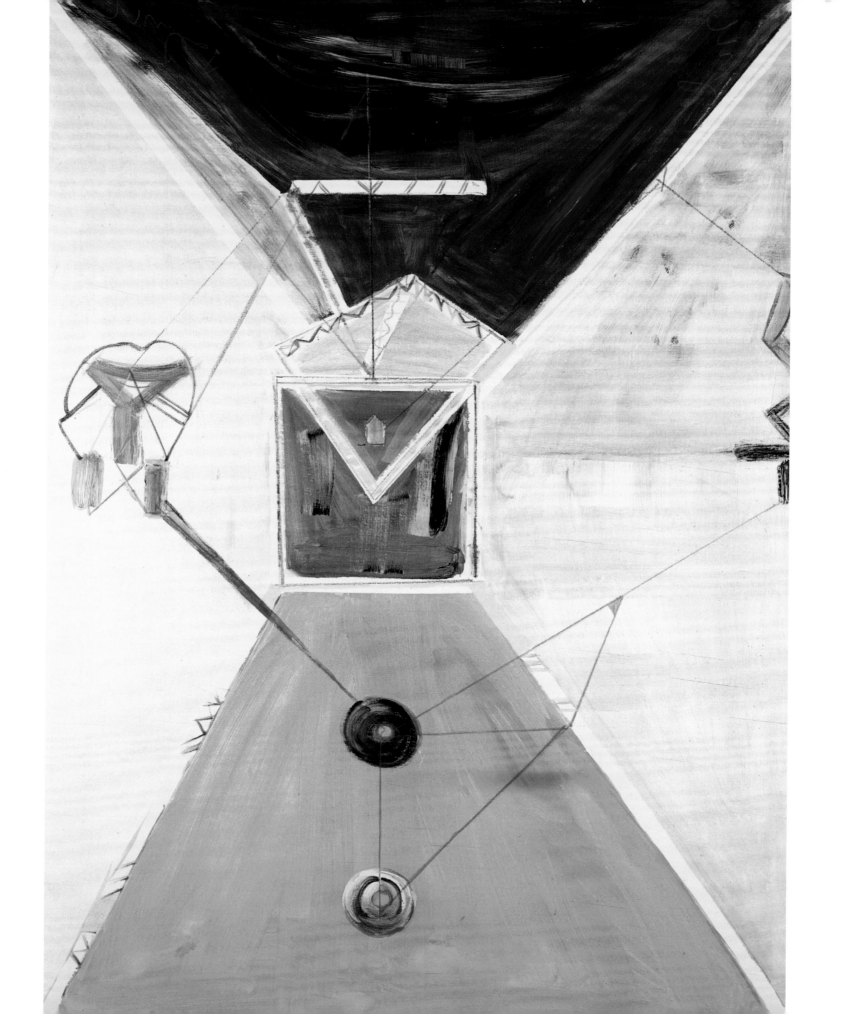

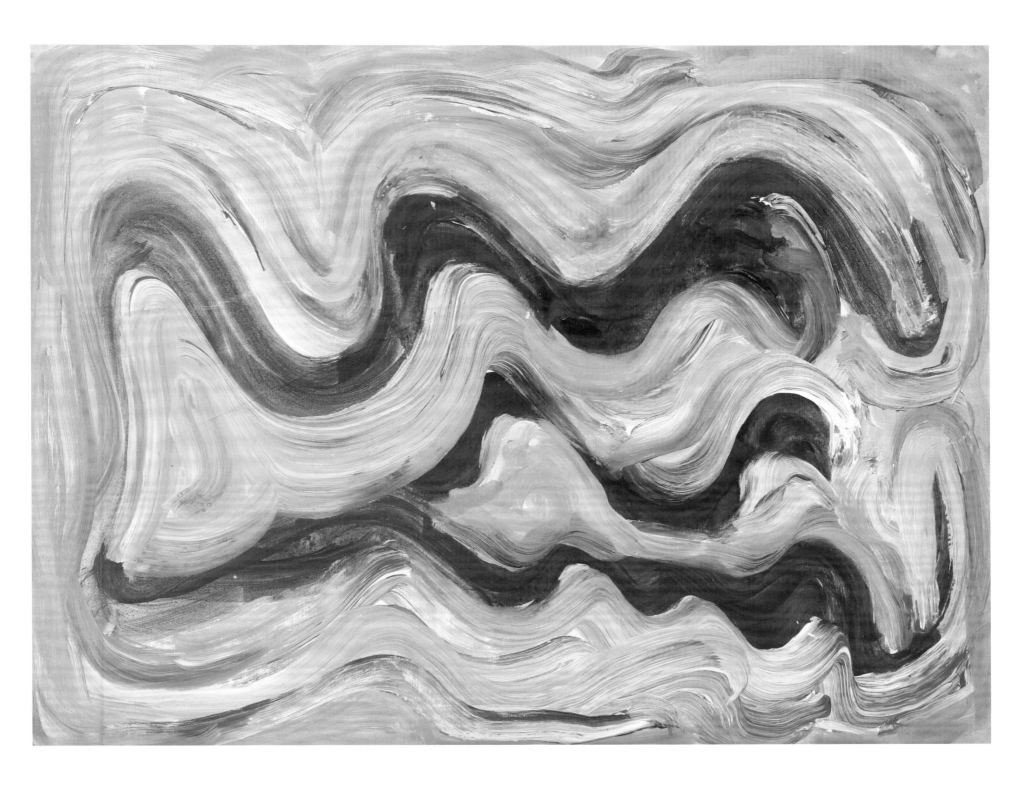

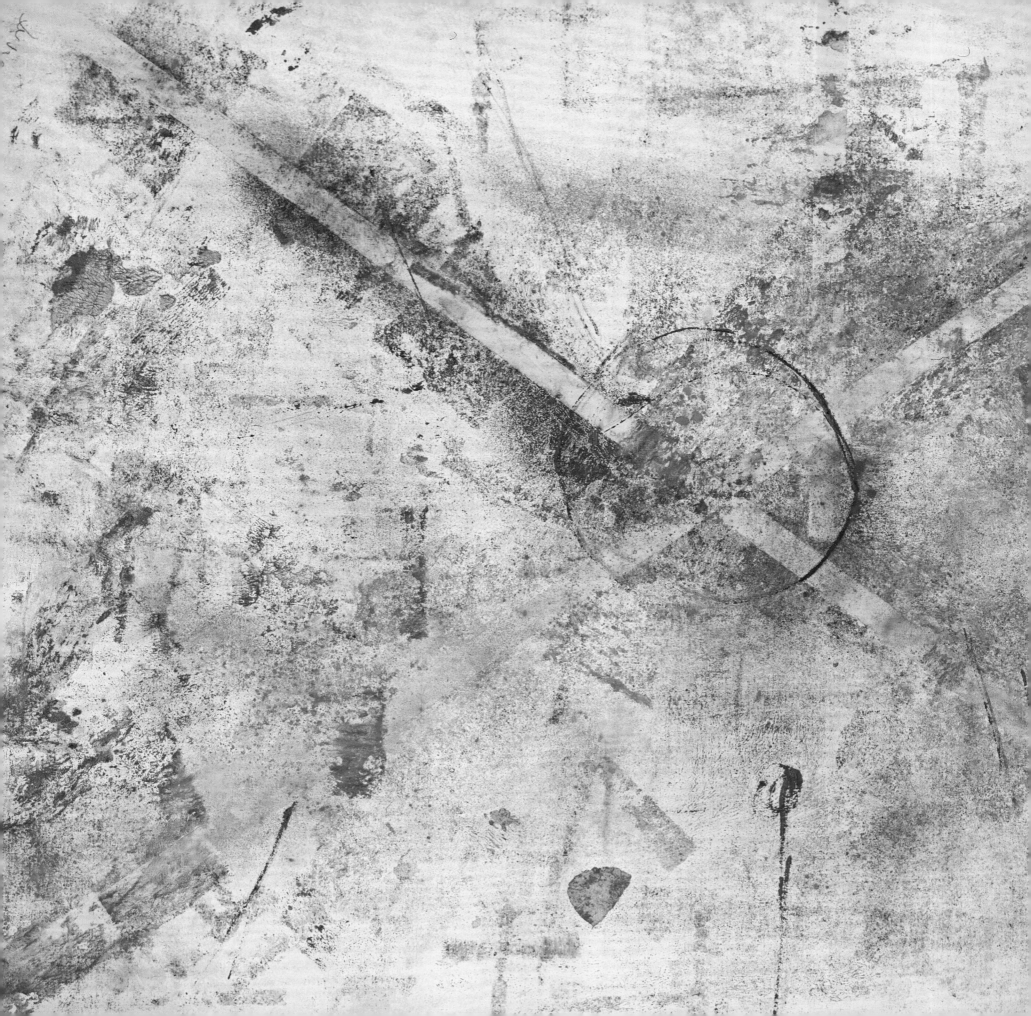

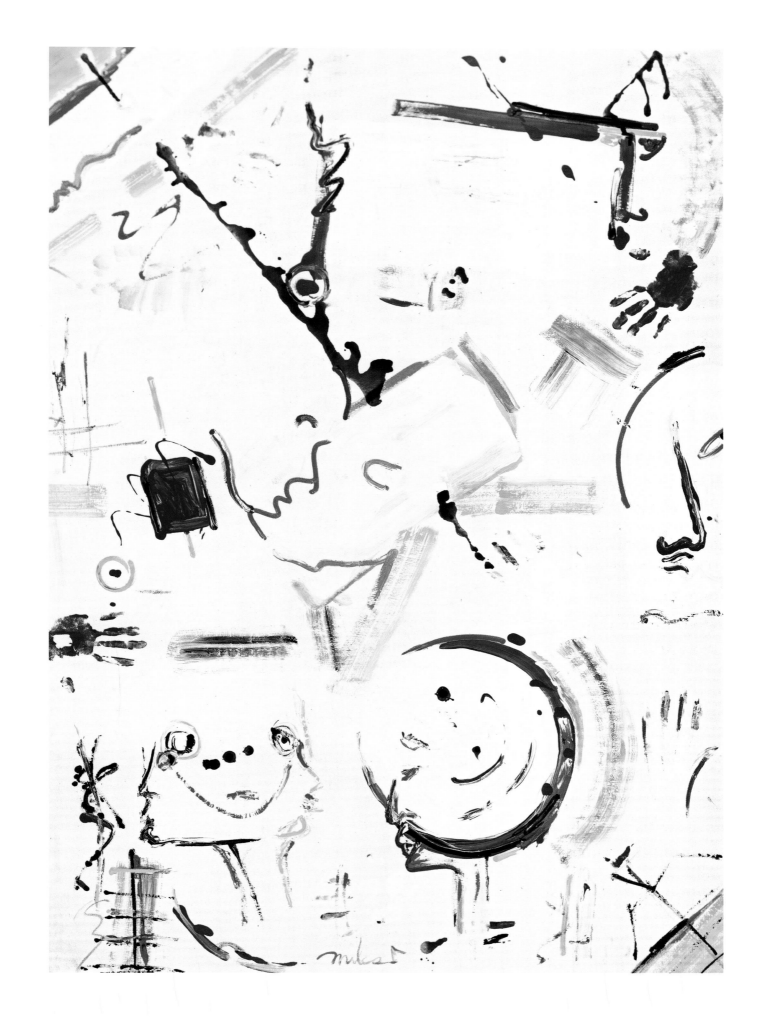

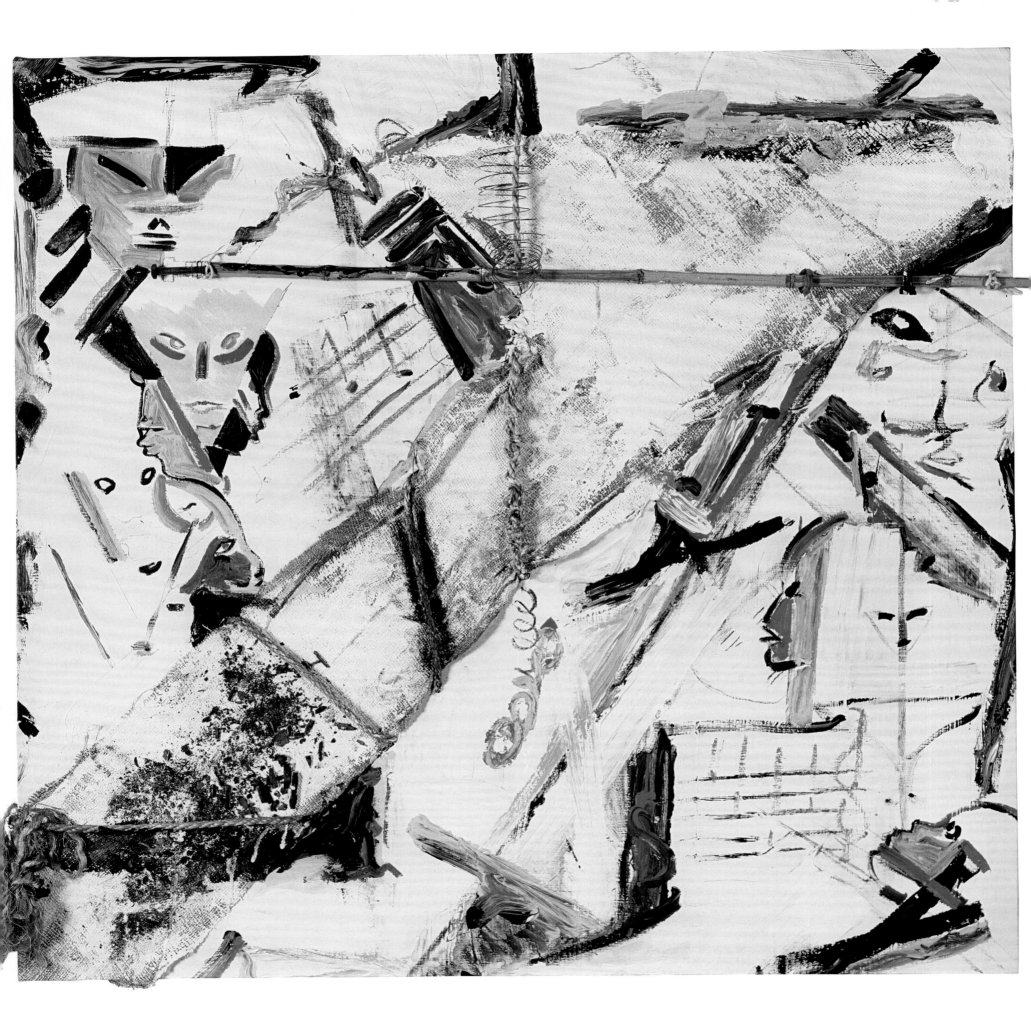

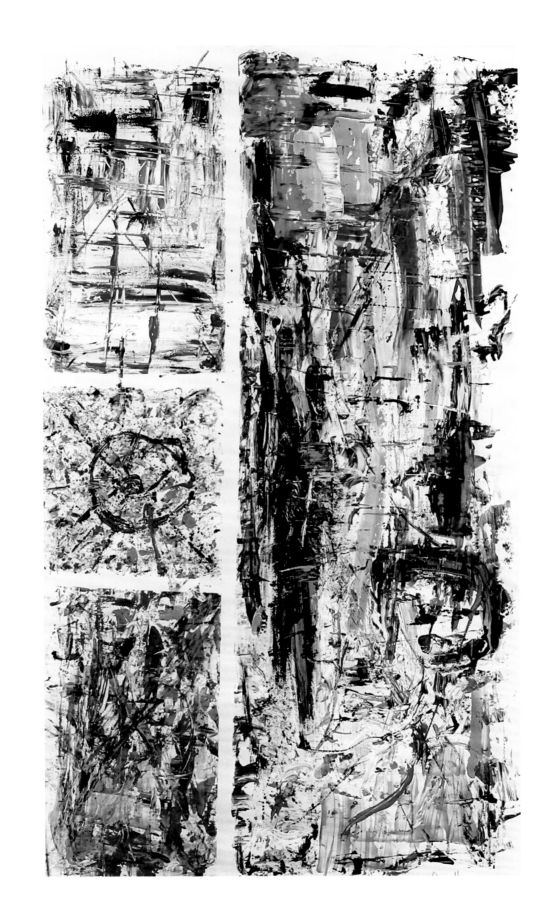

"I like to buy things wherever I go. Especially if I think I'm not getting enough money where I'm playing. My place in New York and my house in California are full of art. Even my garage is full of art. But I don't go to galleries too much; I just have people bring things to me. I bought several paintings from a guy named Jamaal. As soon as I saw his stuff, I bought it. The way he uses varnish and lacquer—I had never seen anything like it."

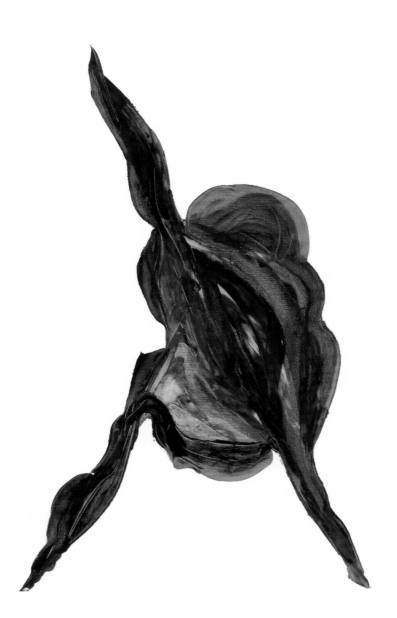

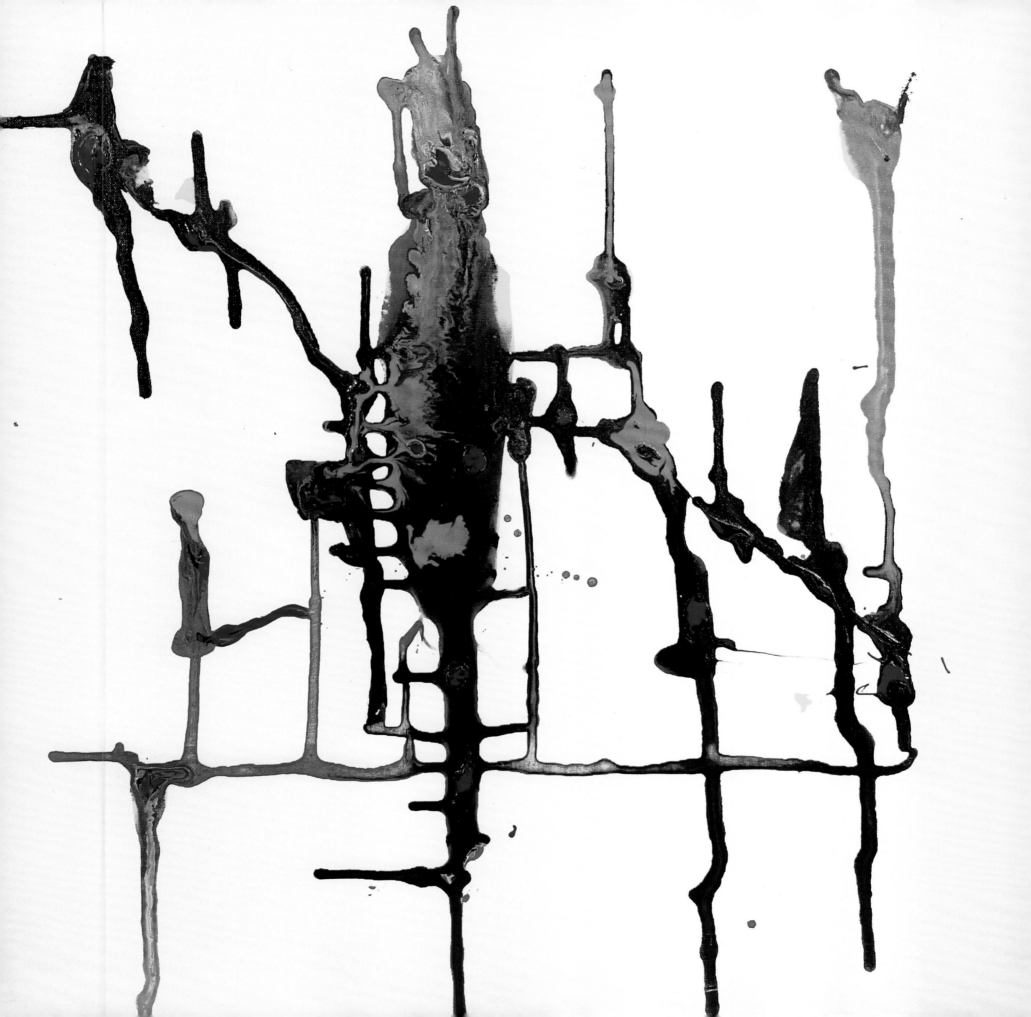

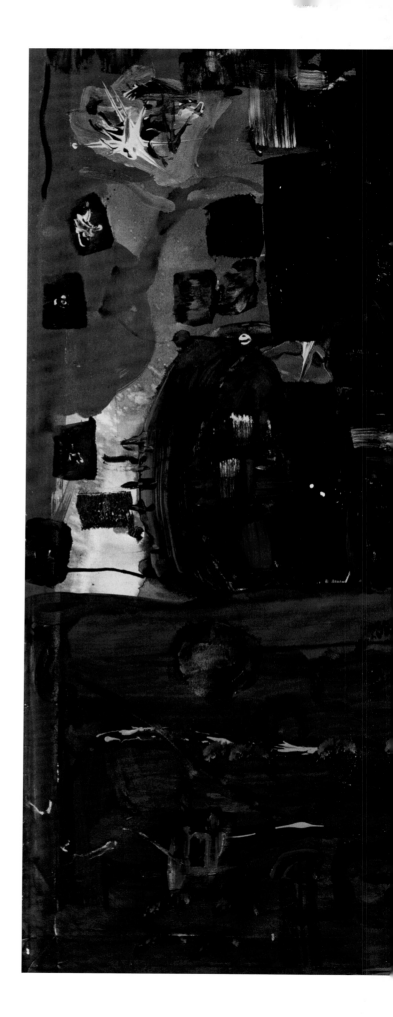

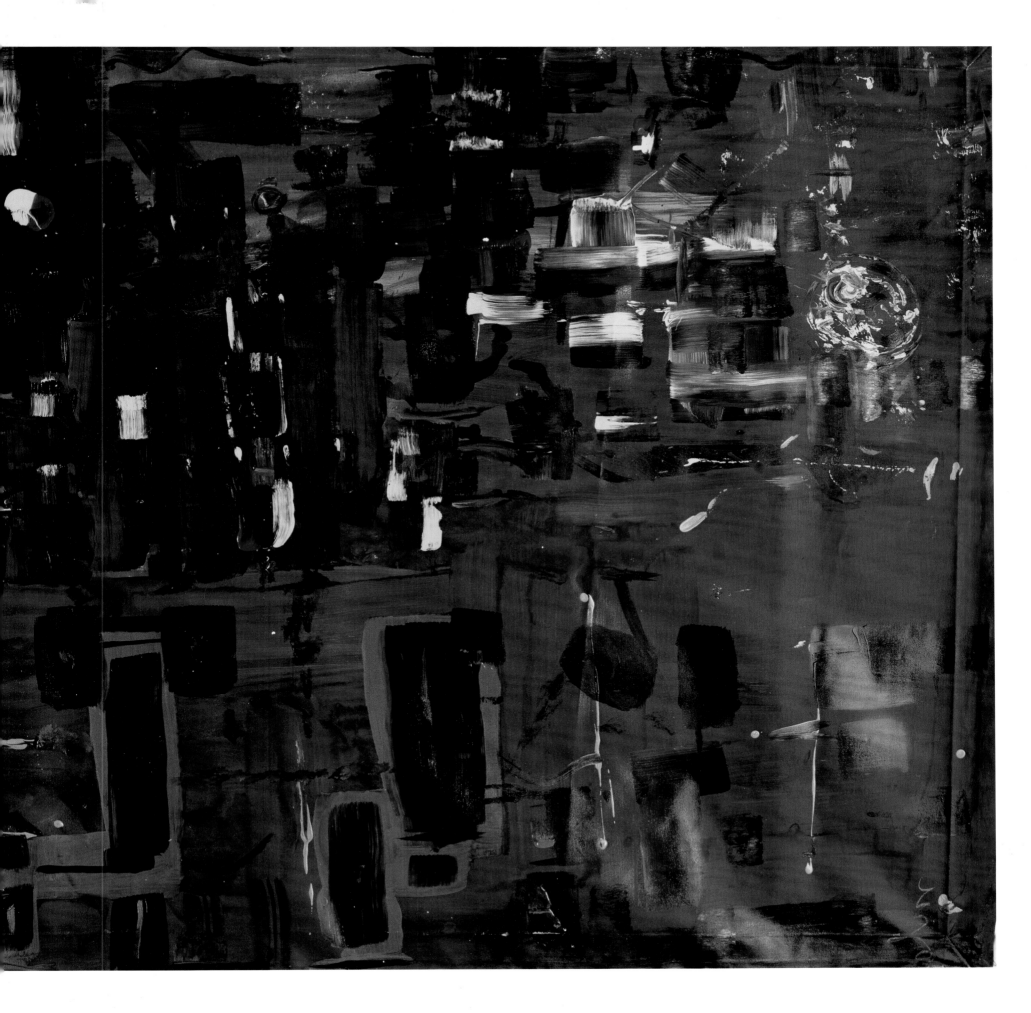

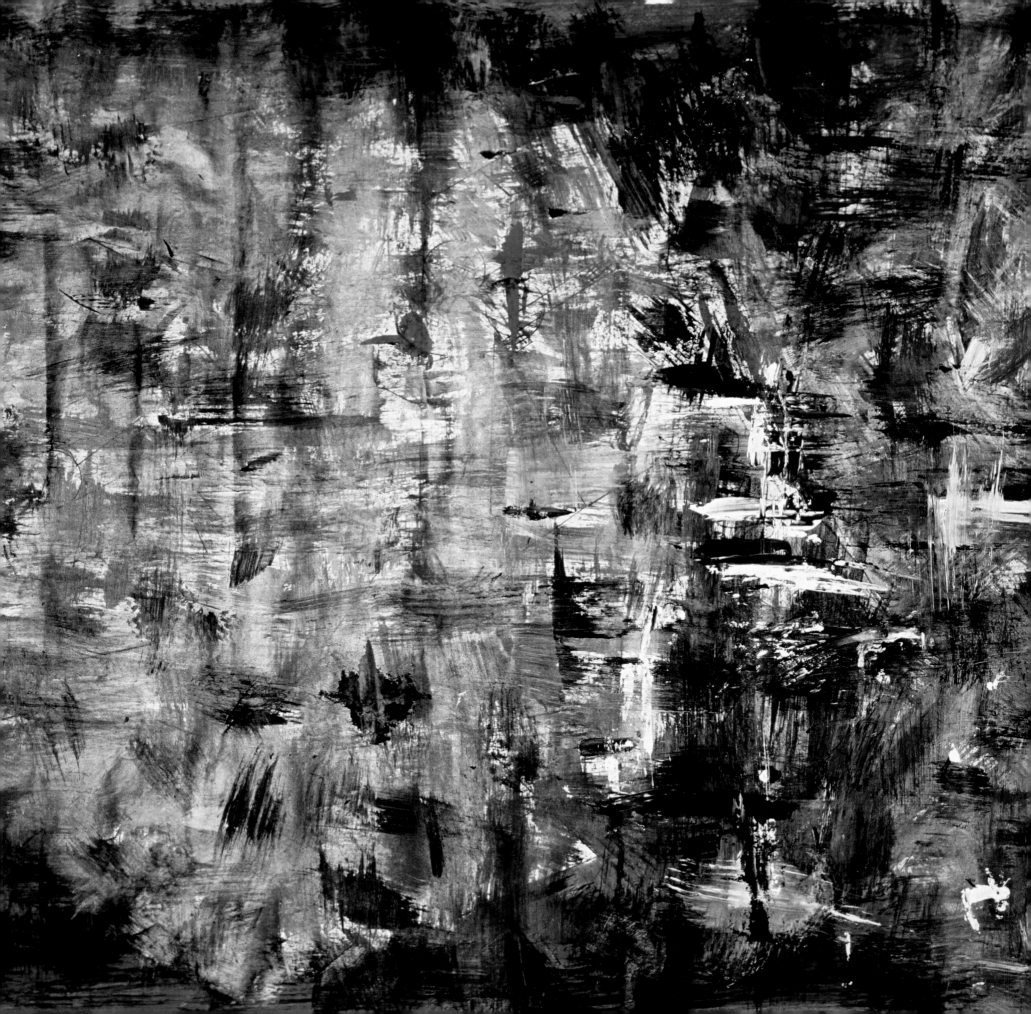

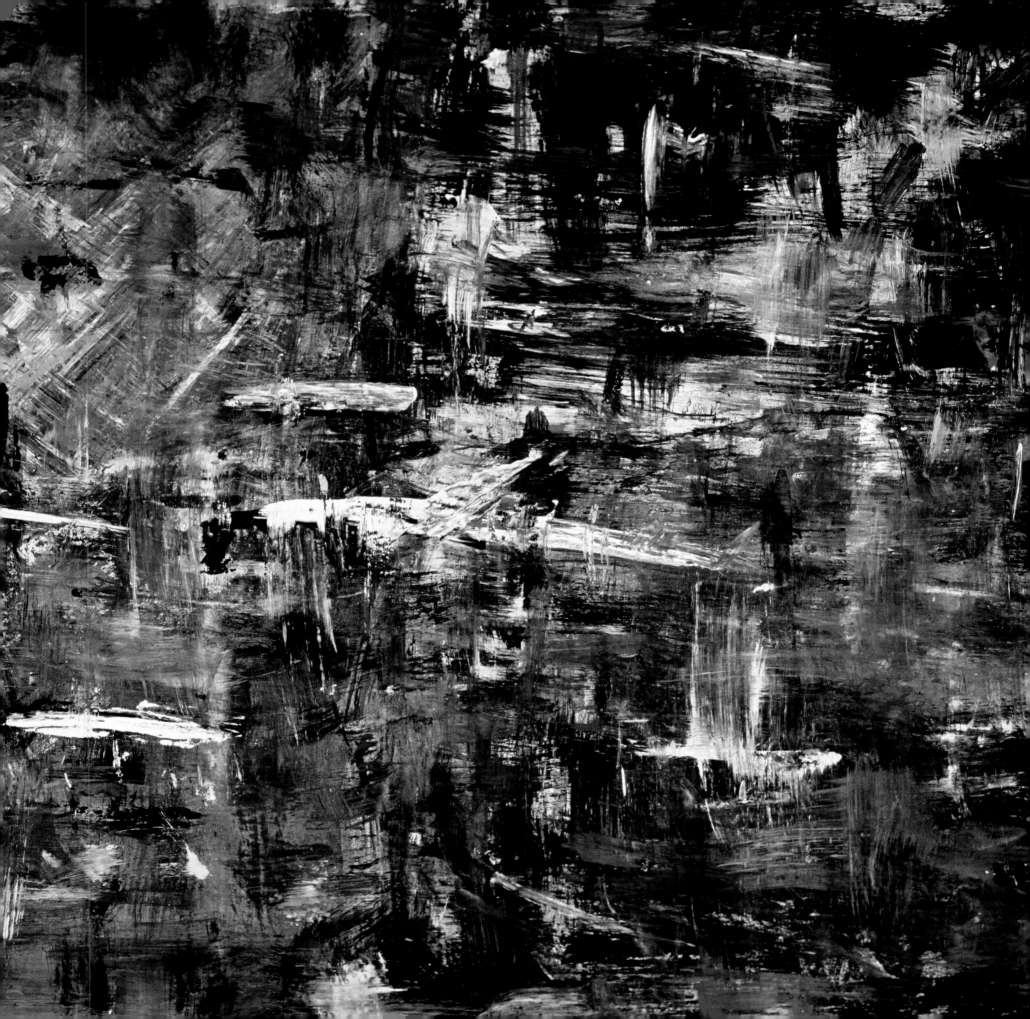

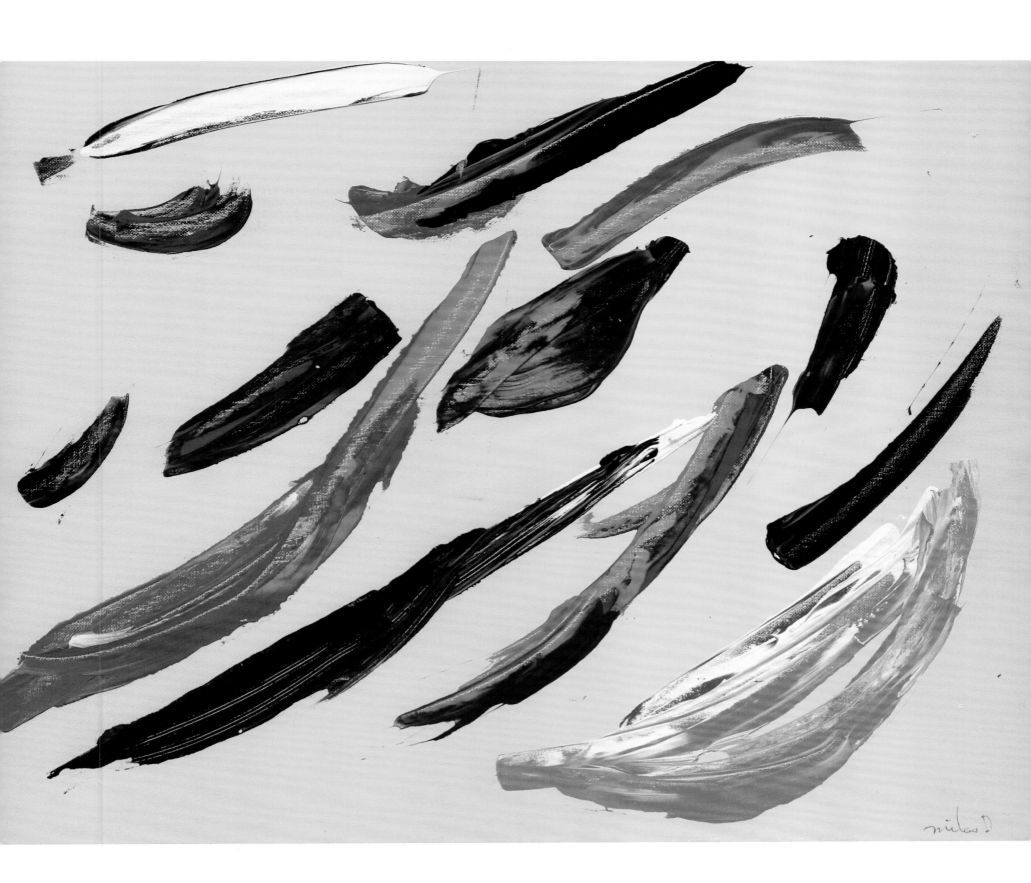

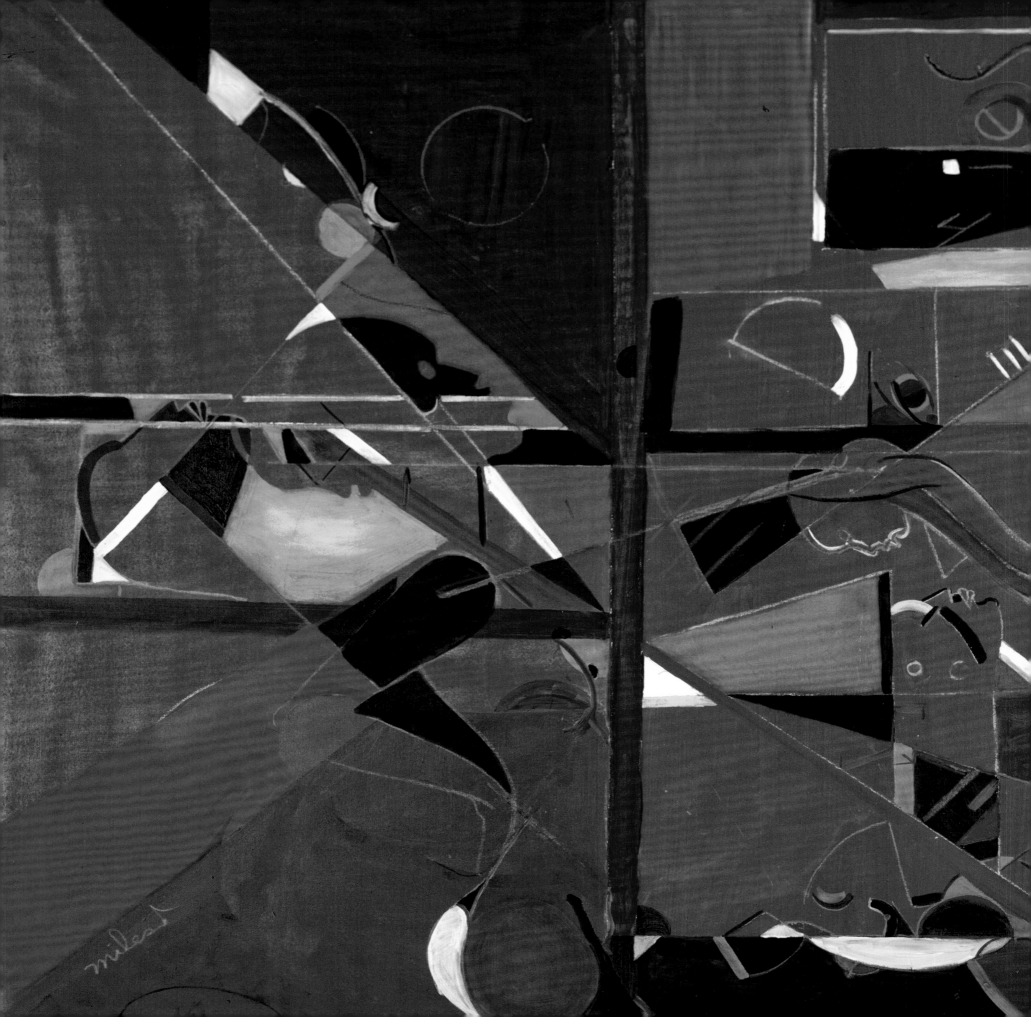

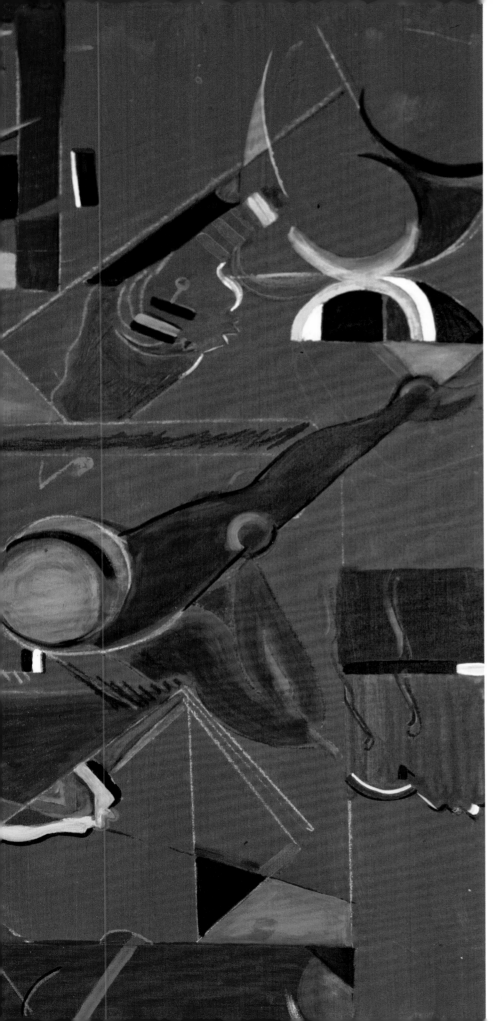

"I only listen to certain people when it comes to criticizing. I don't ask anyone who's going to try and tell me how much they know about art. It's like the same thing with music. A lot of guys write stuff, and they just want to let you know that they know the secret about Miles or that they know a lot about music. But I have enough people around me who know good things about art. Like one of the guys who takes care of my house, he's an art student. In fact, he did several of the paintings in my bedroom—he and I even did one together. I said to him, 'Mike, how do you like this?' He says, 'Chief, I like 'em just before you finish.' He was trying to tell me not to do so much. I called him three motherfuckers! But I heard what he was saying."

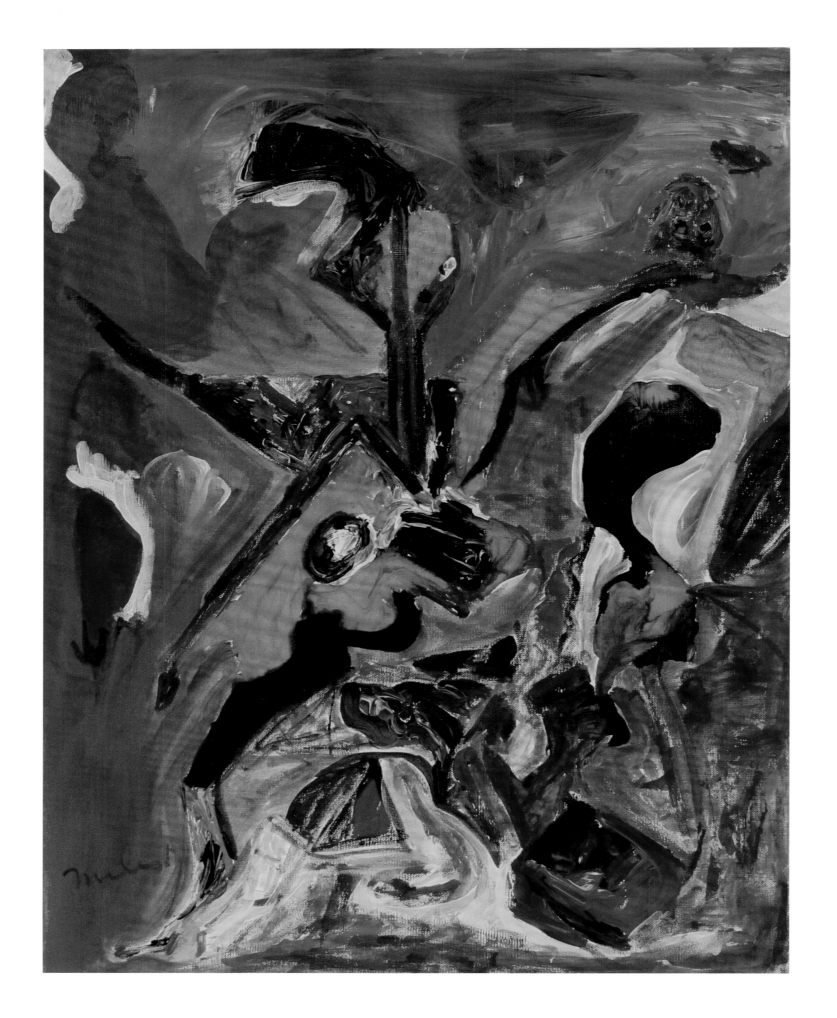

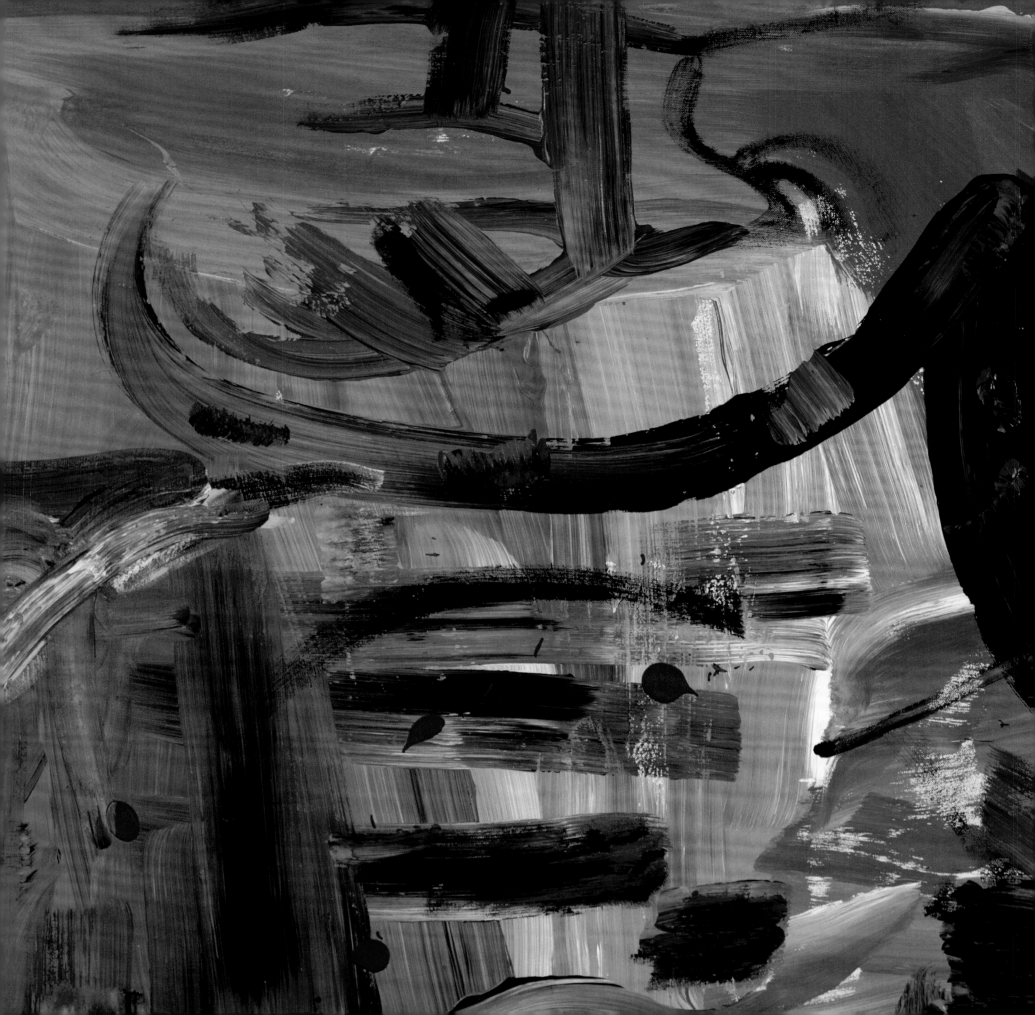

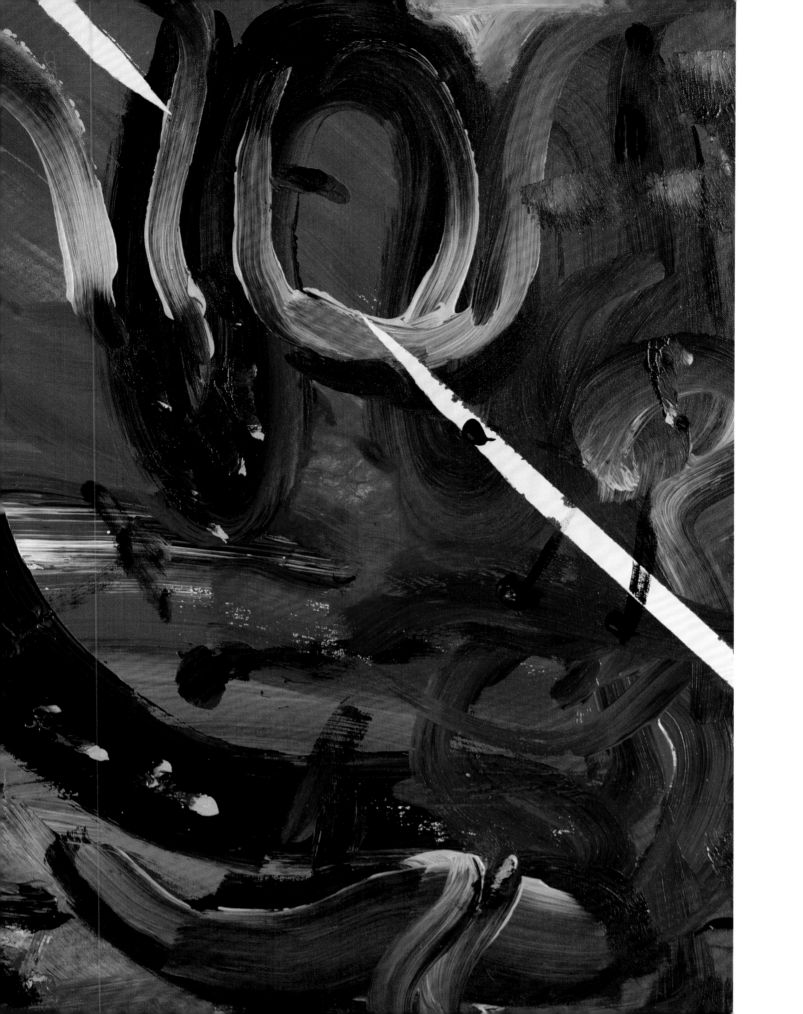

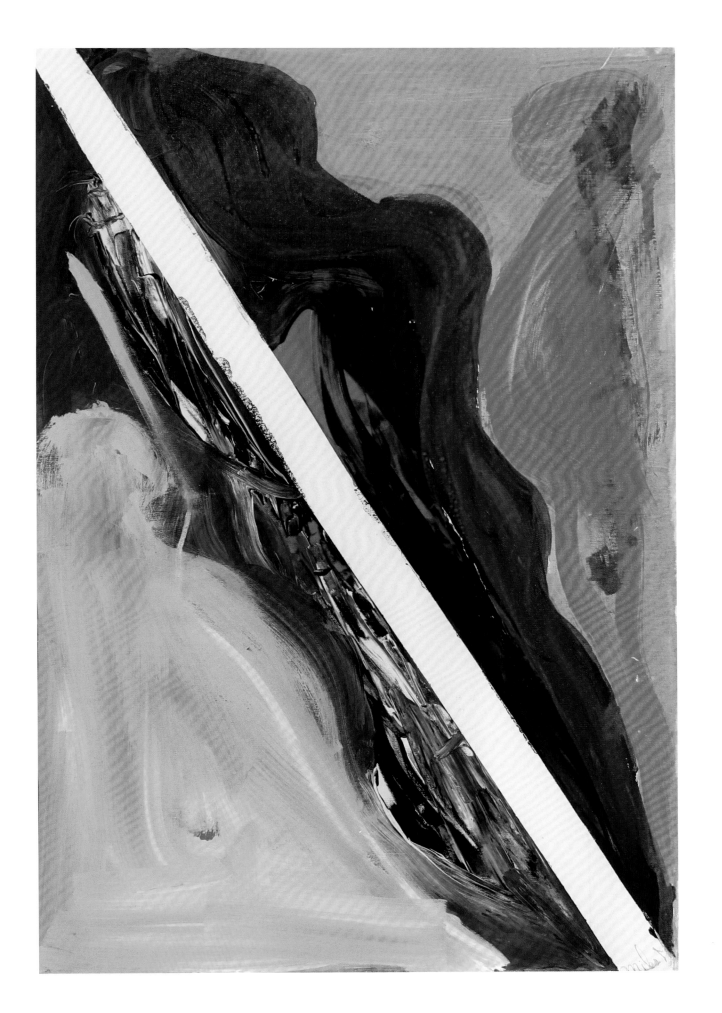

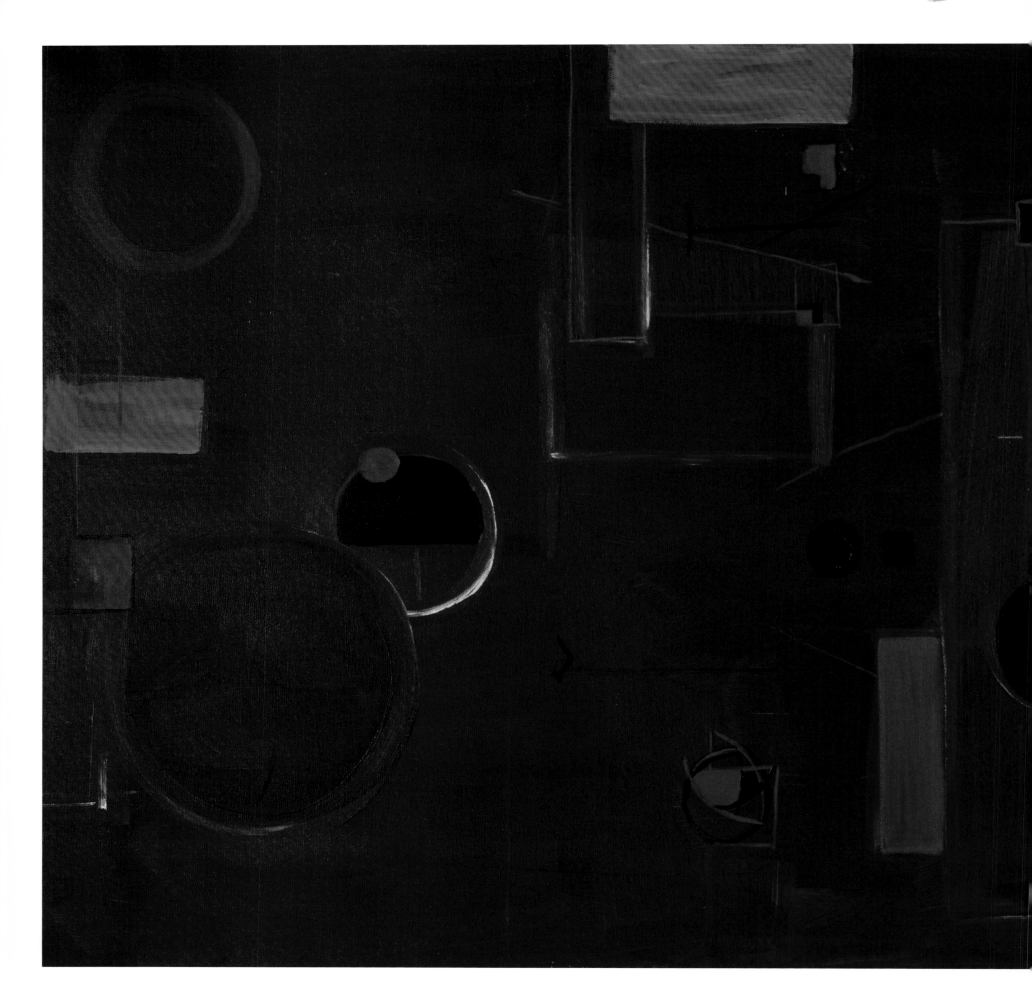

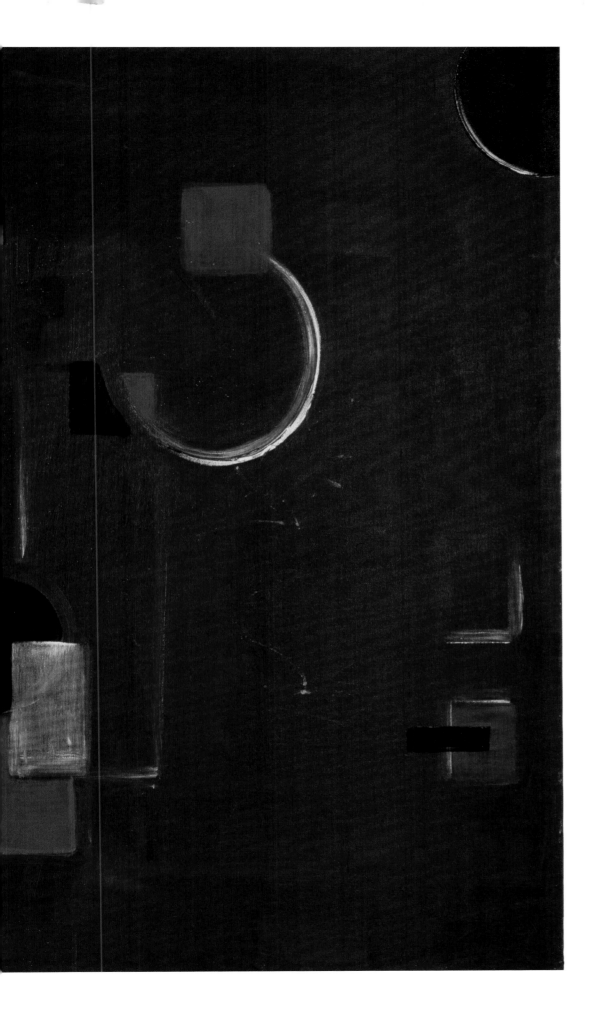

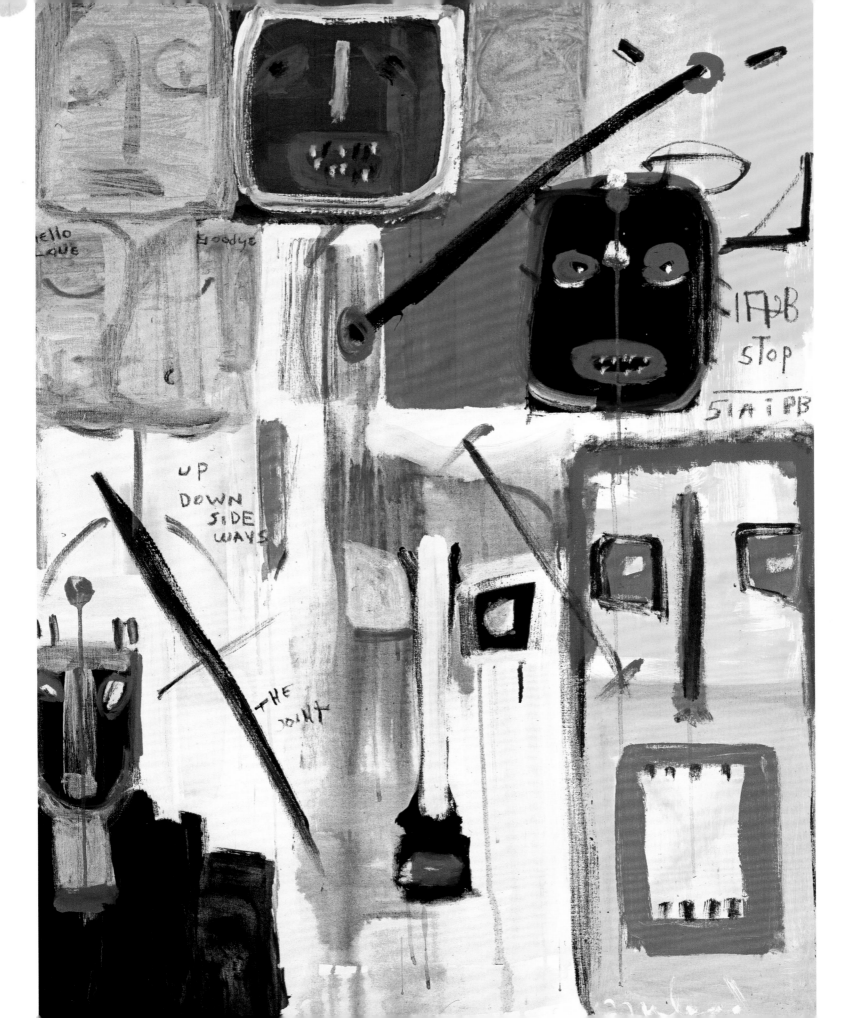

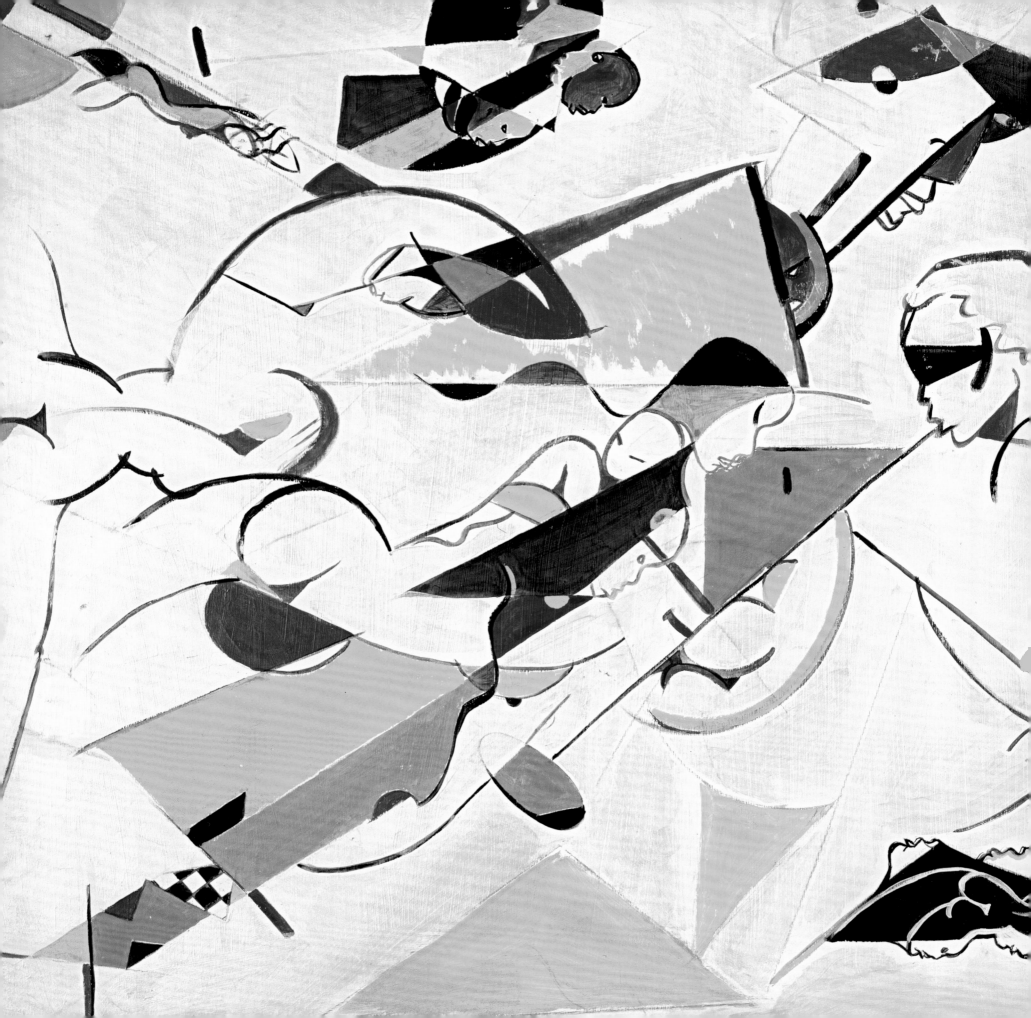

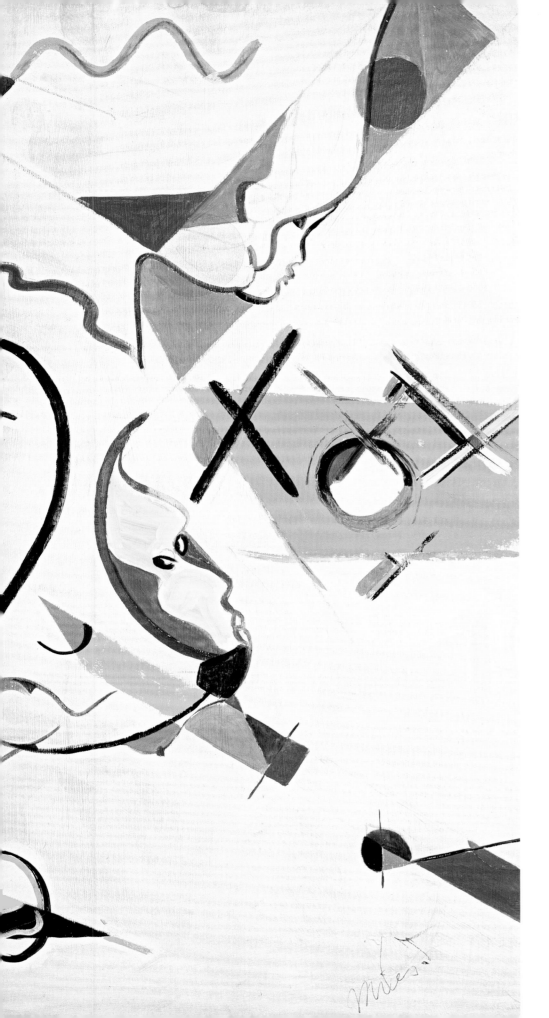

"It's very important not to spoil somebody's groove. You see, it's what you say to people, especially to an artist. For instance, I got a guitar player—people love him, but sometimes he plays the wrong notes. But if I want to tell him he's playing the wrong notes, I'm going to show him. If he says, 'Like what?' I'm going to show him. About two weeks ago I sat him down and showed him some things. He didn't want to ask me, 'cause he's so hip. I never said, 'What are you playing that note for?' I never said it. But I got tired of hearing him play D natural on blues in B flat. There's no D natural in the middle of the chord; it's always the minor third. He didn't know anything about that, or about diminished chords. He wrote me a nice piece once, but it only had two chords in it! So I showed him some diminished chords and just some regular sevenths, and I said, 'You put that here, and that here,' and we just patched it together. And that night he played it. He didn't get mad, I didn't get mad. I just figured he's been waiting for me to show him for two years."

"The way I do things, I just finish when I see what I like. I don't really plan anything in my paintings. Some people might do it that way, but I can't. If I plan something too much, it'll come out looking like a map. I'd rather work from inspiration, and I usually get inspired by the colors themselves."

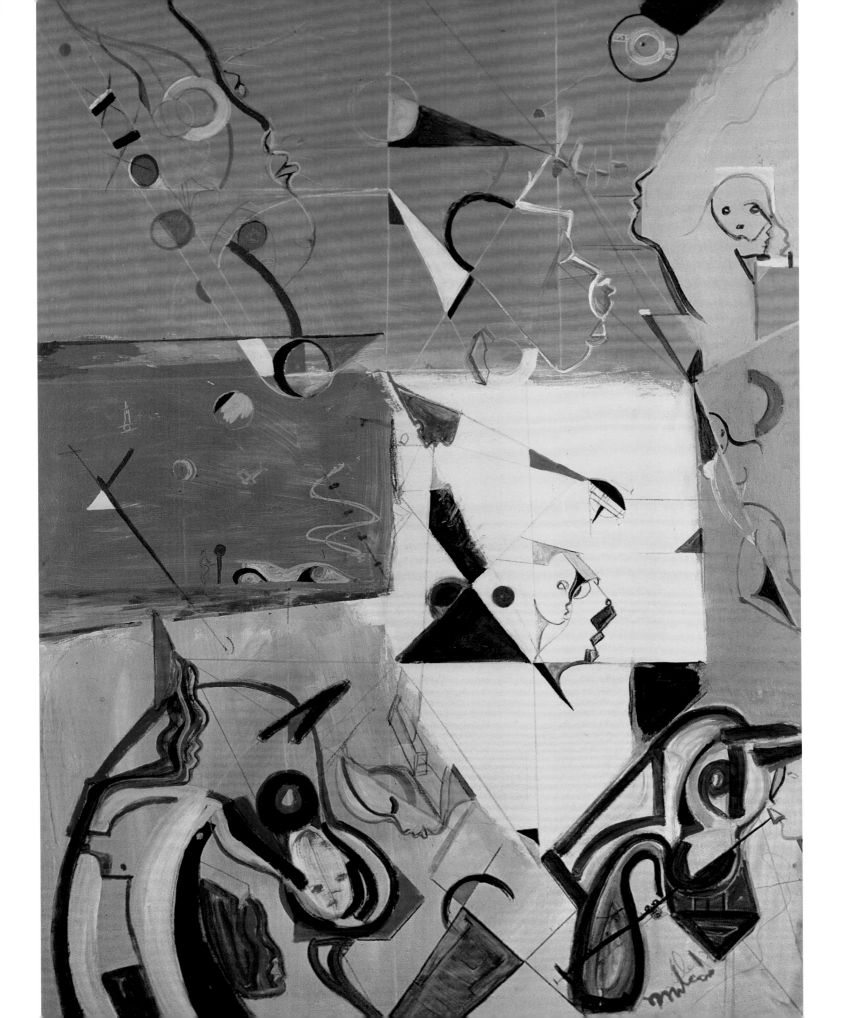

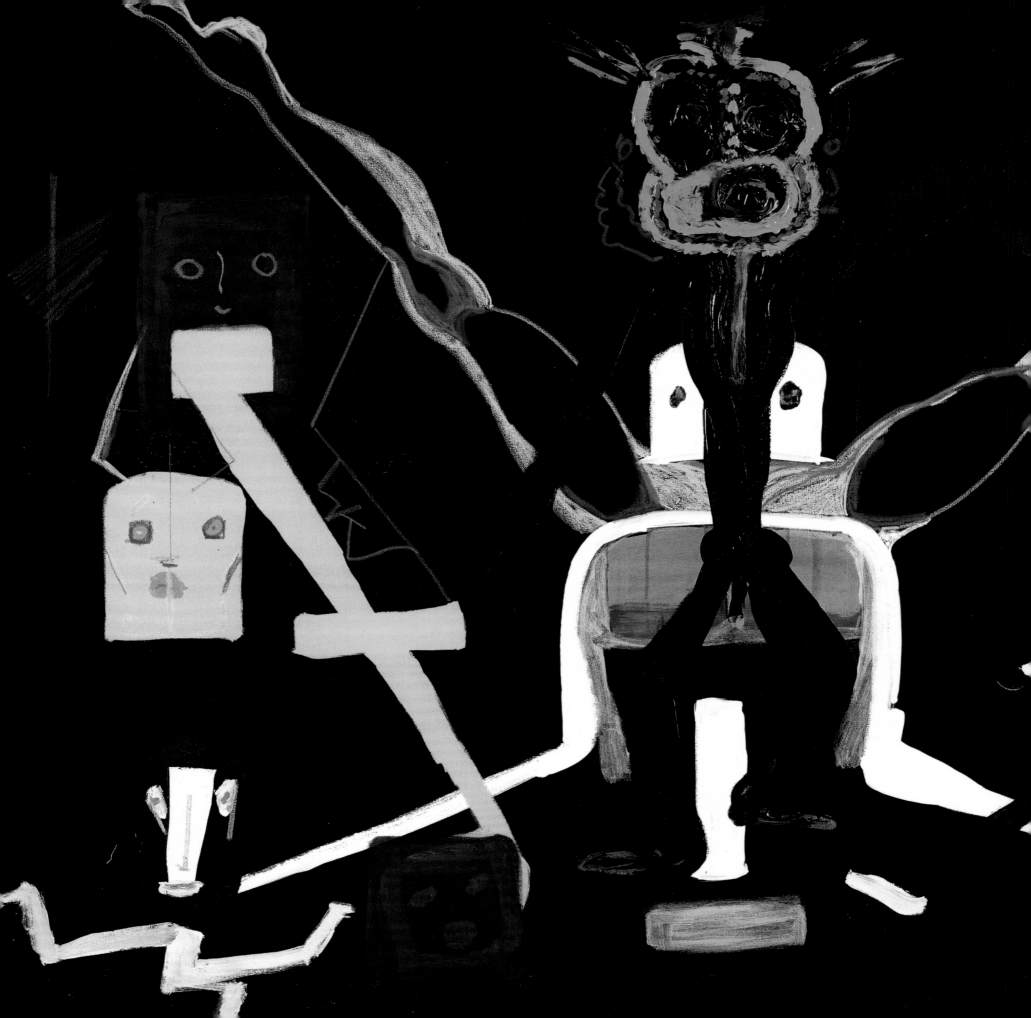

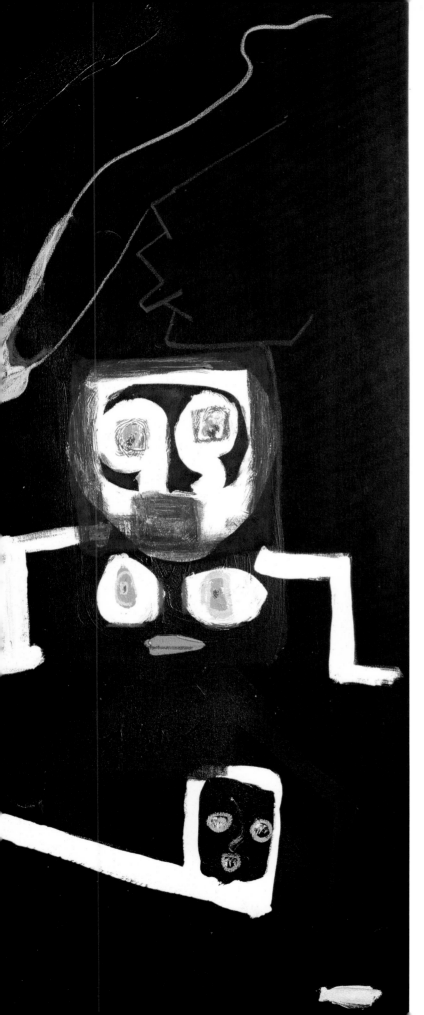

"But you can really spoil people's thing, saying, 'Whadja do dat fo'?' Or 'You'll never be anything.' My mother once asked me, 'Why don't you go to work in the post office?' I left home, even though I knew it was for me to be next to her. See, I never could tell people things like that. If someone is going to throw a ball or something and you say, 'What the fuck are you doing?' it'll fall on the floor."

"I'd give my paintings away, but my lawyers won't let me. Friends of mine were the first people to start buying up my stuff. Quincy Jones got one. And Lionel Richie works near Quincy, so when he saw Quincy's, Lionel wanted one and then another one. That's the way Courtney Ross [wife of Warner Communications chairman Steve Ross] came to own one. She saw one I sent to Quincy, and while he was thinking about it, she saw it and wanted it. I also did one for Prince. It's a great one, too. I did him like a totem pole, real narrow."

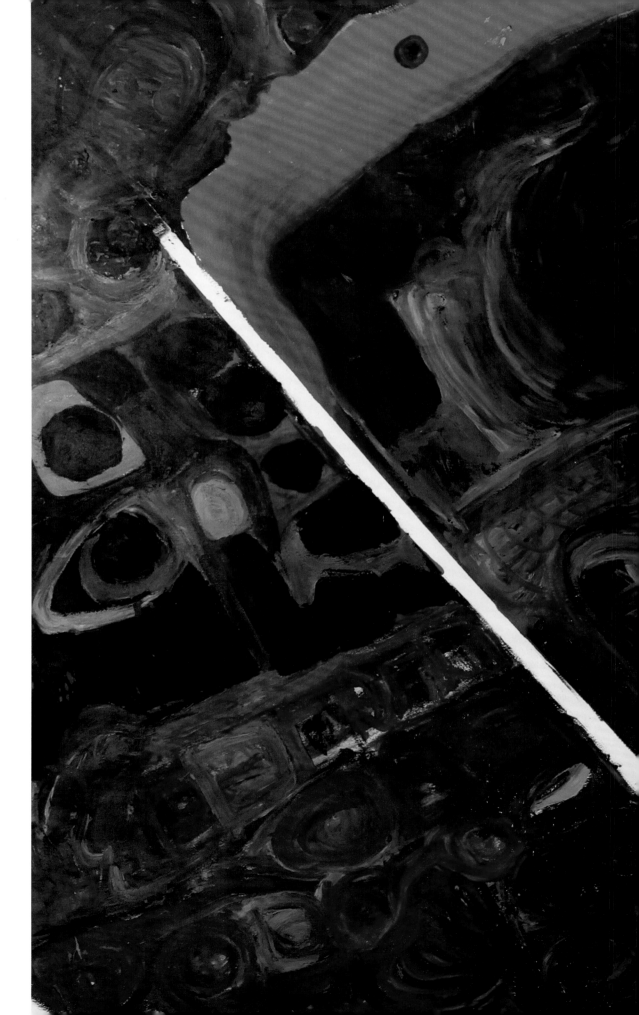

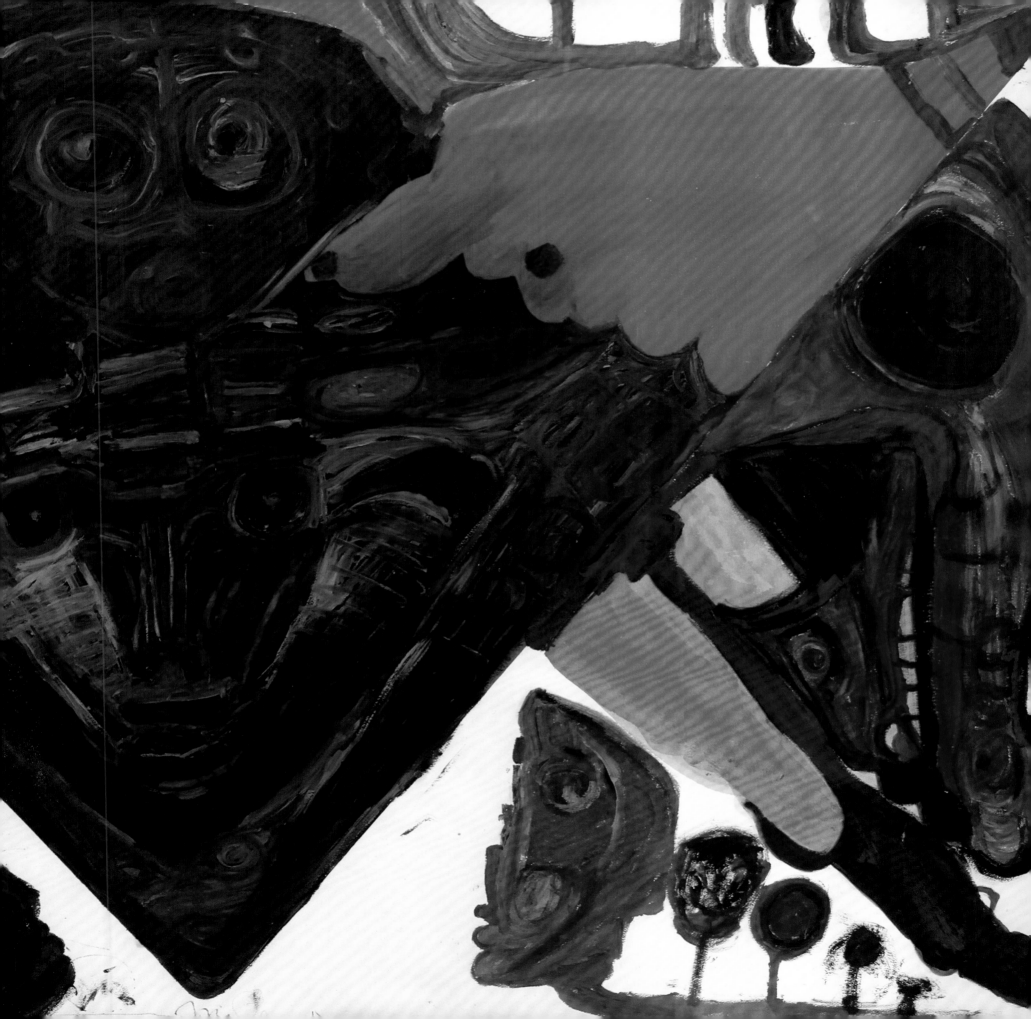

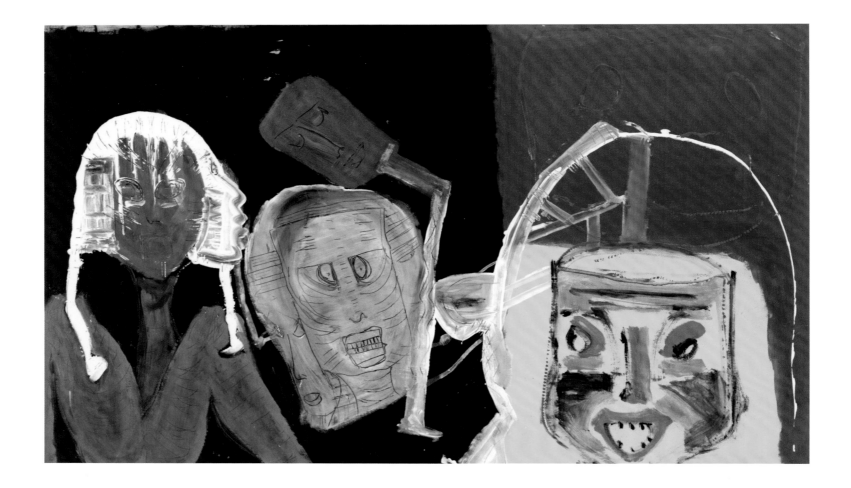

"If I have a canvas, I look at it like I would an arrangement. It has to be balanced. I have to have something going this way, and something going that way. I try to do it like the guy I used to work with all the time, Gil Evans. I can put my head inside his and do things the way we used to do. Most composers, when they write, if they're moving something, most of them take the notes of the scale and use them like checkers. But not Gil. Sometimes there'd be contrary motion from maybe two melodies. He'd run 'em right together. And it would come out, you know, like one of Picasso's things—balanced and modern."

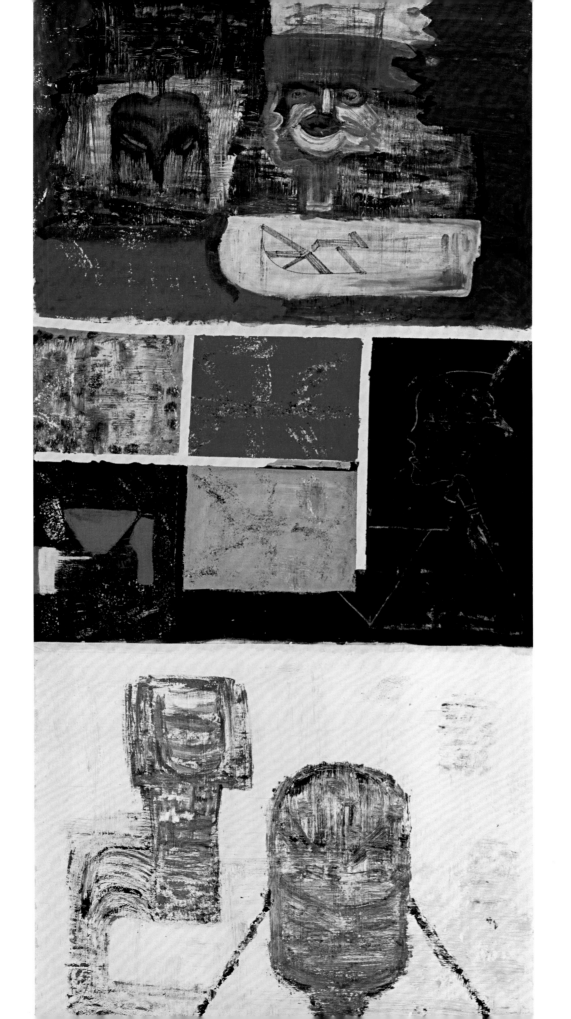

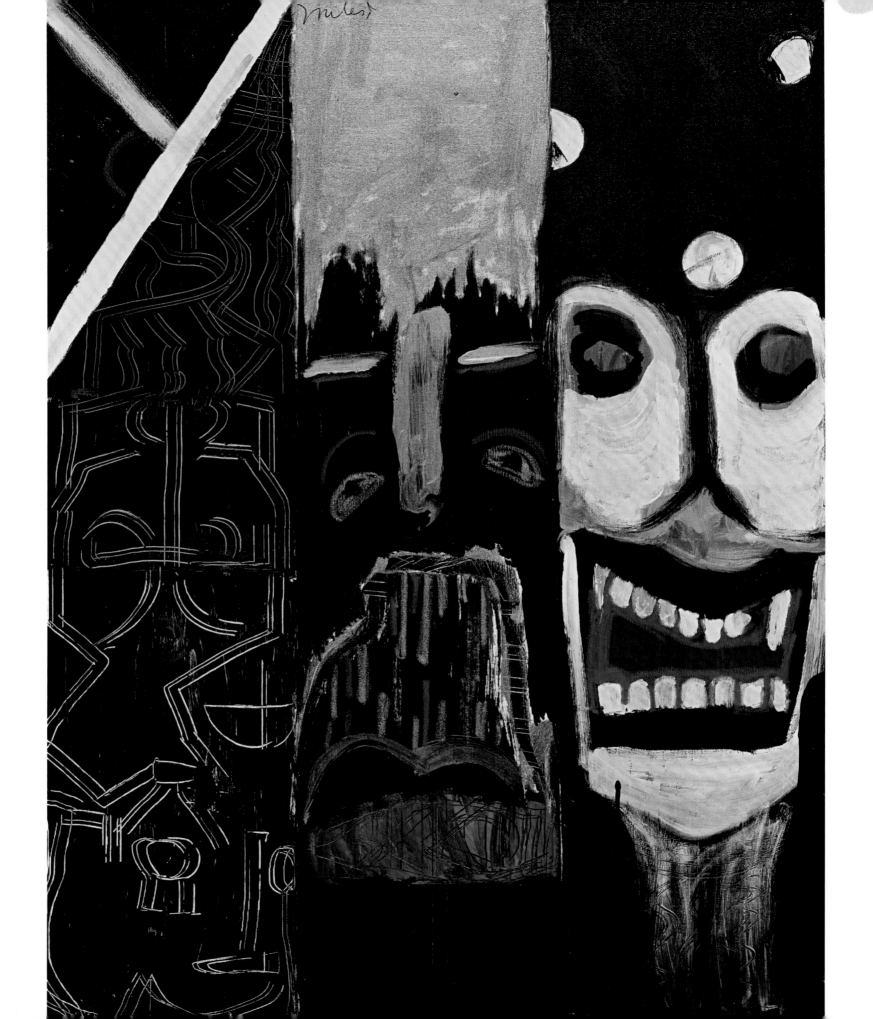

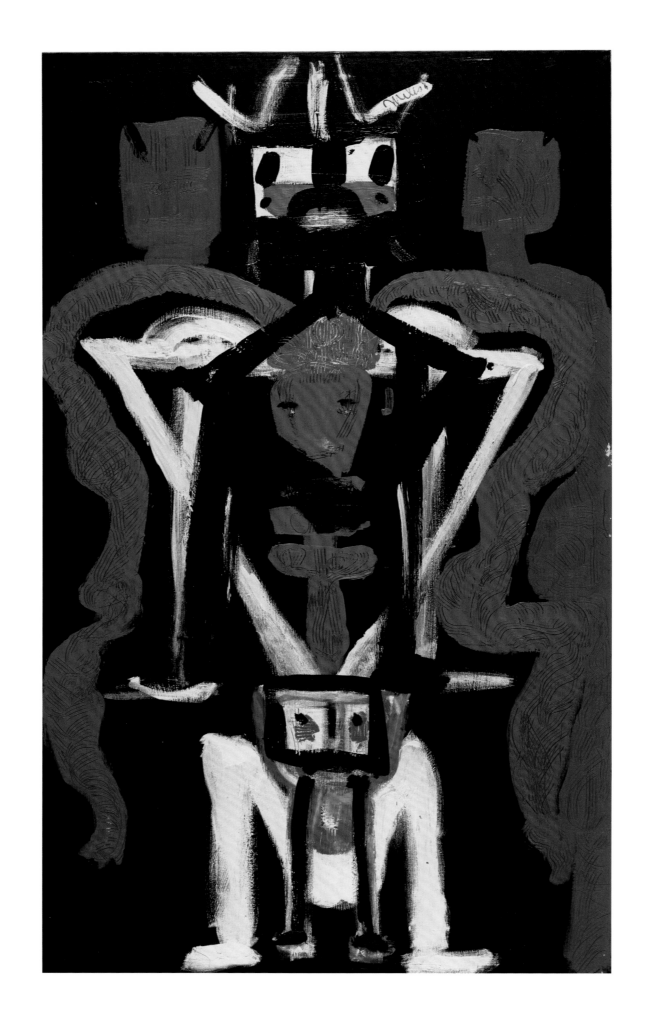

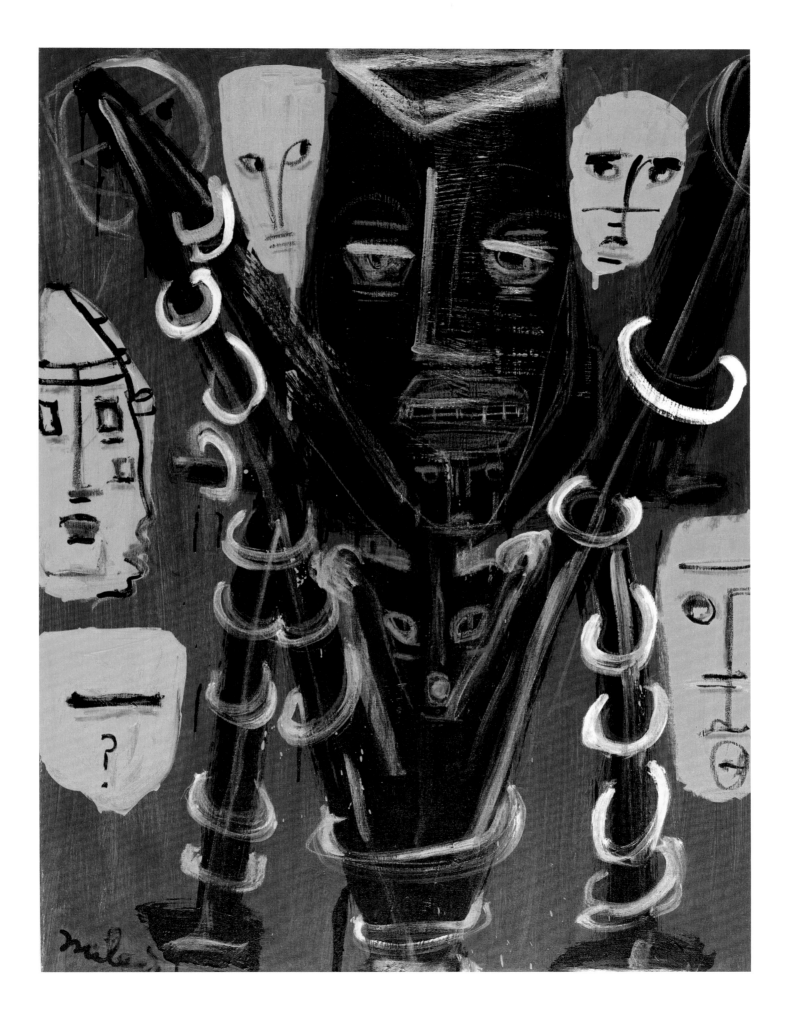

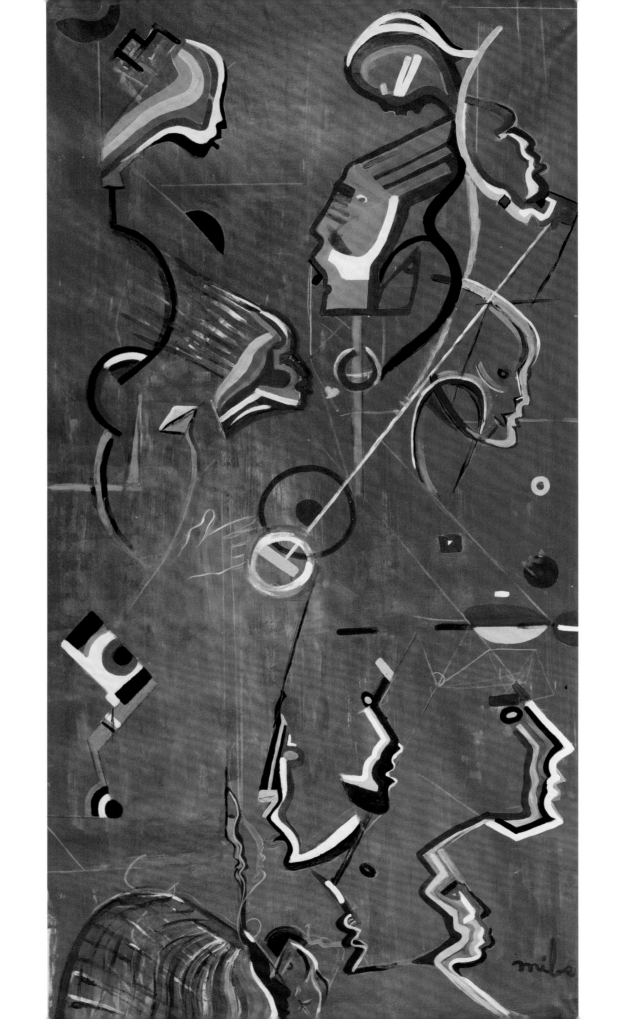

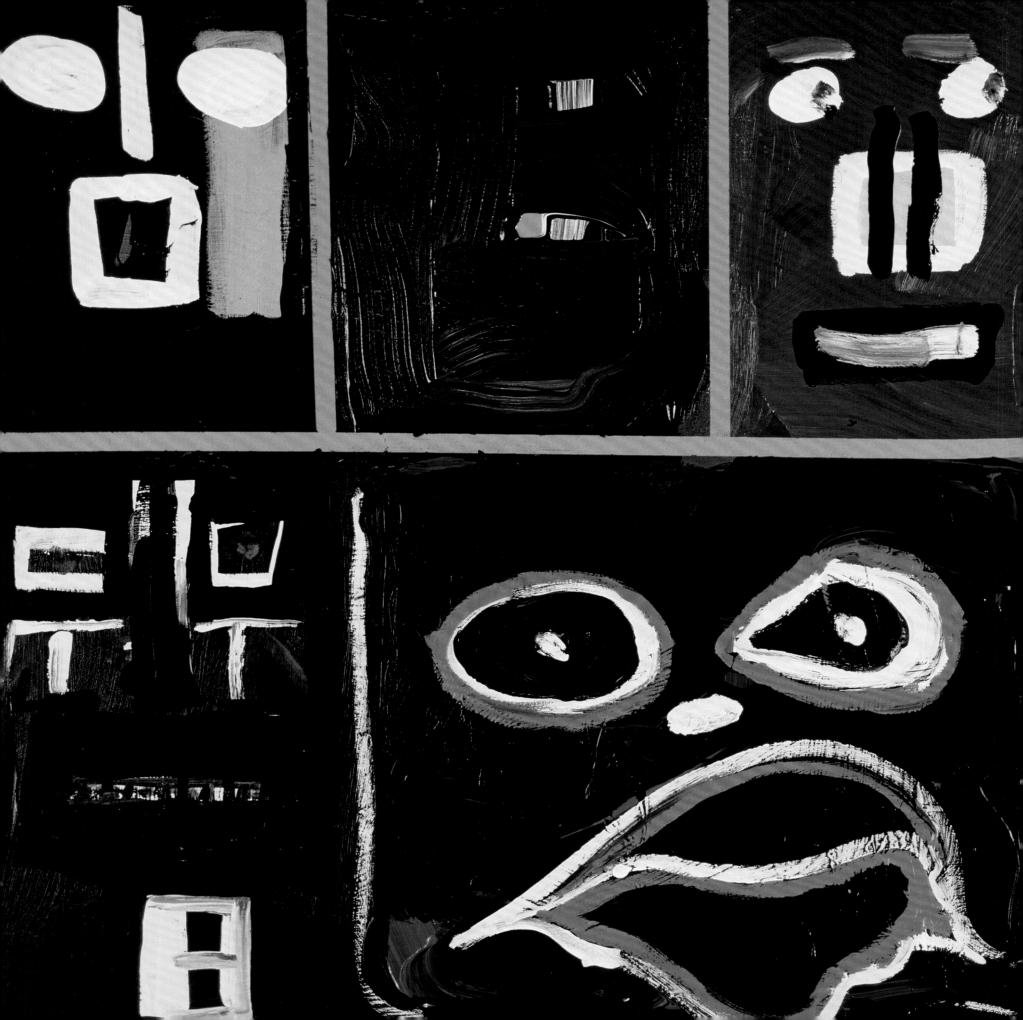

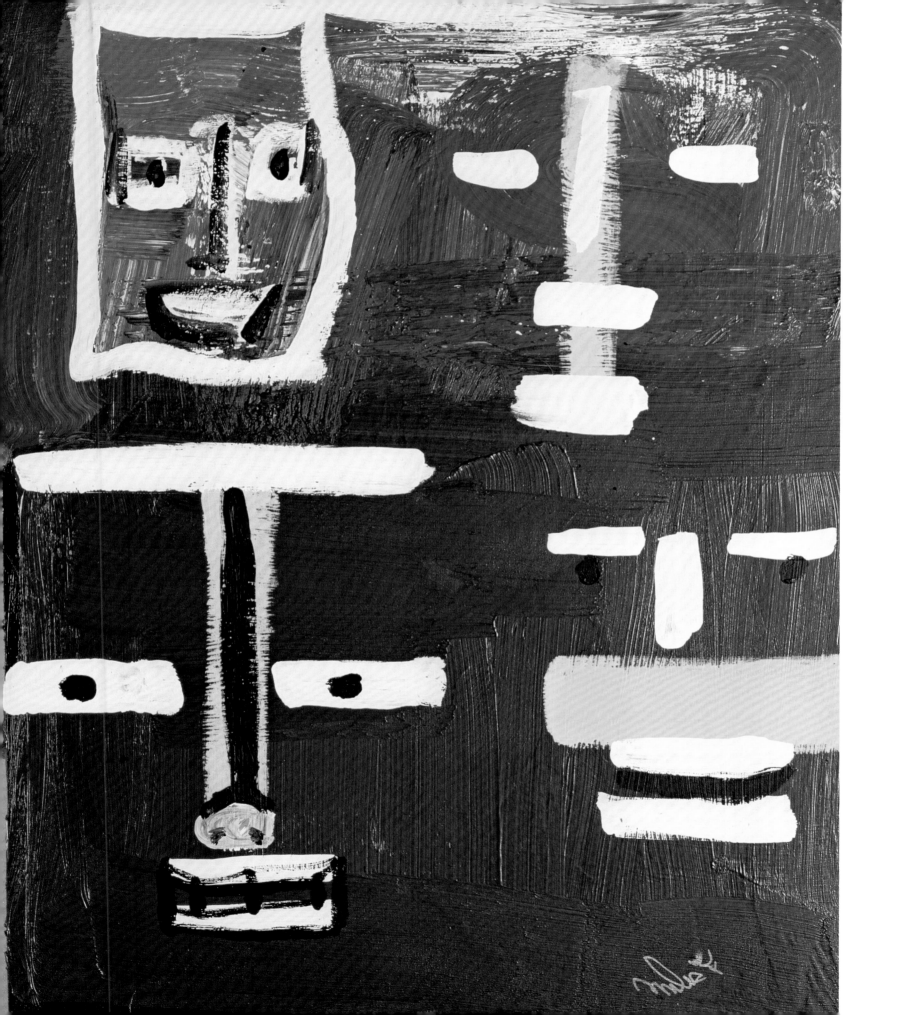

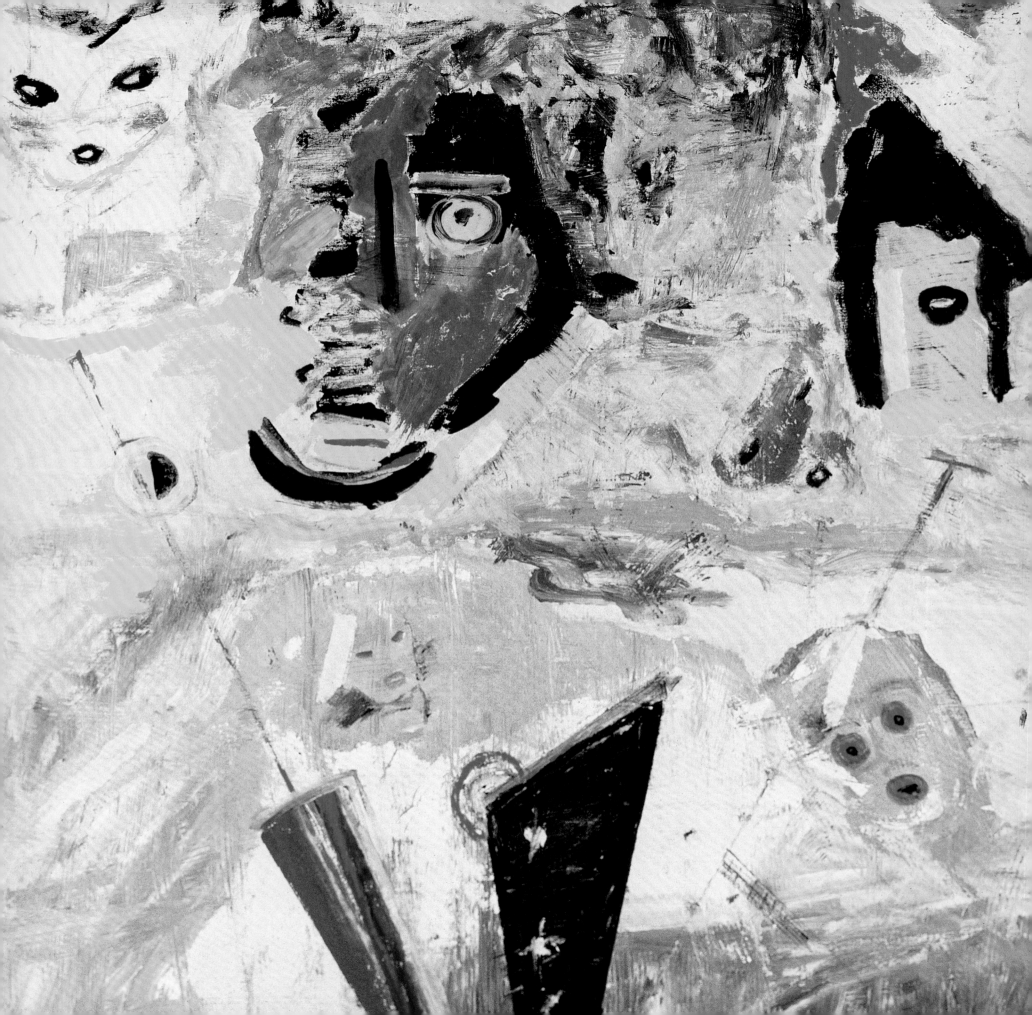

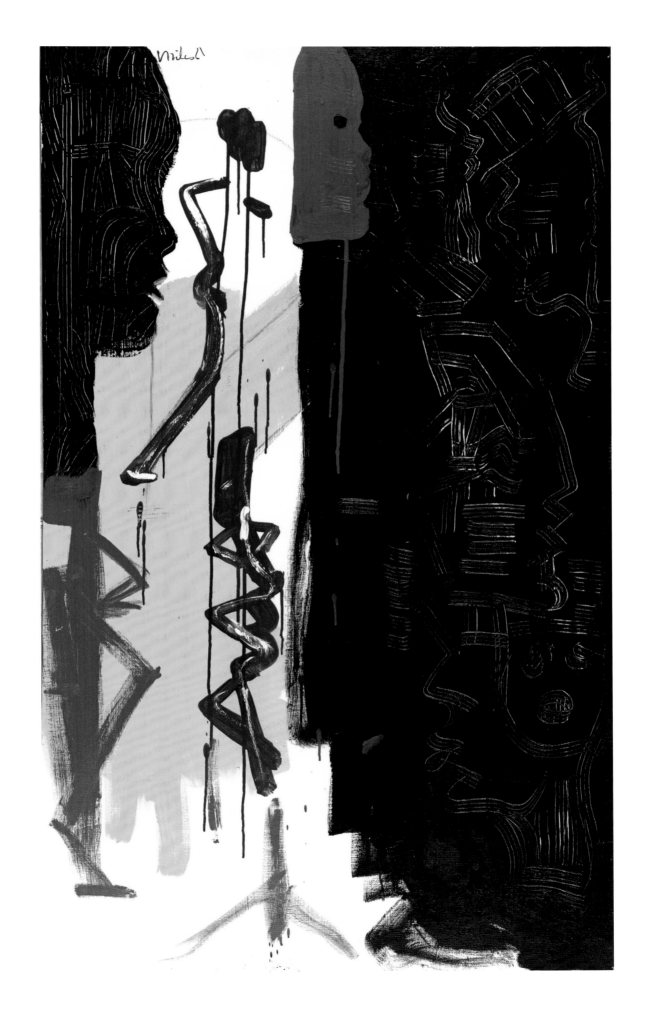

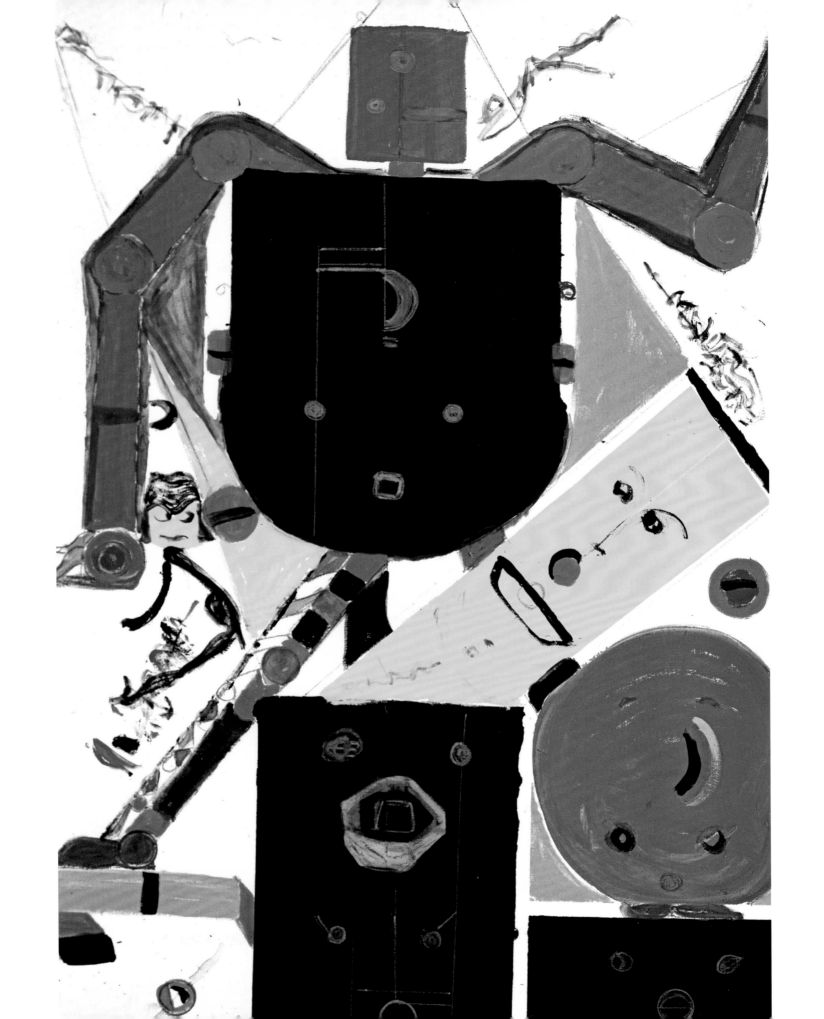

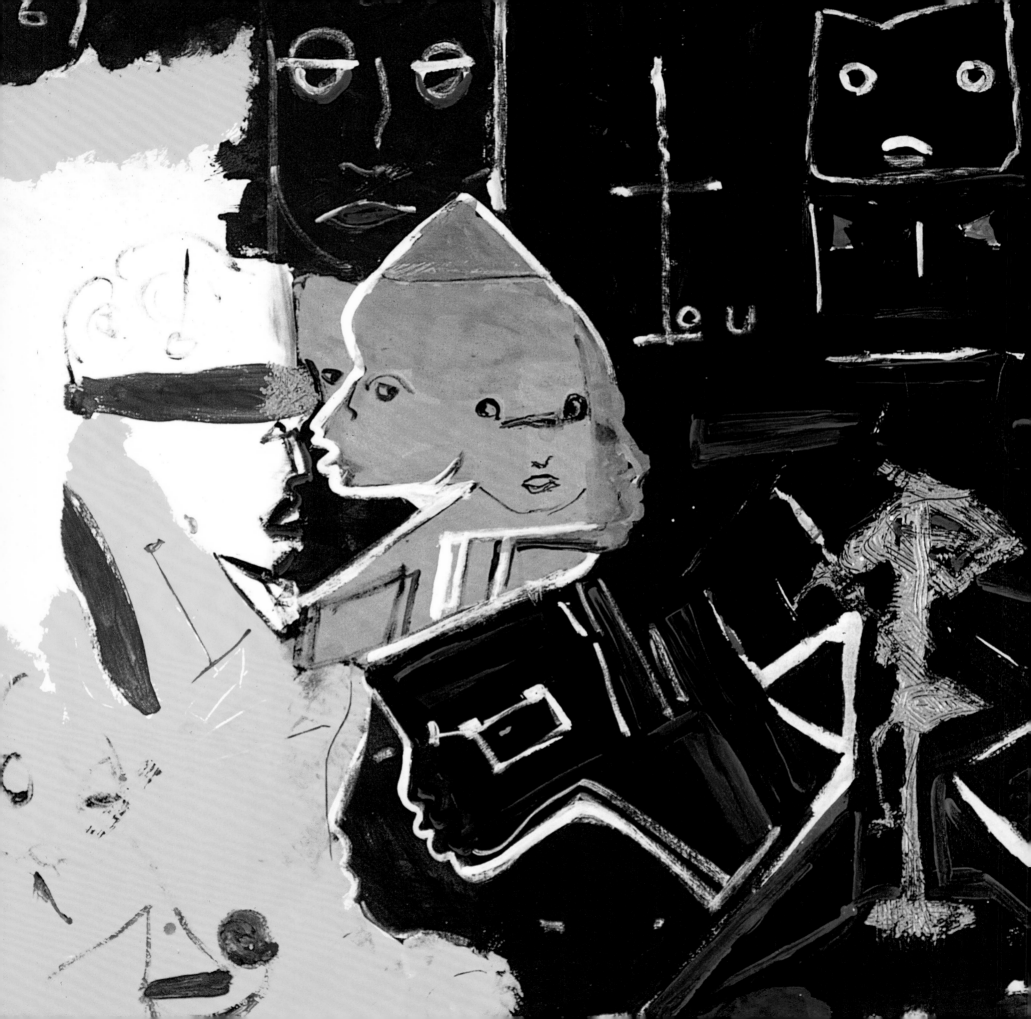

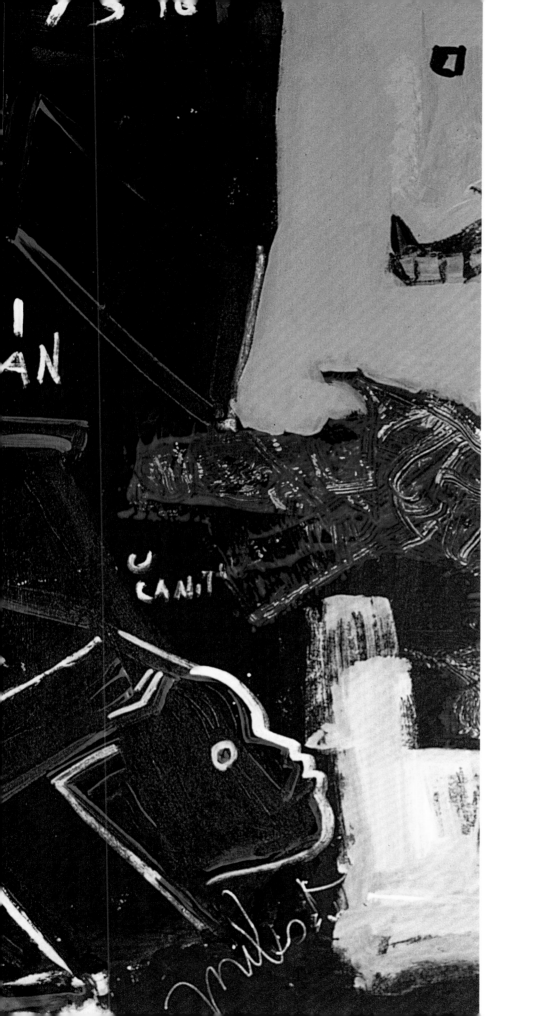

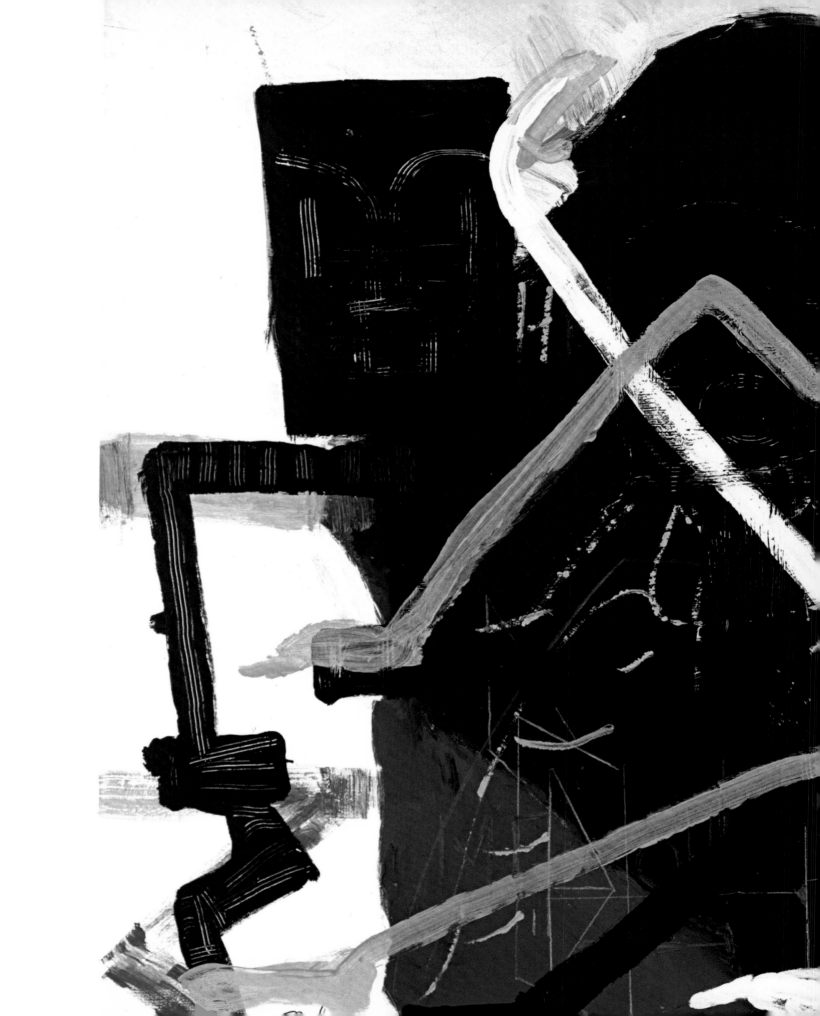

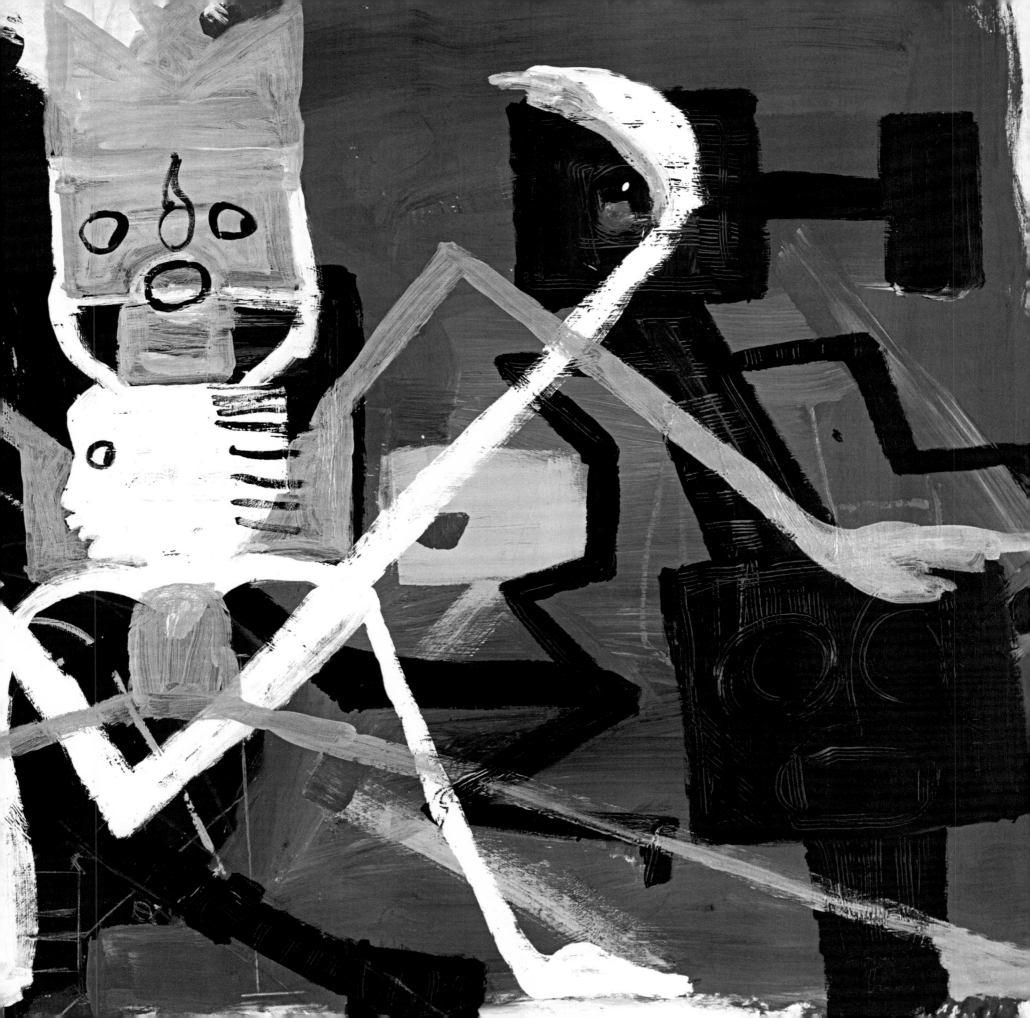

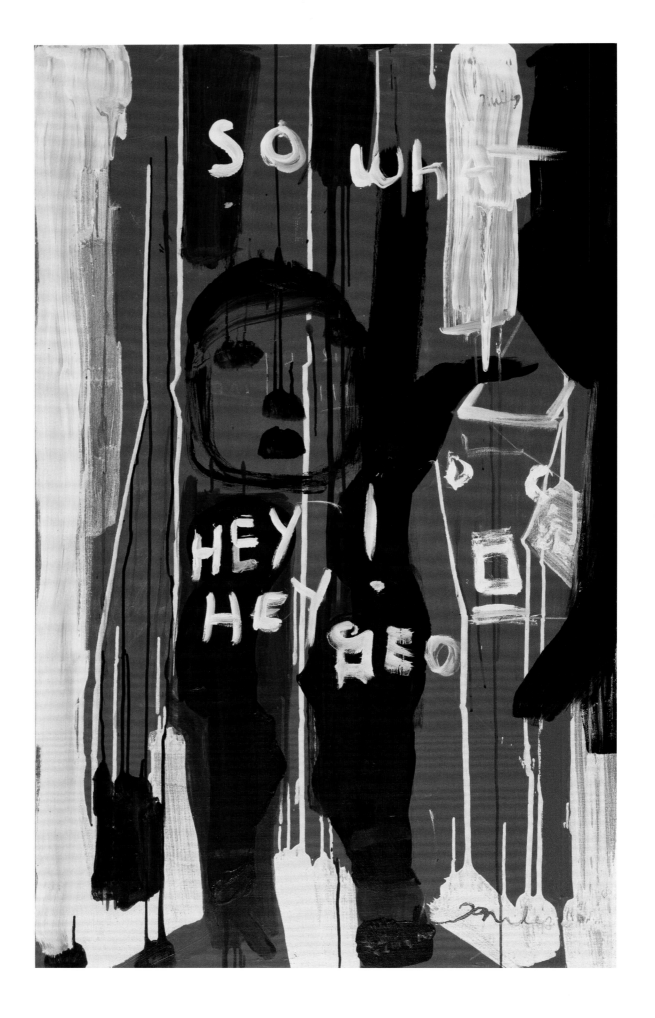

"Sometimes I'd be at a record date, and I'd tell Gil to come, just to be around. And he'd be kneeling down listening while I'm standing up playing. He'd lean over and whisper, 'Now remember, don't play so many Cs, so many B flats. You know how much you worked on your tone. Use it.' You know, things like that. Once he called me up in the middle of the night and said, 'If you ever feel bad, just put on *Miles Ahead* and listen to "Springsville."' Then he hung up, just like that. Man, he was a complex motherfucker. He was so simple that he was complex."

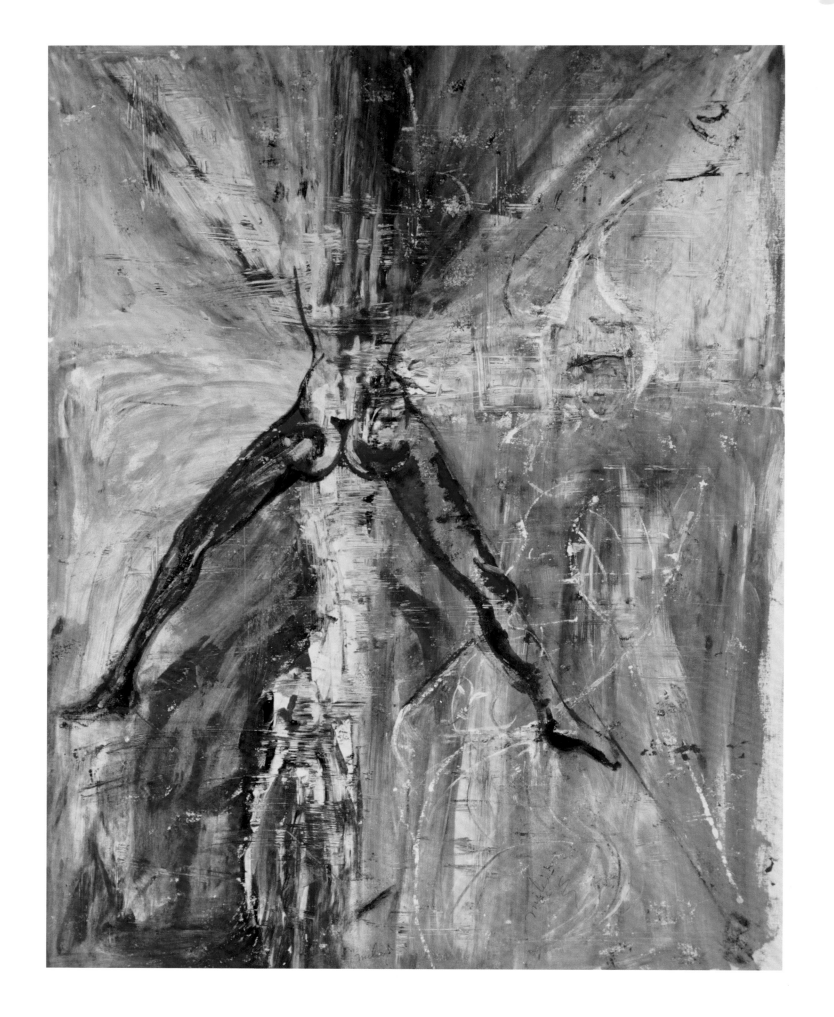

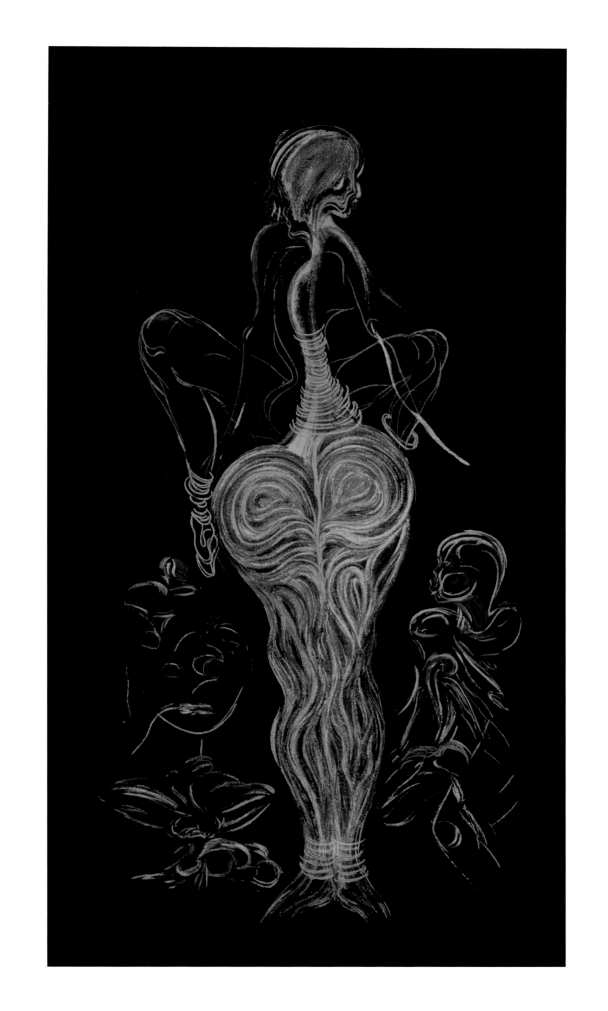

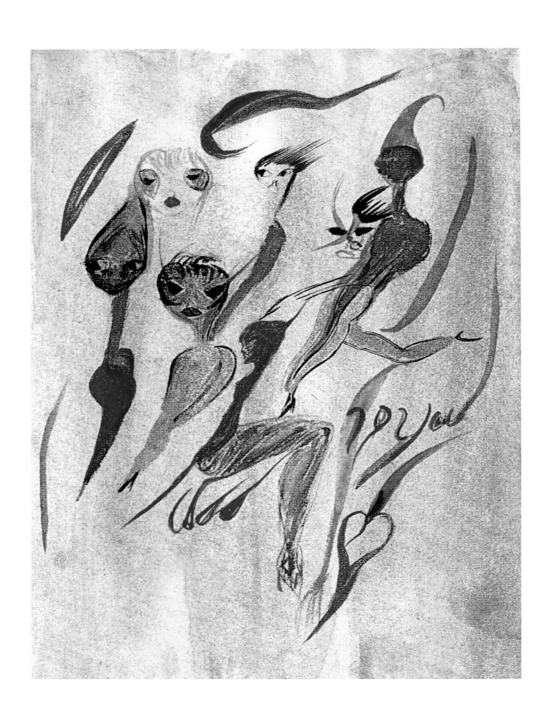

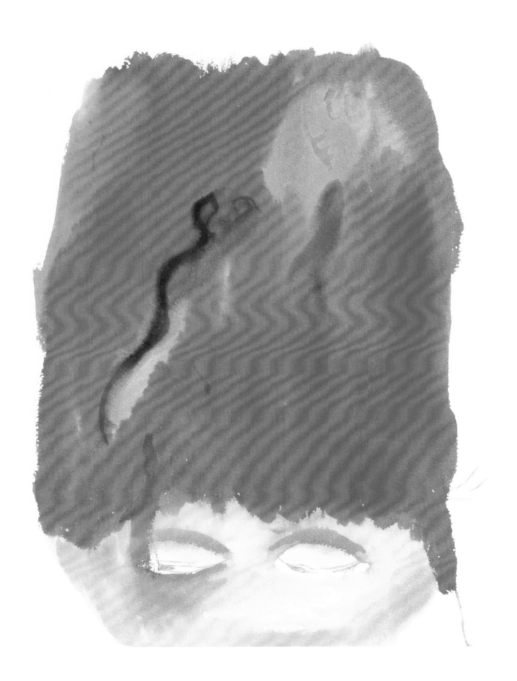

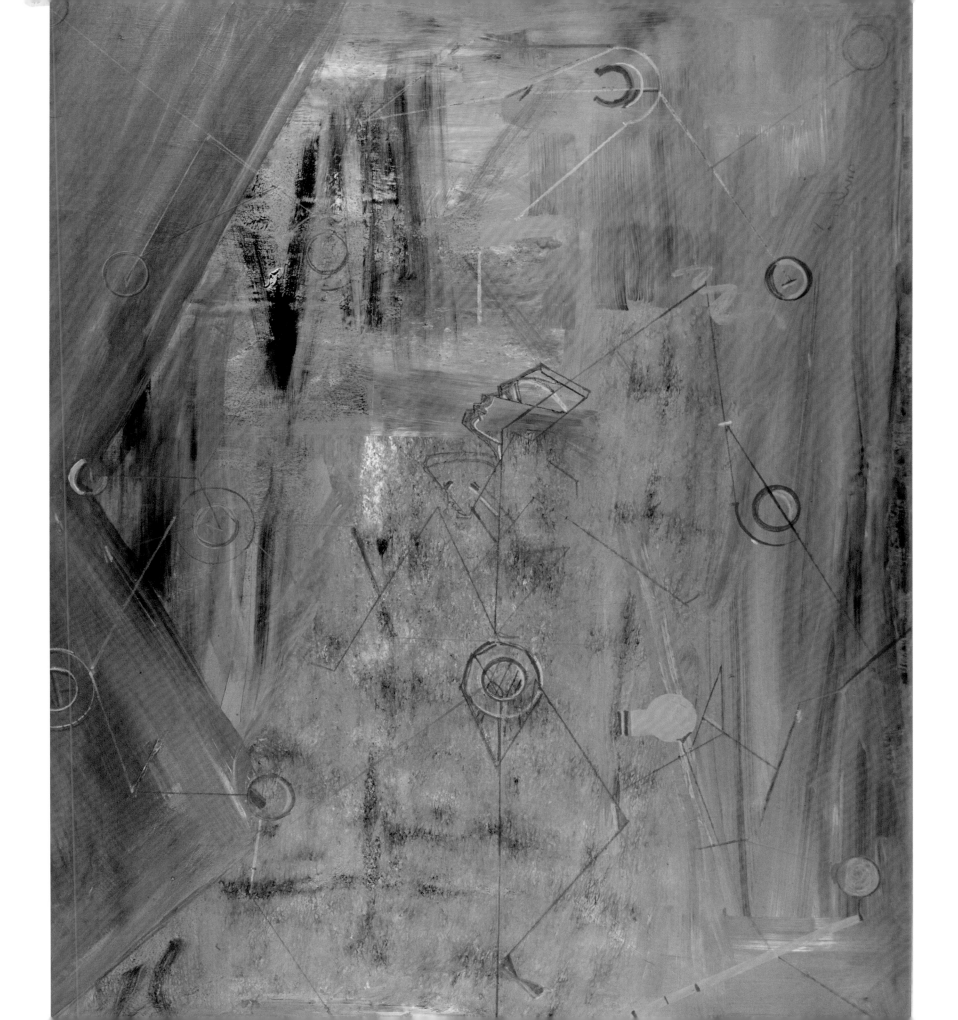

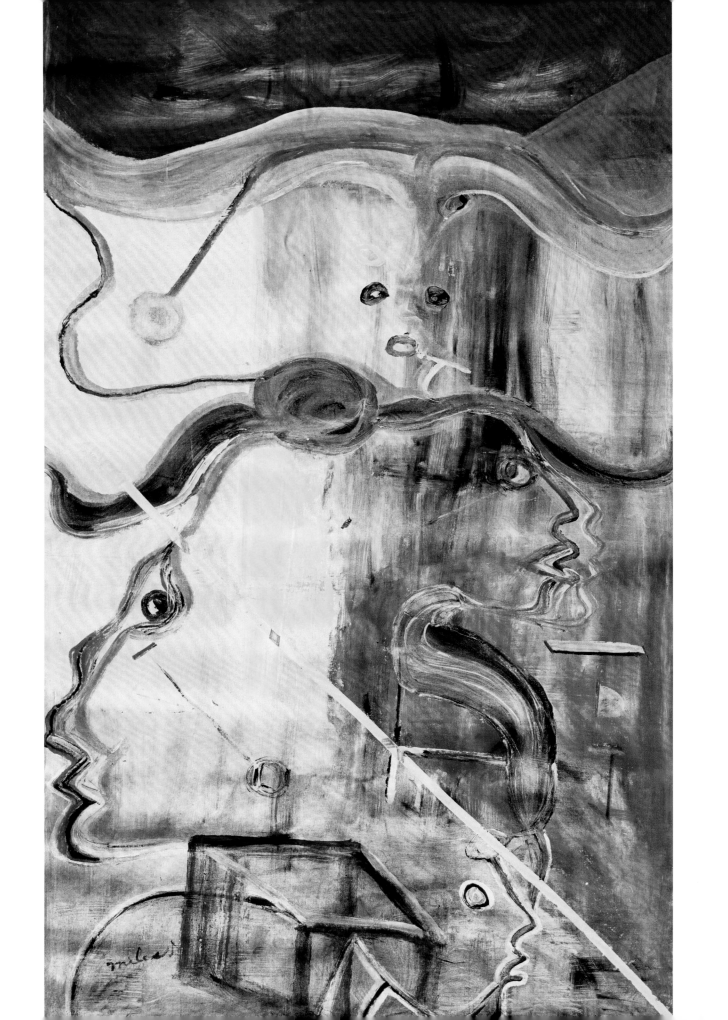

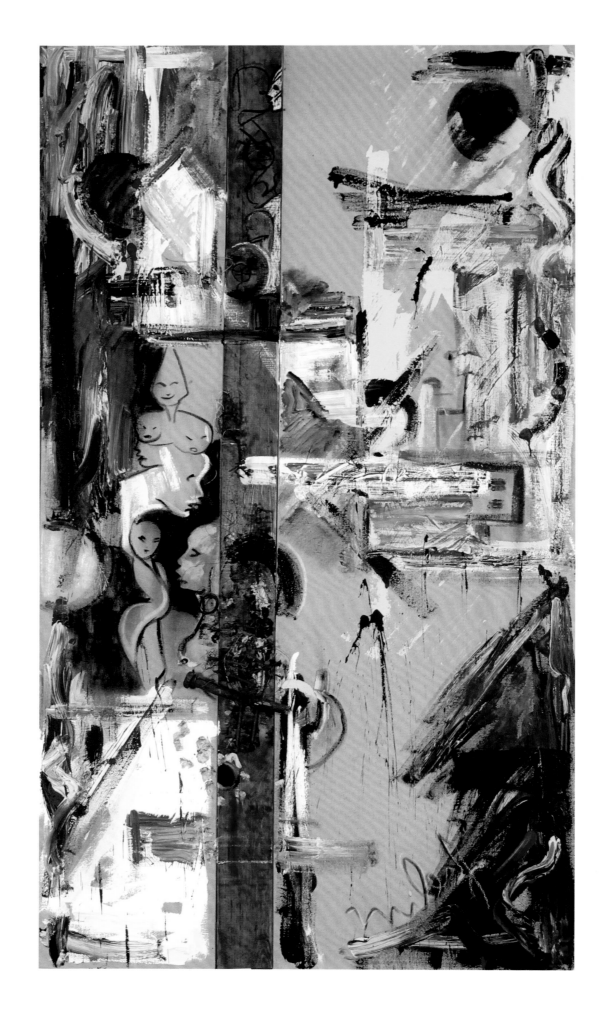

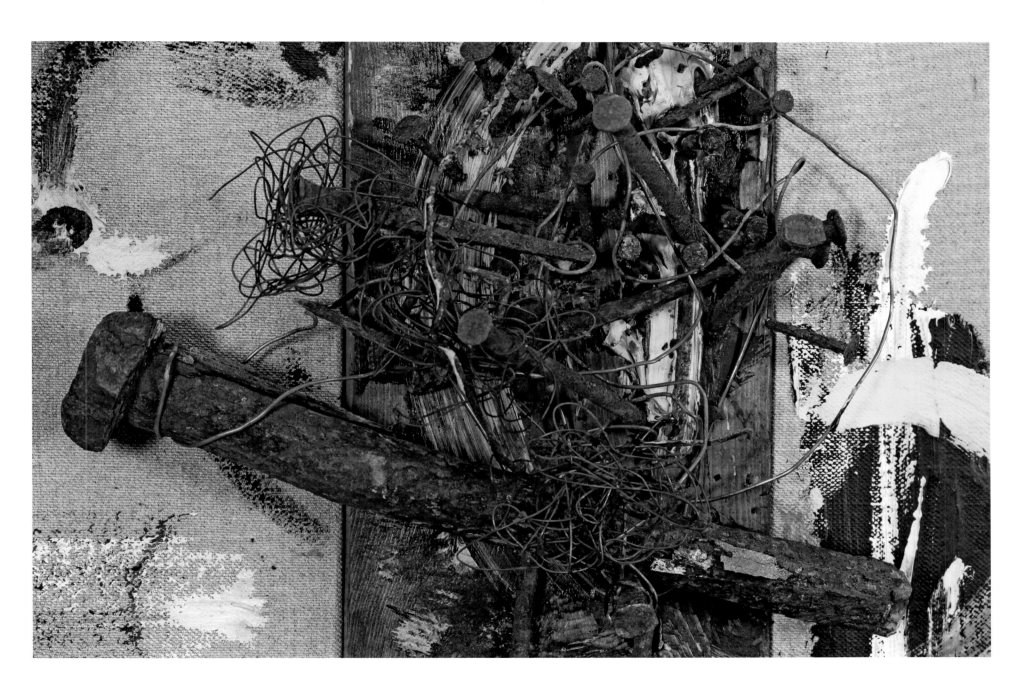

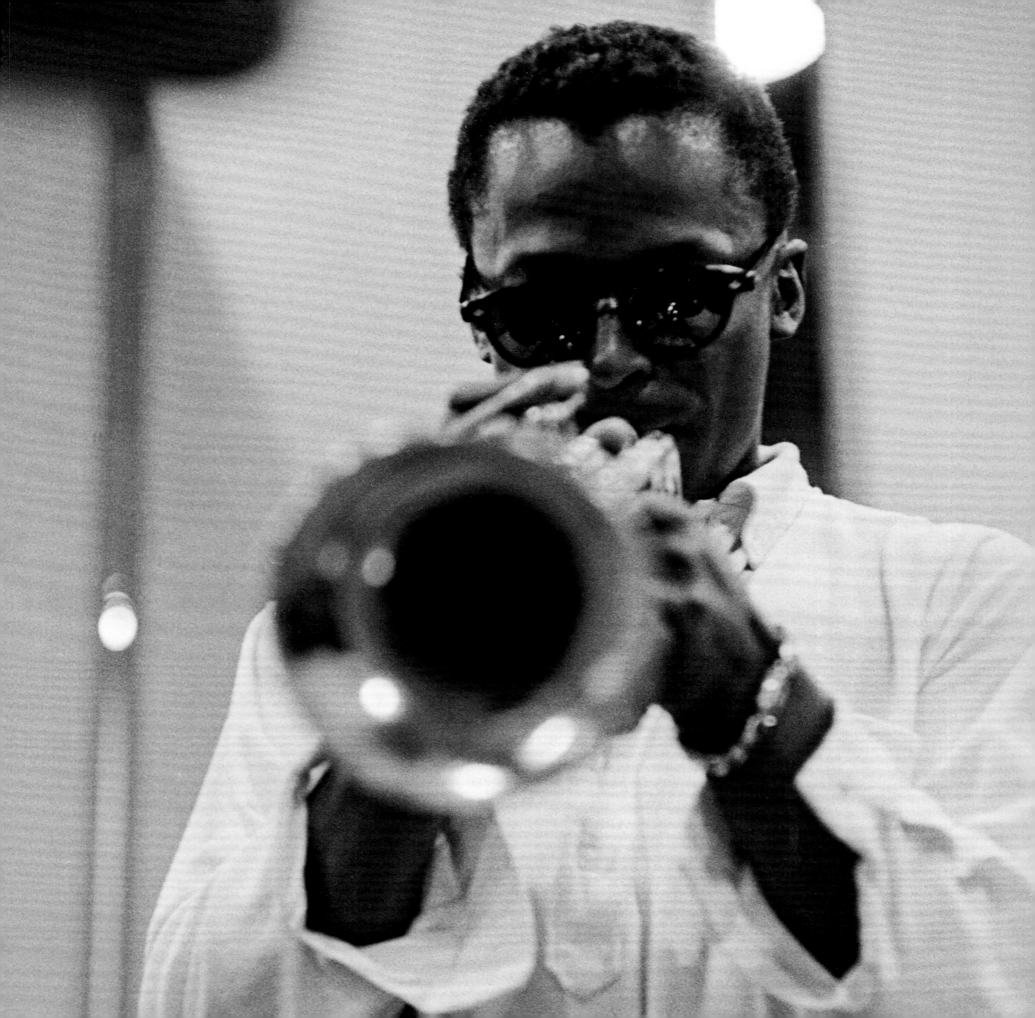

THE STYLES OF MILES | SCOTT GUTTERMAN

There's a story about Miles coming off the stage after a show, turning to one of his bandmates, and asking, "How was it?" Taken aback, he answers, "Oh, you played great, Miles." "No, man," he replies. "I mean, how was the suit?" Long before he began painting, Miles was deeply attuned to visual style. He expressed it through what he wore and how he wore it, blending the casual and the meticulous to arrive at the very definition of cool. The magazine *GQ* went so far as to say, "Davis holds down the #1 spot on our list of 'The Most Stylish Musicians of All Time.'" This evolution took him from a modified Brooks Brothers look in the '50s to slim European suits in the early '60s. The

sweeping changes to his music from the late 1960s onward had an equally marked effect on his visual style. New shapes and flamboyant colors entered the mix, informed by an array of international designers. Yet through it all, as with his music, it is uniquely his style: sure-footed and deliberate, with an easy but profound swing to it.

The two trumpets of his seen here—one with his signature mute, one without—bear traces of this unforced elegance. With Miles's name engraved on them and their bold colors, they declare themselves clearly, like his clean, vibrato-less tone. They don't look much like other players' trumpets, and he didn't play them in the same way,

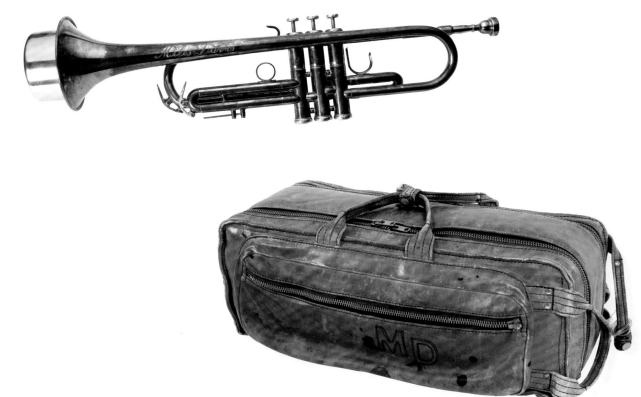

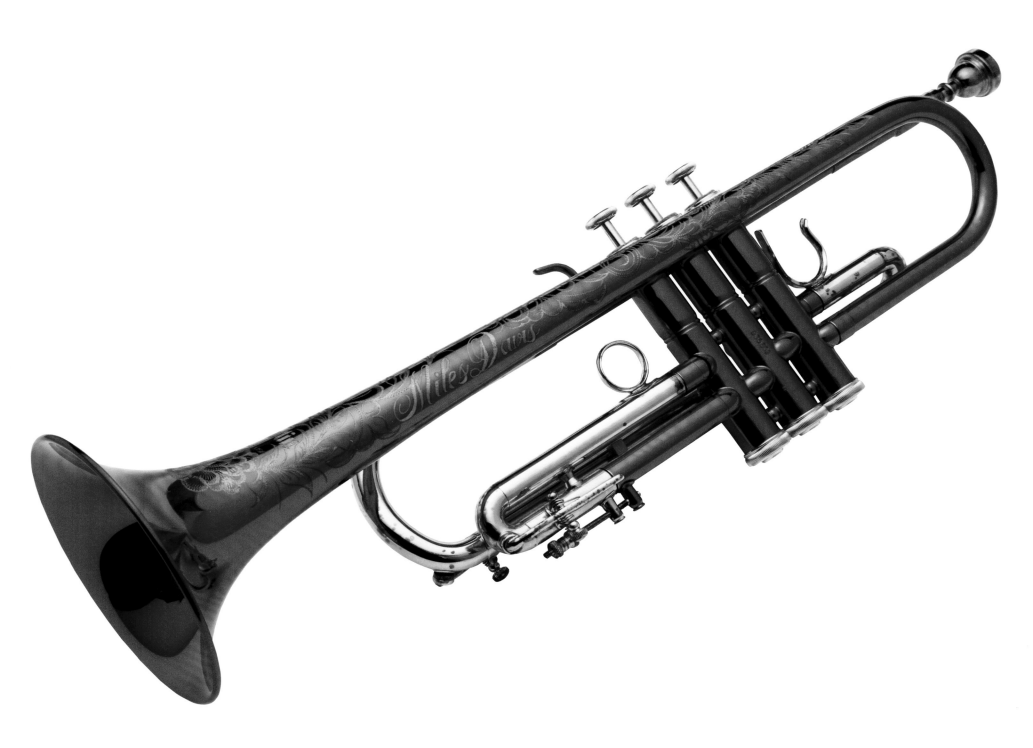

either. Much has been said about his extraordinary sense of space within music, how he incorporated pauses and silences, often to brilliant effect. This page from the score to the *Porgy and Bess* orchestration by his great friend Gil Evans calls to mind his inimitable way with melody, his fresh interpretation of a beloved song creating a new classic. Even his deep-red trumpet bag, with his initials stitched on the side (the MD calling to mind a doctor's kit bag), is a study in subtle style. These artifacts, among the many items that were preserved after his passing, speak of a singular presence. They offer hints to understanding the transformation of Miles from gifted musician to icon. For his many thousands of admirers around the world, he was much more than a composer and performer. He carried some inner authority that expressed itself in everything he did, and those who witnessed it were forever compelled to stop and look and listen.

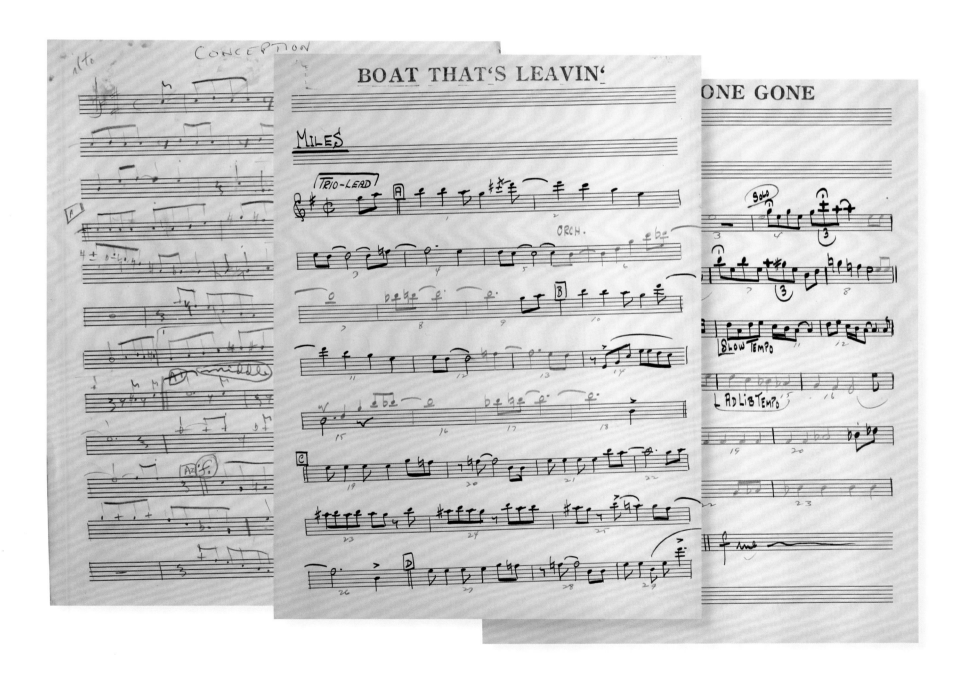

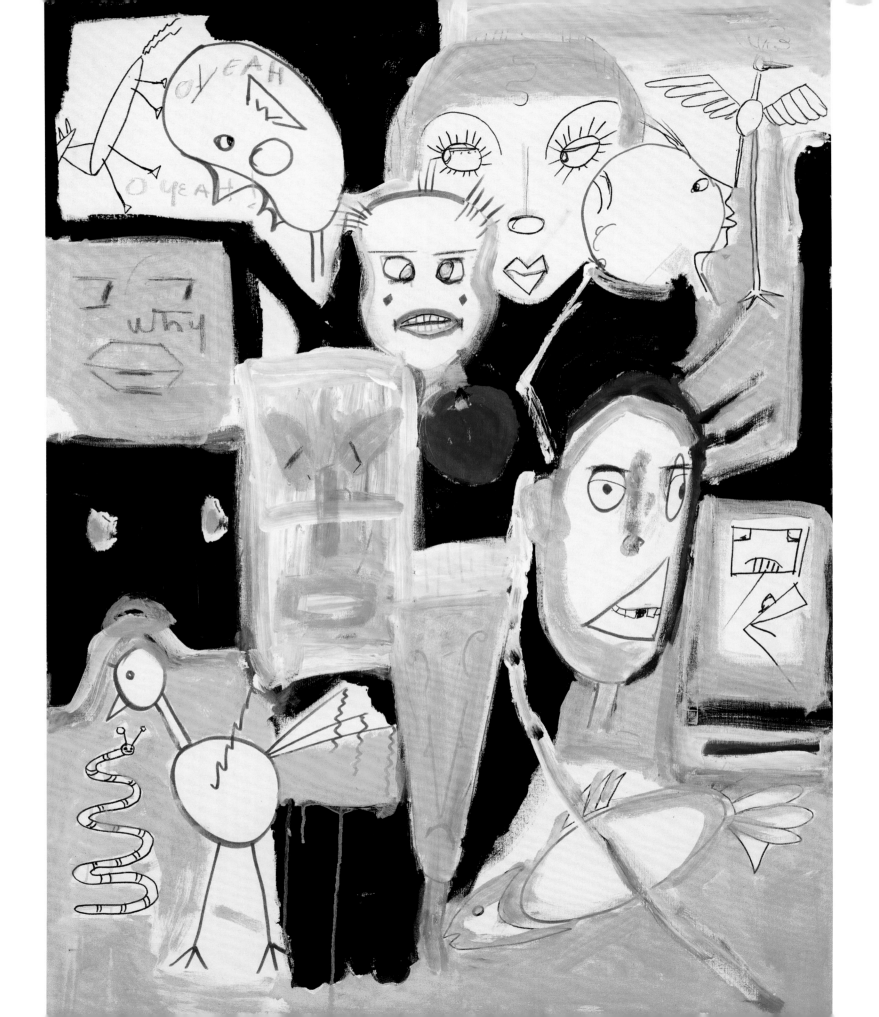

I didn't really think of my father as this legend. He was just my father. I would hear things about him, but a lot of that stuff wasn't true, or at least it wasn't in my experience. A lot of what he did just took place without much discussion. He didn't make a big deal out of something; he just did it.

Who he was started with his family. He had a brother and a sister, and all three of them were very confident people. It showed in whatever my father did, his presence, even just the way he walked. I think artistry starts with understanding what you're about and liking who you are.

There was very little room in my family for feeling like you were a big star. For instance, I taught for a number of years in East St. Louis, and people were just as likely to have heard of my grandfather, who was a very prominent dentist there, as my father. They'd say, "Oh, yeah, Doctor Davis, he fixed my teeth!"

My father did a lot of things just because he wanted to do them. When he was touring, he would take away a part of the culture and traditions as his experience. He was a Gemini, and Geminis are like that. They can do more than one thing well at a time.

When he was being a chef, he used to get me to gather ingredients for him. He'd use special spices that you couldn't get at the regular store. It had to be done a very specific way. For me, cooking and music have the same root, because they're about different flavors and textures. Visual art is the same way.

He was in tune with what some of the Eastern religions talk about, which is a higher level of mindfulness. Like the smell in the air after the rain or the energy that certain people generate in a room. When he was in New York, the everyday sounds of living inspired him: the wind through the buildings, the people clicking their heels on the pavement—he heard that, and he listened.

He never was a stereotypical jazz musician. He started out being unique enough to be accepted to Julliard. He had horses, a house in Malibu. He really didn't like any limits placed on him. Of course, he fought the demons of his era, of that time and place. Drugs and racism were all around, but he managed to live through them and gained a perspective that he could balance his life with and not look back.

I understood what he was about. I knew how important his music and art were to him, and that was enough. The main thing is, I'm glad he was my father. I'm glad he was uniquely himself.

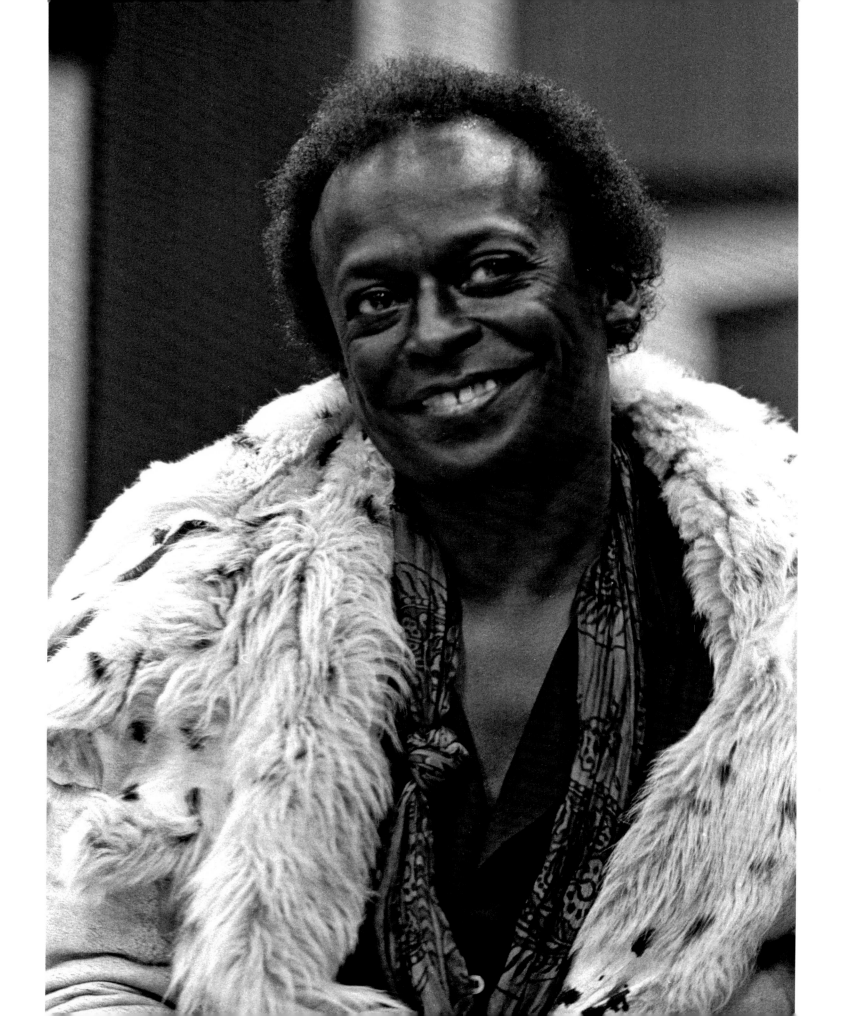

ACKNOWLEDGMENTS

It's an honor and a privilege to bring another dimension of the creativity of Miles Davis to light with this book. I would like to thank the Estate of Miles Davis, in particular Erin Davis, Cheryl Davis, and Vince Wilburn Jr., for their cooperation and kindness. Thanks to my new friends at Insight Editions, especially Michael Madden, for making this book possible. My deepest thanks to Jamie Kay and Michael Gutterman for their incredible love and support. Finally, my thanks to the late Miles Davis, whose genius continues to blaze brightly.

COLOPHON

PUBLISHER: Raoul Goff
CO-PUBLISHER: Michael Madden
ART DIRECTOR: Chrissy Kwasnik
DESIGNER: Jenelle Wagner
EDITOR: Kelli Fillingim
ASSOCIATE EDITOR: Leigh Mitnick
PRODUCTION MANAGER: Jane Chinn

Insight Editions would like to thank Darryl Porter, Erin Davis, Cheryl Davis, Vince Wilburn Jr., Scott Gutterman, Quincy Jones, and Lionel Richie for their continued support.

INSIGHT EDITIONS

PO Box 3088
San Rafael, CA 94912
www.insighteditions.com

Find us on Facebook: www.facebook.com/InsightEditions
Follow us on Twitter: @insighteditions

Library of Congress Cataloging-in-Publication Data available.

ISBN: 978-1-60887-223-7

REPLANTED PAPER ROOTS of PEACE

Insight Editions, in association with Roots of Peace, will plant two trees for each tree used in the manufacturing of this book. Roots of Peace is an internationally renowned humanitarian organization dedicated to eradicating land mines worldwide and converting war-torn lands into productive farms and wildlife habitats. Roots of Peace will plant two million fruit and nut trees in Afghanistan and provide farmers there with the skills and support necessary for sustainable land use.

Manufactured in China by Insight Editions

10 9 8 7 6 5 4 3 2 1

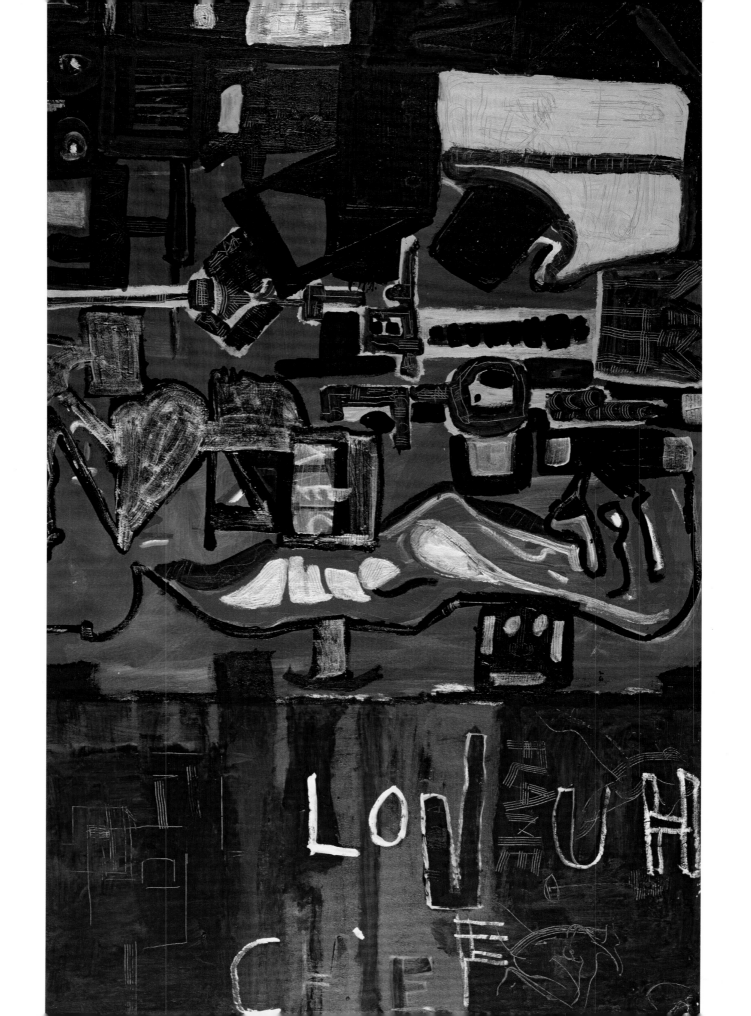